Con textos introductorios de/ With introductions by
Michael Erlhoff

Product Design

Feierabend

WITHDRAWN

Product Design

© 2005 Feierabend Verlag OHG
Mommsenstraße 43, D-10629 Berlin

Text: Prof. Dr. Michael Erlhoff

Project management: Lars Oscenda & Elisabeth Wehrmann
Translation into English: Anna L. Grant
Translation into Spanish: Silvia Gómez de Antonio

Design and Layout: Roman Bold & Black, Cologne
Production: Stephanie Leifert
Cover: Bd Ediciones de Diseño (design: Ross Lovegrove)
Back cover: p.465, p.350, p.256, p.68, p.439, p.515, p.272, p.482, p.212

Concept: Peter Feierabend

Printed in the EU
ISBN 3-89985-183-8
25-03080-2

Contenido

Contents

	Diseño vivo	Living design	6
01	Vivir es algo más	Living in bliss	18
02	Accesorios	Accessories	130
03	Cocina y baño	Kitchens and bathrooms	186
04	Hágase la luz	Let there be light!	322
05	Muebles para la oficina	Office furniture	416
06	Medios de comunicación y entretenimiento	Media and entertainment	472
07	Deporte, ‹Hobby›	Sports and hobbies	522
08	Entorno diseñado	The designed environment	590
09	Diseño industrial	Industrial design	670
	Índice	Index	700

Diseño vivo

No hay duda: Toda nuestra vida se desarrolla dentro del diseño y está organizada por él. La forma en que vivimos, nos bañamos, conducimos, observamos el mundo o guardamos nuestras cosas está siempre configurada, es decir, «diseñada». En numerosas ocasiones, sin embargo, hemos podido experimentar que esto no siempre es algo útil. A veces nos tropezamos con el diseño, no comprendemos las cosas o, simplemente,

There can be no doubt about it: we live our entire lives surround-
ed and organized by design. The way we live, take a bath, drive, package
things, even how we view the world through our glasses: all this has already
been shaped and 'designed' for us. However, as we all already know from
a wealth of experience, this is by no means always an unqualified success.
We can sometimes stumble over design, misinterpret objects, or simply

Living design

no nos gustan. El diseño no es algo sencillamente bueno, día a día nos exige analizar los objetos diseñados (también los símbolos y los servicios), comprenderlos, tocarlos, dar vueltas a su alrededor y valorarlos porque, al fin y al cabo, somos nosotros quienes, con su uso diario, decidimos qué está bien diseñado o no.

A veces, sin embargo, tenemos que aprender primero a utilizar lo diseñado. En algunas ocasiones el diseño puede resultar incluso una provocación provechosa, nos revela nuevas experiencias, nos exige un cambio en nuestro comportamiento y se anticipa a lo que en algunos años aceptaremos como normal. Por eso el trato con el diseño que nos rodea y que dota a nuestra vida de diversidad no sólo causa placer sino que también puede

8

dislike them. Design is not just simply a good thing in itself; it requires us on a daily basis to test, understand, take hold of or even jump around on the objects (including also symbols and services) that it has shaped – and to evaluate them. We pass judgment in the course of our actions and in all aspects of our daily lives as to what is well designed.

Sometimes, however, we must first learn how to use a designed object. Indeed, from time to time, design is a useful provocation, opening up new experiences, even compelling us to change our behavior, and anticipating what most of us will only accept as the norm a few years later.

Thus our interaction with design – with all that surrounds us and shapes our lives in so many ways – can give rise to pleasure and sometimes even

exigirnos un esfuerzo. En cualquier caso debemos informarnos de lo que sucede en este ámbito porque se trata de una información sobre nuestra vida y sus posibilidades.

Detrás del concepto de diseño se esconden otras muchas cosas como por ejemplo un importante factor de mercado. El diseño dota a los objetos de nuevas funciones, de nuevas formas de uso y de un aspecto diferente. Además permite a las empresas utilizarlo de una forma consciente y variada, lo que supone una gran ventaja en el mercado: atrae la atención, resalta el producto, fundamenta de forma convincente los precios y es una expresión de calidad. El diseño inteligente disminuye incluso los costes de la producción, facilita el ahorro de material y de energía y determina hasta la

10

difficulty. Whatever the case, we must be able to keep up with what is happening in design, for it is a vital source of information about life and its possibilities.

But there is much more to design than this. It is, for instance, a significant market factor. Because design develops new functions and consumer applications for objects, and transforms their appearance, it gives design-conscious businesses with a flexible approach a significant market advantages in terms of visibility, unique positioning, a rational price structure and the expression of quality.

Clever design even cuts product costs through economical use of materials and energy, while also making provision for the repair or alternative use of

eliminación de los objetos, su reparación o su reciclaje. Por lo tanto el diseño es un factor importante si queremos relacionarnos de una forma respetuosa con el medio ambiente. El diseño ha desarrollado también muchos materiales nuevos y ha introducido su empleo en nuestra vida diaria.

Por eso cuando discutimos sobre el diseño estamos hablando también de las perspectivas económicas, técnicas, ecológicas, sociales y, como no, culturales de una sociedad. Pero el diseño no es sólo la base de las particularidades culturales, a veces nos ofrece también la oportunidad de adornar nuestras vidas con elementos de otros lugares. Los muebles escandinavos son diferentes a los italianos, que, a su vez, se distinguen de los japoneses; el diseño de los coches alemanes difiere del de los americanos y franceses,

an object, and for its disposal and eventual end. In this respect design is also an important factor in environmental considerations. Design has developed many innovative materials and their applications, as well as smart technologies and the rational implementation of these resources in everyday life. Thus any discussion of design must also take into account the economic, technical, environmental and social perspectives – and cultural considerations. Design forms the basis of cultural characteristics, and so can occasionally offer the chance to enhance our personal environment with forms from other cultures. Scandinavian and Italian furniture styles are by no means the same and they both differ from their Japanese counterpart; German automobiles are based on different design concepts to those of

y en Holanda la señalización de las calles no es la misma que en China. La variedad expresada a través del diseño agota todas las discusiones sobre la globalización y sobre el afán de igualar las culturas.

A través de unos procesos creativos extremadamente complejos, el diseño nos permite vivir y experimentar una increíble variedad. Por eso lo más importante es ser concientes de ello.

Este es el motivo que hace de este libro una obra tan estimulante y relevante: Nos presenta nuevas perspectivas de formas de vida concretas y nos abre todas las posibilidades con las que soñamos y que incluso podemos llegar a alcanzar. Su lectura es apasionante y relajante, inquietante y placentera.

14

the Americans and the French, while street signs in the Netherlands are not the same as those in China. Although there is much justified discussion of globalization, and of a general leveling down, this will not prevail, thanks to the continuing diversity created by design.

Through extremely complex design processes, design makes it possible to live with and experience magnificent diversity. It is vital to increase our awareness and knowledge of all this.

It is for these reasons that this book is so stimulating and also so important. It opens up perspectives for all of us on specific ways of living and all those possibilities that we dream of, or may even fulfil. This makes for reading that is both stimulating and relaxing, disturbing and pleasurable.

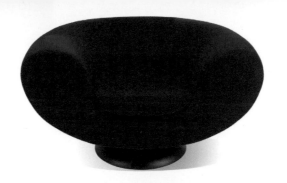

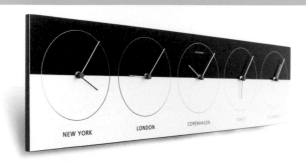

NEW YORK LONDON COPENHAGEN TOKYO LOS ANGELES

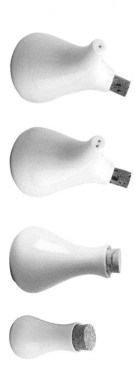

01

Vivir es algo más

A menudo las personas solemos olvidar que el verbo «vivir» no sólo significa tener vida sino que, además, describe una actividad. Amueblamos y acomodamos las casas donde vivimos, es decir, nos creamos un espacio vital. Pero como no construimos toda la vivienda porque seguramente se tambalearía constantemente, se estropearía y eliminaría muchos puestos de trabajo, componemos nuestro propio estilo de vivienda a partir

Unfortunately, people all too often forget that domestic living is not just a passive state of bliss but also an active process. We take up residence, we set ourselves up – that is to say we create our own specific living space. However, as we quite sensibly do not make everything ourselves – it will always be wobbly, or quickly loses its appeal, and anyway would just lead to job losses – we can construct our own very personal

Living in bliss

de aquello que nos ofrece el diseño. Este proceso puede ser muy creativo si antes nos hemos informado bien de lo que hay en el mercado.

Es especialmente en los espacios dedicados a la vivienda donde cada uno puede crearse su propio mundo y mezclar formas y diseños diferentes. Para ello sólo necesitamos información y seguridad en nosotros mismos.

Atrévase: Aquí encontrará numerosos ejemplos de estimulantes diseños para los cuartos de estar y los dormitorios.

style of living from all that design offers. And this can in itself be highly creative, as long as we investigate all the appropriate options beforehand. Particularly here, in our living areas, we can use a diverse mix of shapes and designs to create our own personal world. All that is needed to do so is information and self-confidence.

Go for it! Here you will find lots of creative ideas for living room and bedroom design to inspire you.

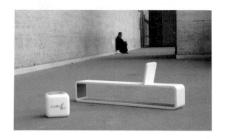

Cubi
designer: Bjørn Blisse,
Folker Königbauer, Reinhard Zetsche
www.transalpin.net

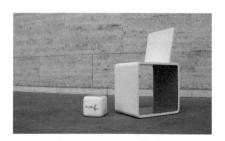

above Jive **opposite** Sukie
producer: Ellips www.ellips.de

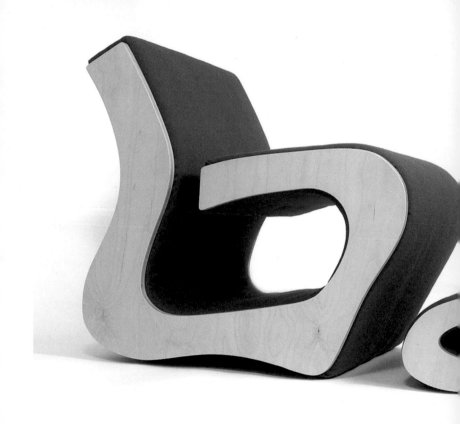

Otto
designer: John Greg Ball
www.johngregball.com

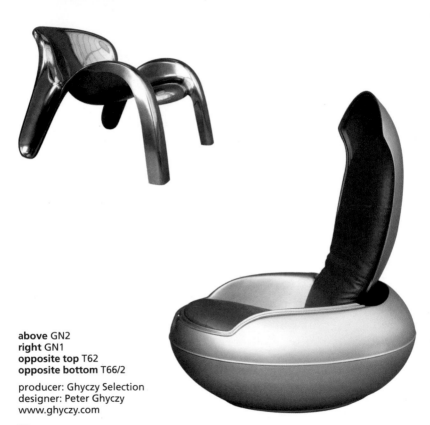

above GN2
right GN1
opposite top T62
opposite bottom T66/2

producer: Ghyczy Selection
designer: Peter Ghyczy
www.ghyczy.com

30

31

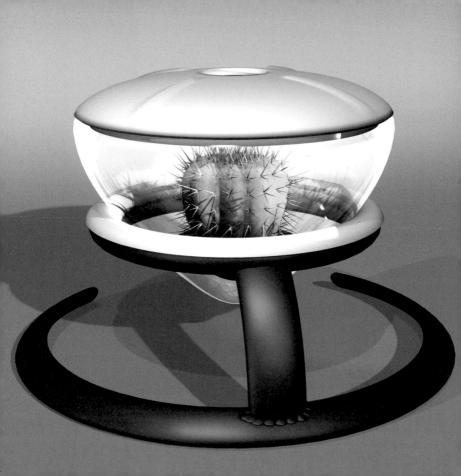

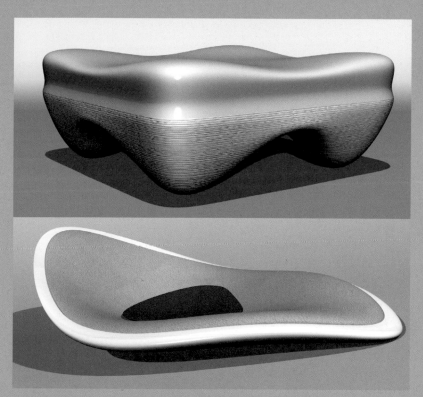

opposite Louise **top** Tablechair **above** Ultra Cosi
designer: Gilles Roudot www.kidino.com

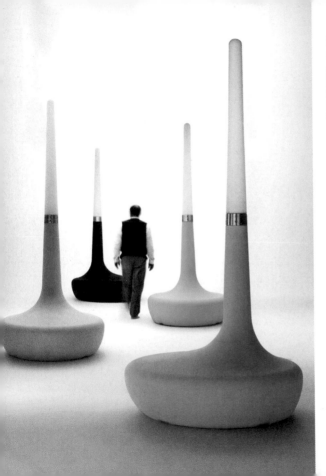

left Lamp
opposite Bench

producer:
Bd Ediciones de Diseño
designer:
Ross Lovegrove
www.bdbarcelona.com

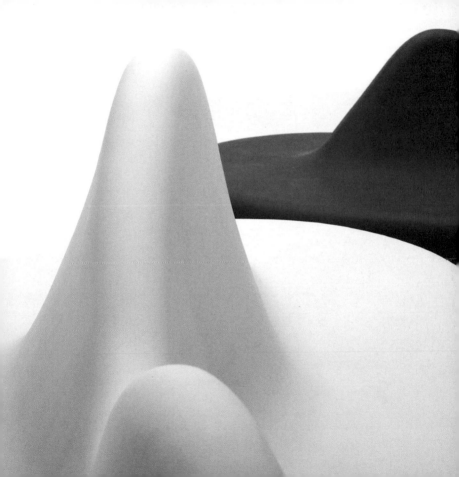

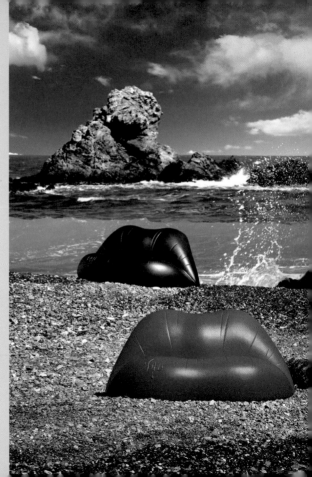

opposite top
Muletas/Bracelli/Leda
opposite bottom
Lámparas Dalí

producer:
Bd Ediciones de Diseño
designer:
Salvador Dalí
photographer:
Leopold Sams
www.bdbarcelona.com

right Dalílips
producer:
Bd Ediciones de Diseño
designer:
Salvador Dalí
photographer:
Rafael Vargas
www.bdbarcelona.com

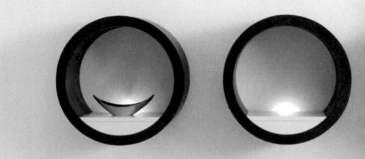

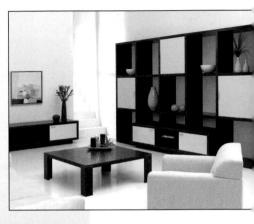

left BE
above Concept

producer:
A/S Hammel Møbelfabrik
www.hammel-furniture.dk

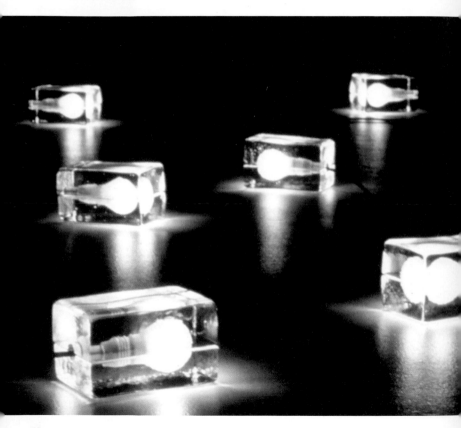

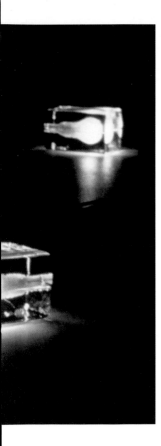

left Block Lamp designer: Design House Stockholm
below Sofa Bed **bottom** Low Working Table

producer: Harri Koskinen Friends of Industry Ltd.
www.harrikoskinen.com

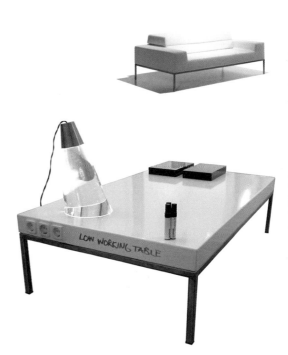

LOW WORKING TABLE

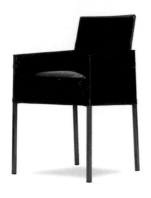

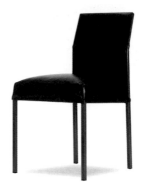

above Texas **below left** Nivo **below right** Just designer: KFF Design www.kff.de

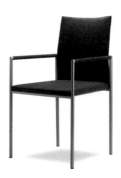

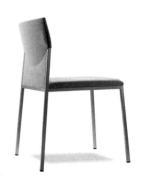

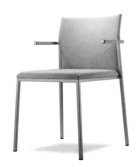

above and below right Unit **below left** Cube designer: KFF Design www.kff.de

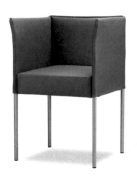

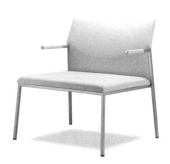

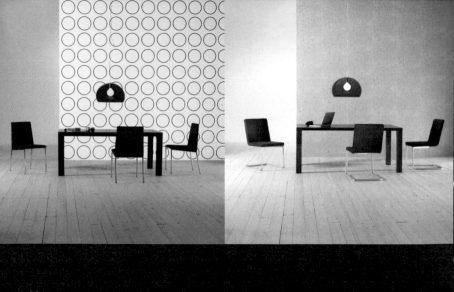

44

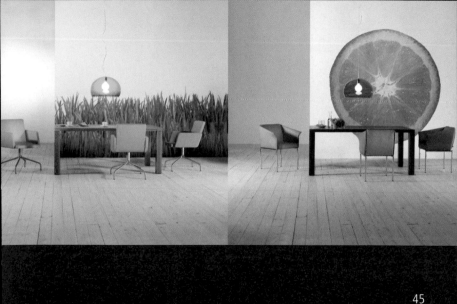

45

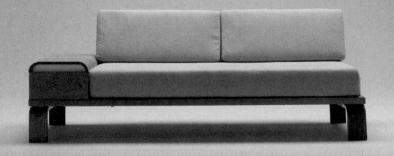

opposite top left Karlanda
designer: Tord Björklund
opposite top right Ture
designer: Maria Vinka
right Fridene
designer: Carina Bengs
opposite bottom and below Lessebo

producer: IKEA www.ikea.com

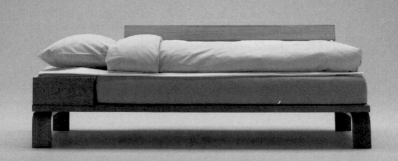

47

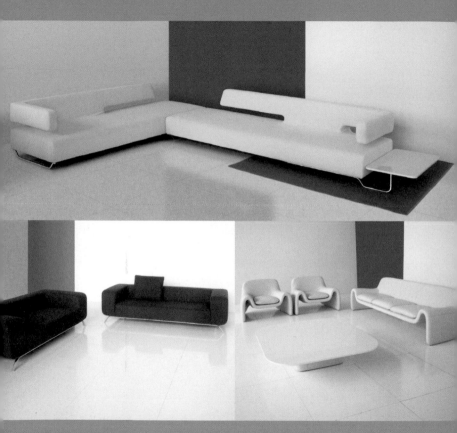

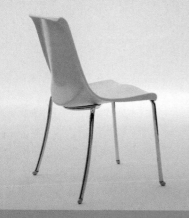

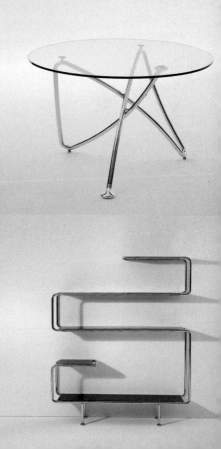

opposite top Elle
opposite bottom left Comfort
opposite bottom right Moon
producer: Cinova
designer: Massimo Iosa Ghini
www.cinova.it www.iosaghini.it

above left Hydra
above right H 20
right DNA
producer: Bonaldo
designer: Massimo Iosa Ghini
photographer: Santi Caleca
www.bonaldo.it www.iosaghini.it

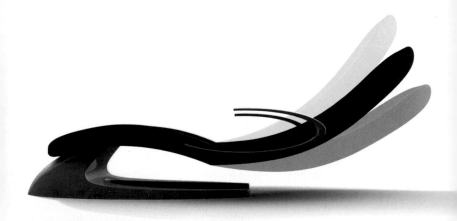

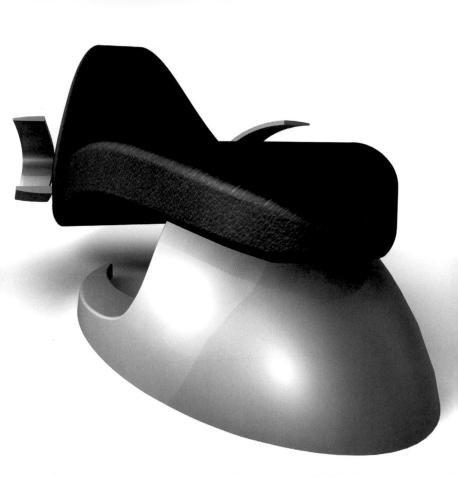

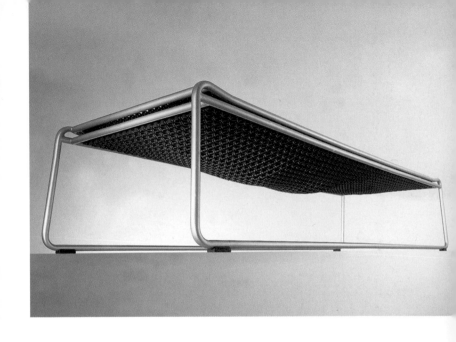

above Daybed ADB-105
opposite top Tatami Chair ATC-108 **opposite bottom** Daybed ADB-105

producer: Accupunto designer: Yos S. & Leonard Theosabrata www.accupunto.com

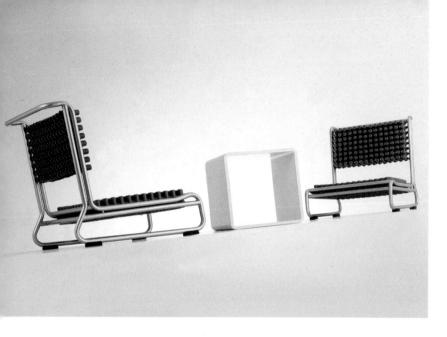

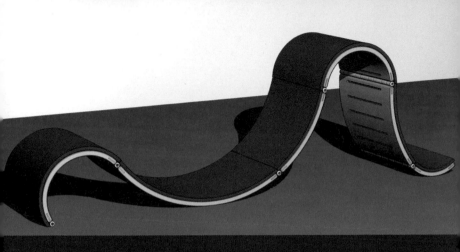

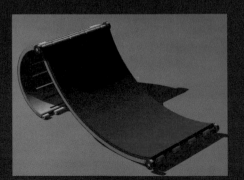

Sit Set
producer: Alexandra Breitenfeldt
designer: Alexandra Breitenfeldt
www.alexausberlin.de

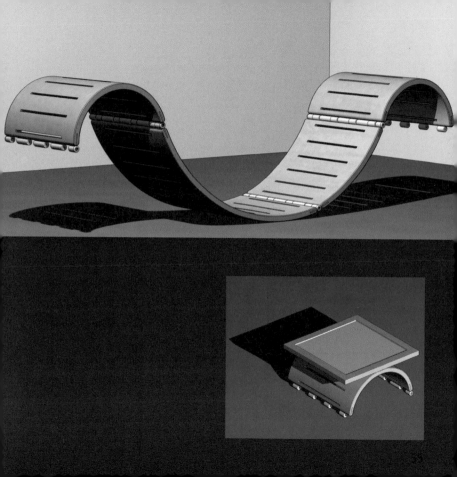

above left Ottavio **above center** Oliver **above right** Olaf
producer: Christine Kröncke Interior Design designer: Andreas Weber
below Odessa producer: Wittmann designer: Andreas Weber

www.andreasweberdesign.com

above Stratus **below** Phoenix

producer: Christine Kröncke Interior Design
designer: Andreas Weber
www.andreasweberdesign.com

57

Faust
producer: Driade S.p.A. Italy
designer: Mario Bellini
photographer: Tom Vack
www.atelierbellini.com

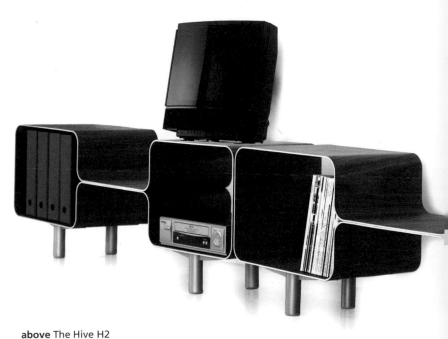

above The Hive H2
designer: Chris Ferebee
photographer: Mikkel Adsbøl
opposite Shape Your Own

producer: Cinal www.cinal.dk

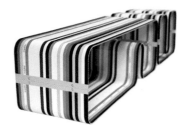

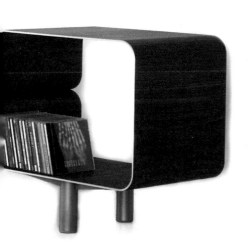

61

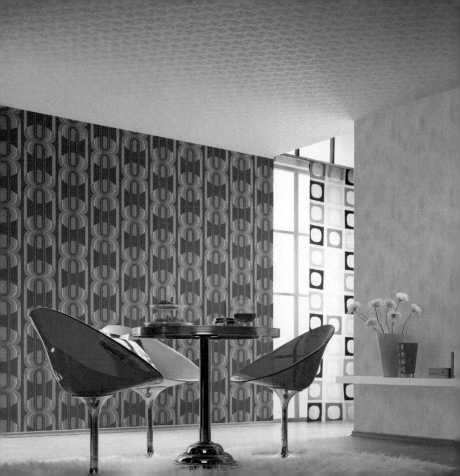

opposite and below
Retro Vision
designer: Katja Pieroth
right New Walls Please
designer: Stefan Hajduga

producer: A.S. Création
www.as-creation.de

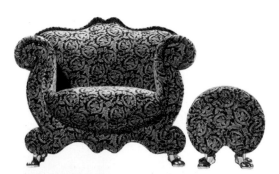

above Lucky
left Emily
opposite top
Aladin/Gaudi
opposite middle Flat
opposite bottom
La Ola/Mammut

producer:
Bretz Brothers Design
www.bretz.de

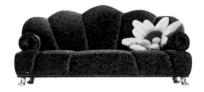 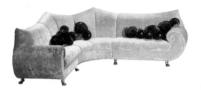

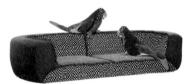

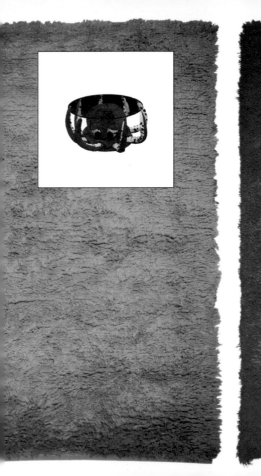

opposite left Alibaba
(background) Lilies
opposite right Rose
(background) Wild Cat
left Octopus
(background) Rug Shaggy
above Sunflower
(background) Rug Shaggy

producer:
Bretz Brothers Design
www.bretz.de

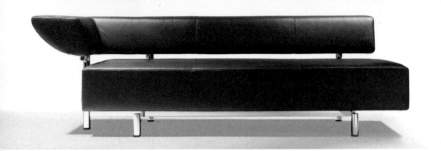

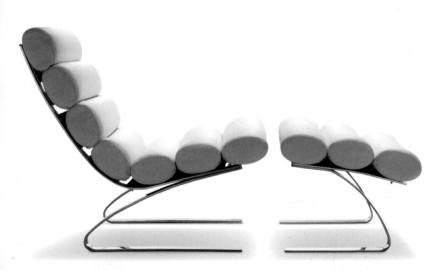

68

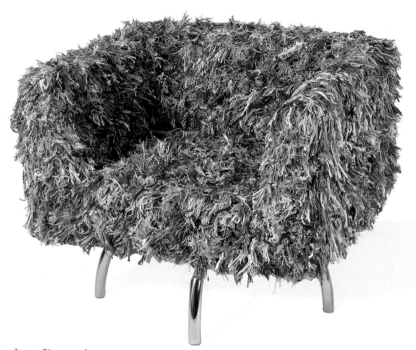

above Giramundo
producer: Bull & Stein GmbH & Co. KG
designer: Marcus Ferreira www.bullstein.com

opposite top Arthe designer: Prof. Wulf Schneider & Partner
opposite bottom Sinus designer: Reinhold Adolf & Hans-Jürgen Schröpfer
producer: Cor Sitzmöbel Helmut Lübke GmbH & Co. KG www.cor.de

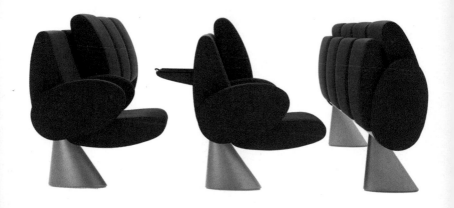

above Tulip producer: Kron Spain designer: Bartoli Design
opposite Kerouac producer: Ycami designer: Bartoli Design

70

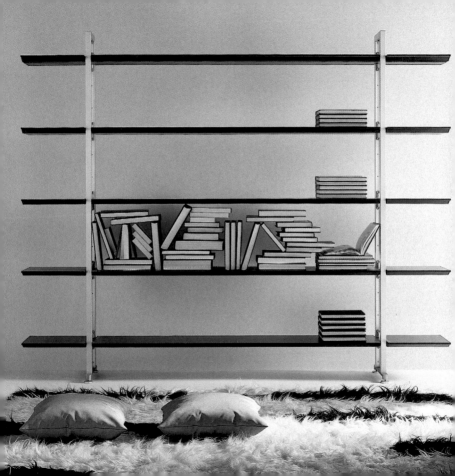

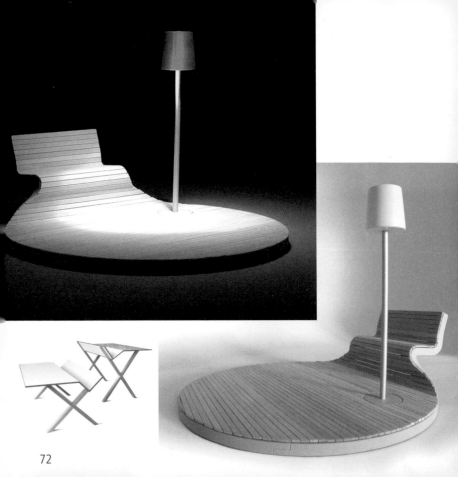

72

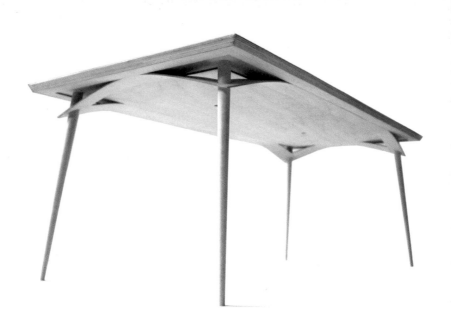

opposite top and opposite bottom right Urbaninteriors **above** T1
designer: Patrick Frey & Markus Boge
www.patrick-frey.de www.markusboge.de
opposite bottom left Kant
producer: Moormann
designer: Patrick Frey & Markus Boge
www.moormann.de www.patrick-frey.de www.markusboge.de

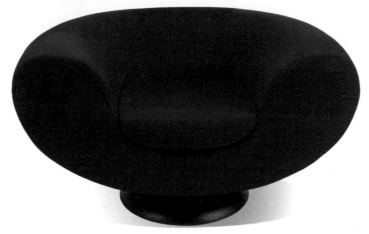

above and below Smile designer: Marko Macura
opposite bottom left Flip designer: Tim Power
opposite right Loop designer: Biagio Cisotti & Sandra Laube

producer: B.R.F. www.brfcolors.com

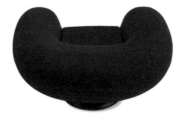

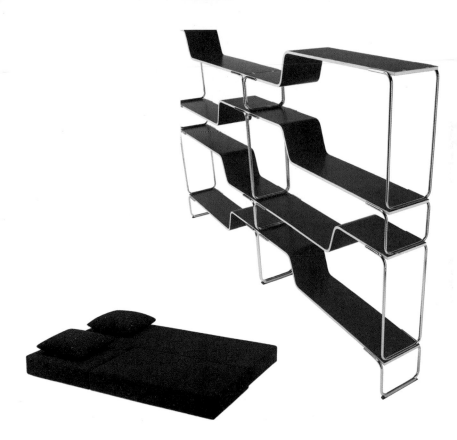

75

above left Mombasa **above right** Tenno
producer: Lambert GmbH www.lambert-home.de

below Schmöbel designer: Andreas Kowalewski a_kowalewski@web.de

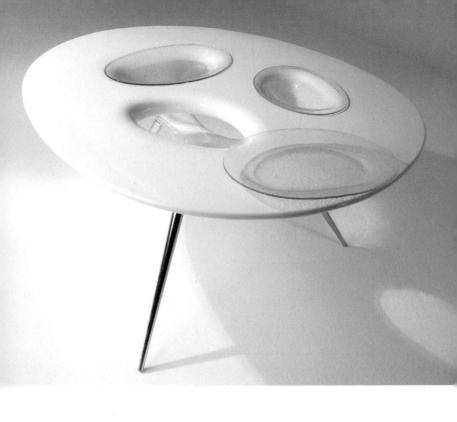

above Bodhi producer: Kundalini designer: Giorgio Gurioli www.kundalini.it

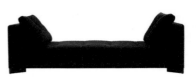

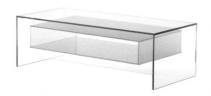
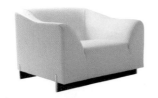
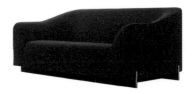

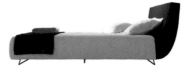

opposite top
Cuddle designer: Pascal Mourgue
Snowdonia Chaise Lounge
designer: Eric Jourdan
opposite middle
Pêle mêle designer: Bernard Moïse
Dyne designer: Christian Von Ahn
opposite bottom
Snowdonia Armchair/Snowdonia Settee
designer: Eric Jourdan

above
Kali designer: Michel Ducaroy
Lover designer: Pascal Mourgue
below
Flexus designer: Peter Maly
Satisfaction designer: Pascal Mourgue

producer: Roset Möbel GmbH
www.ligne-roset.de

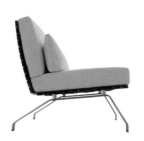

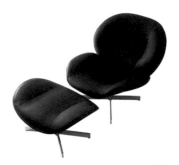

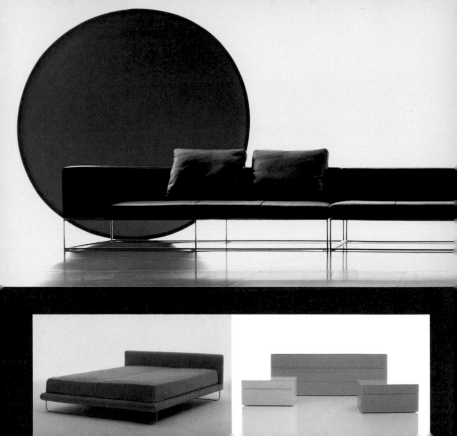

below LE **opposite bottom left** Avalon
producer: Living Divani designer: Piero Lissoni
www.livingdivani.it www.lissoniassociati.it

opposite bottom right Boxes **bottom** System Next
producer: Porro designer: Piero Lissoni
www.porro.com www.lissoniassociati.it

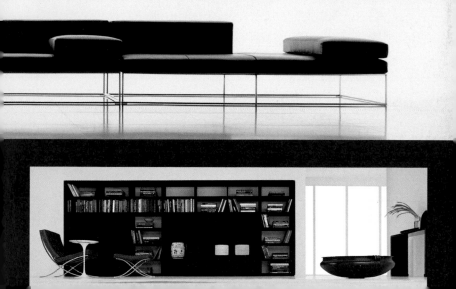

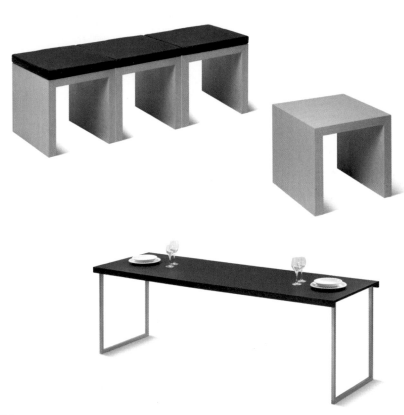

opposite top and middle CUB
opposite bottom Butterfly
right Connecta **below** CUB

producer: Novalia
designer: Cactus & Quim d'Espona
www.novalia.net

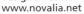

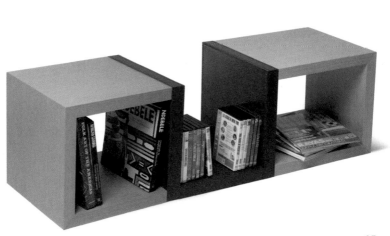

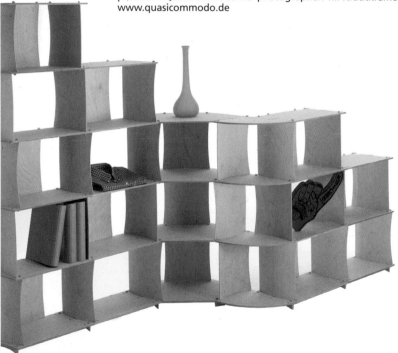

below and opposite right Shelf designer: Lothar Paulmann
opposite top left Hallstand designer: Andreas Giller
opposite bottom left Phono-Rack designer: Andreas Giller
producer: Quasicommodo KG photographer: Till Krautkrämer
www.quasicommodo.de

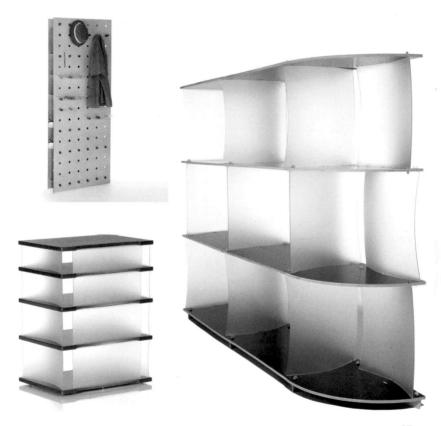

Shelf producer: Quasicommodo KG
designer: Lothar Paulmann
photographer: Till Krautkrämer
www.quasicommodo.de

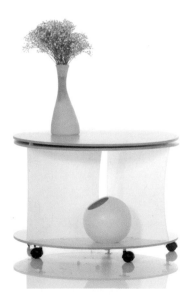

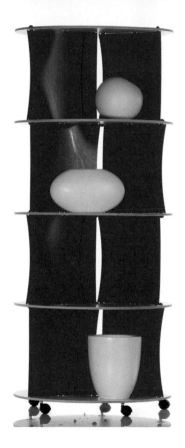

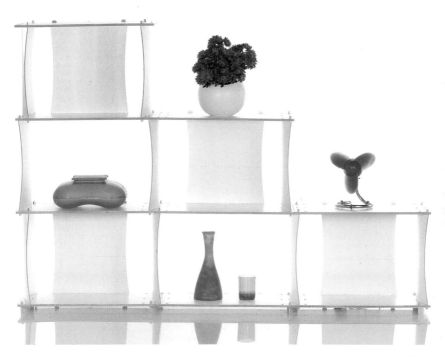

89

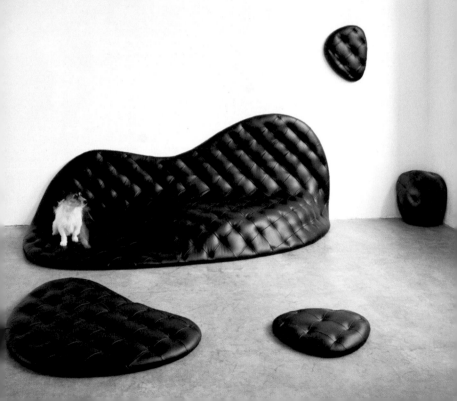

Pools & Pouf producer: Gallery Klaus Engelhorn 20 Vienna
designer: Robert Stadler photographer: Patrick Gries

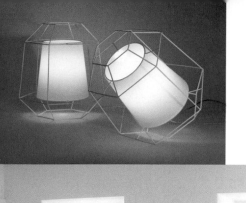

left Exolight
producer: Toolsgalerie
designer: Robert Stadler
below Audiolab 3
producer: Caisse des Depots
et Consignations & Fondation
Grand-Duc Jean du MUDAM
designer: Laurent Massaloux
& Thierry Balasse

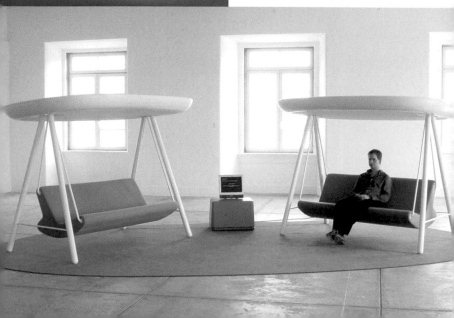

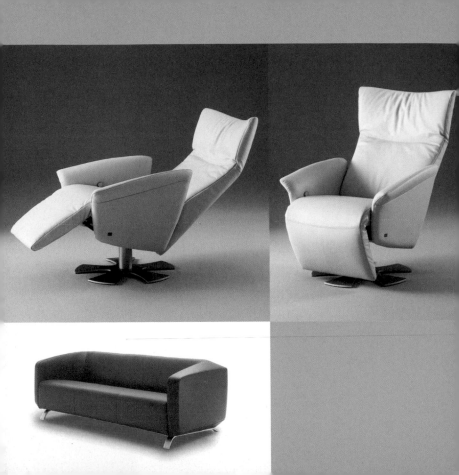

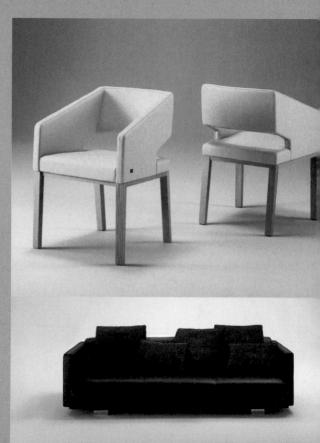

opposite top 5700
designer:
Georg Appeltshauser
photographer:
Karl Huber
opposite bottom 6000
designer:
Bernhard Eigenstätter
photographer:
Karl Huber
right 7700
designer: Norbert Beck
photographer:
Karl Huber
bottom right 6300
designer:
Christian Werner
Hollenstedt / Appel
photographer:
Peer Brecht

producer: Rolf Benz
www.rolf-benz.de

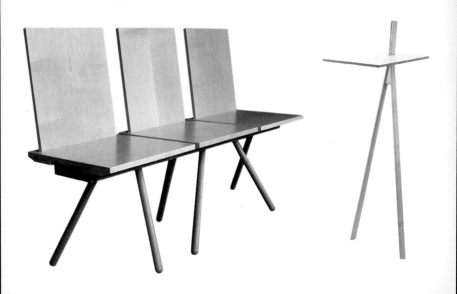

above left Deutsche Bank designer: Bisjak Graf & Richter
above right Der kleine Lehner designer: Jörg Gätjens
opposite left Last Minute designer: Hauke Murken
opposite right Magnetique designer: Swen Krause

opposite Next Plus Desk
right Trio Ex-Tables
below Next Office

producer: Mobi Furniture
& Interior Co. Ltd
designer:
A. Rasit Karaaslan
photographer:
H. Cumhur Aygun
www.mobi.com.tr

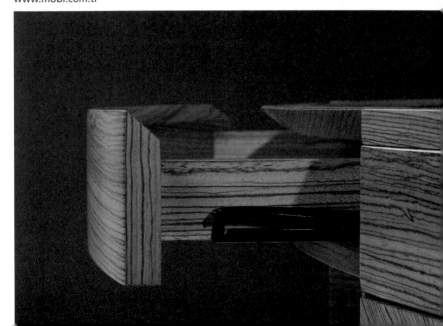

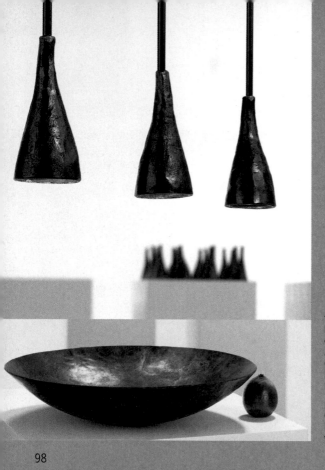

top left XI-3
left Phoenix
opposite
Apus
Orion
Herkules
Leo Minor

producer: Silke Finke
designer: Bernhard &
Heinrich Finke GmbH
www.silkefinke.com

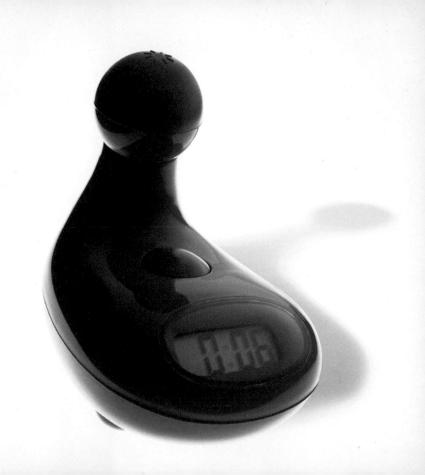

opposite Anp/r in Radio producer: Alessi
designer: George J. Sowden & Hiroshi Ono
photographer: livio Salle
www.sowdendesign.com

below Palace Chair
right D'Antibes Cabinet
producer: Memphis
designer: George J. Sowden
photographer: Sowden Design
www.sowdendesign.com

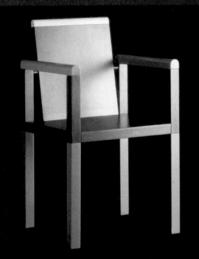

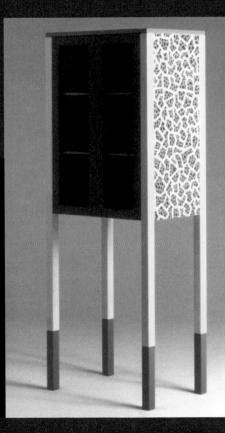

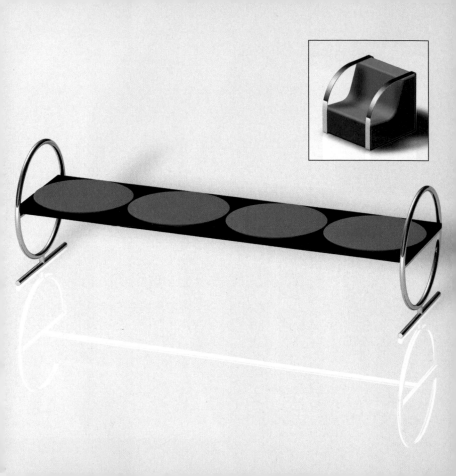

opposite top Quarter **opposite bottom** Circ **below left** Three **below right** Zed
designer: Stiltreu – Christian Dorn www.stiltreu.de

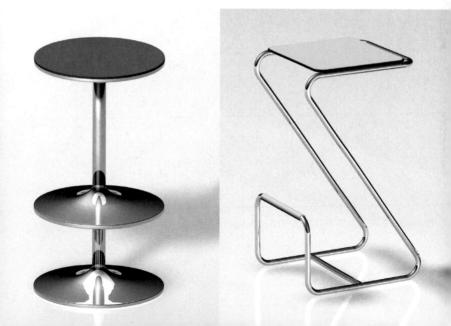

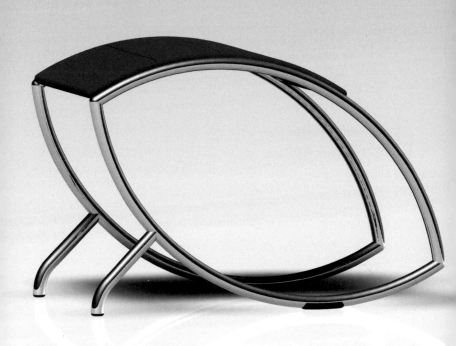

above Appearance **opposite** Roll On
designer: Stiltreu – Christian Dorn www.stiltreu.de

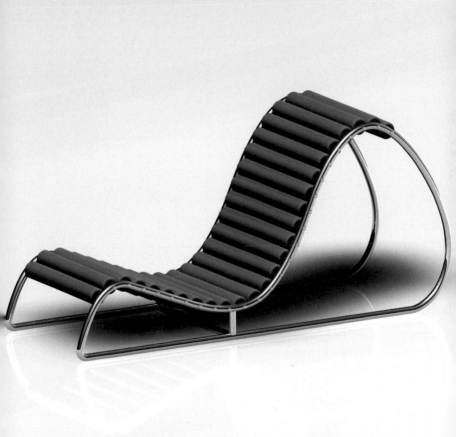

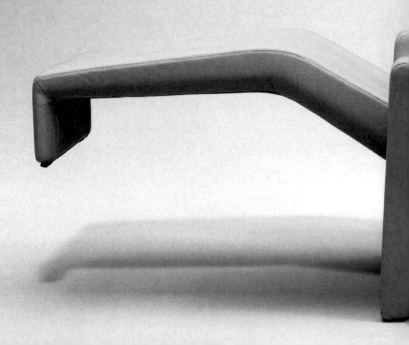

Davos producer: Wittmann Polstermöbel Werkstätten designer: Andreas Struppler
www.wittmann.at www.andreasstruppler.com

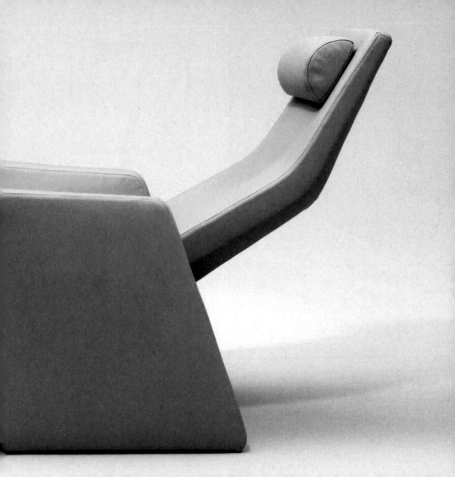

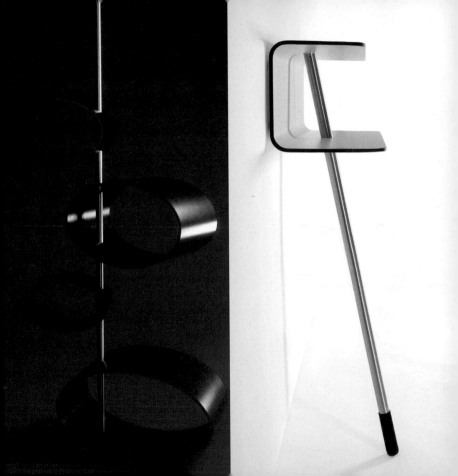

opposite left Oval Office **above** Jaffa
producer: Designerslabel designer: Markus Honka
photographer: Marion Stephan
www.designerslabel.com

left and opposite right Wallflower
producer: Jonas & Jonas designer: Markus Honka
photographer: Marion Stephan
www.jonasundjonas.de

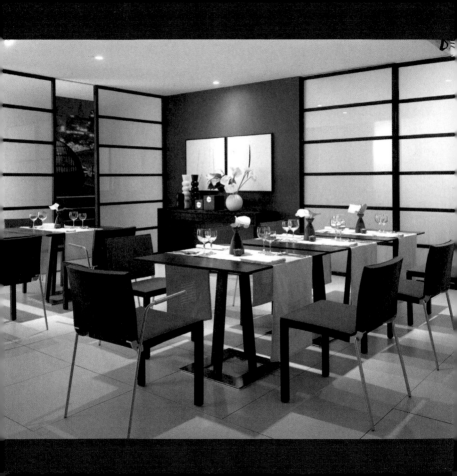

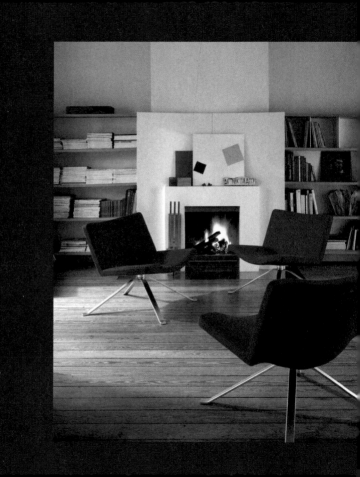

below Posito producer: Hey-Sign designer: Susanne Meier
www.hey-sign.de www.deezign.de
opposite Ron-Alda producer: Bonaldo S.p.A. designer: Ron Arad
www.bonaldo.it

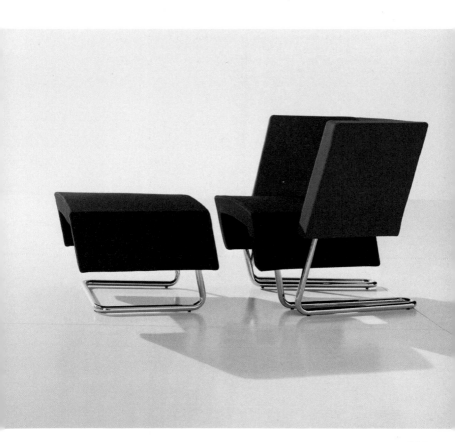

opposite Padouk
right Wooden Screens
producer: Danzer Furnierwerke GmbH
designer: Designschneider
www.danzergroup.com
www.designschneider.de

below Paco
producer: Lesser
Modernes Wohnen GmbH
designer: Designschneider
www.lesser-polster.de
www.designschneider.de

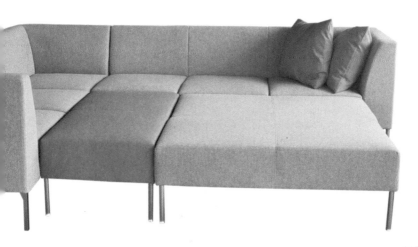

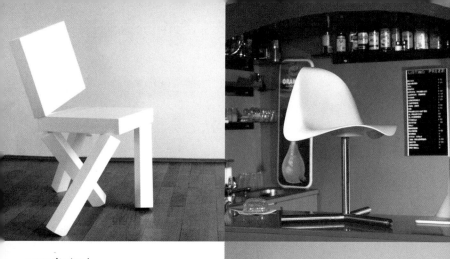

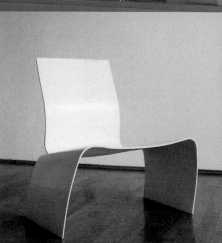

opposite Leni
producer: Next Germany
www.next.de
above left Il Crollo
producer: Kundalini Italy
www.kundalini.it
above right Valeria
producer: Ycami Italy
www.ycami.com
right Flight
producer: Habitat
www.habitat.org

designer:
Hopf & Wortmann/büro für form
photographer: David Steets
www.buerofuerform.de

below Personal Pond producer: Toyota/Lexus
opposite Loop Chair producer: RPI
designer: Ecco Design www.eccoid.com

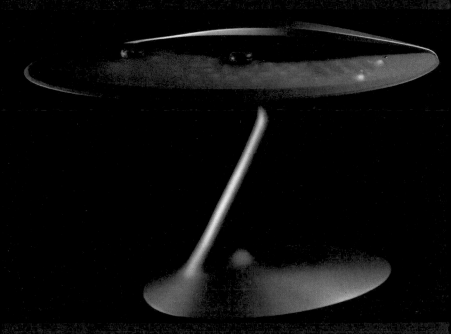

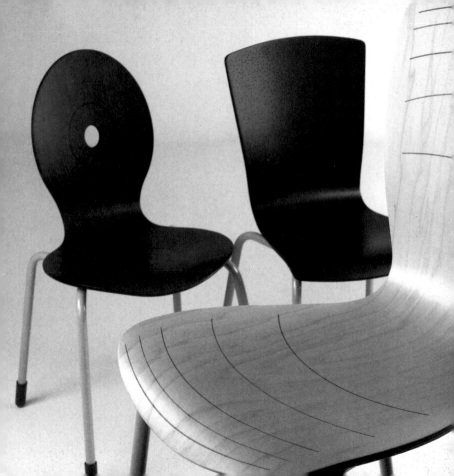

designer: Studiotreats
www.studiotreats.com

below left Basil **below right** Nori **opposite** Spargel
designer: Ostermann www.oh2.at

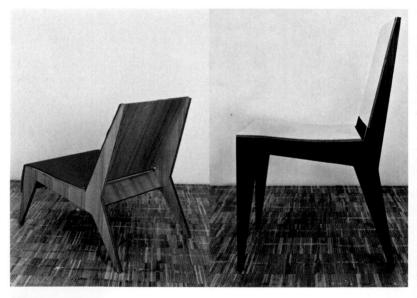

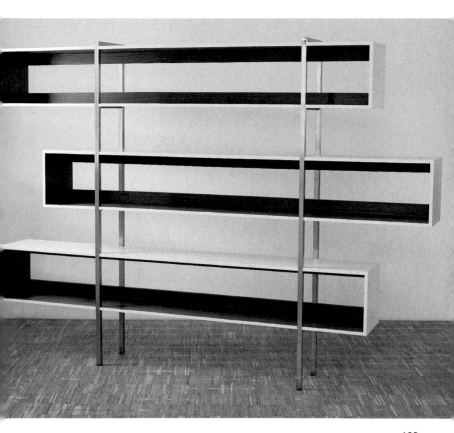

123

above Blade producer: Manufacturas Celda S.A. designer: Porsche Design
www.porsche-design.at

below S 411
designer: Thonet
photographer:
Georg Valerius
right 4000
designer: Jehs & Laub
photographer:
Michael Gerlach

producer:
Gebrüder Thonet
GmbH, Frankenberg
www.thonet.de

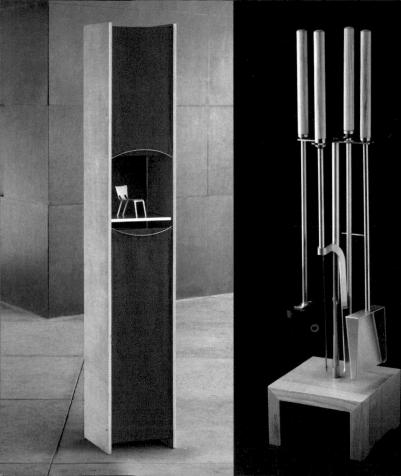

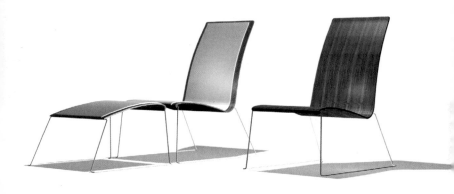

opposite left Estante
photographer:
Markus Bassler
opposite right Firetools
producer: Conmoto
photographer:
Ursula Raapke
above Otto Plus

designer: Sol.Design
www.sol-design.net

right Dialounge
designer: Workshop
www.workshopdesign.de

127

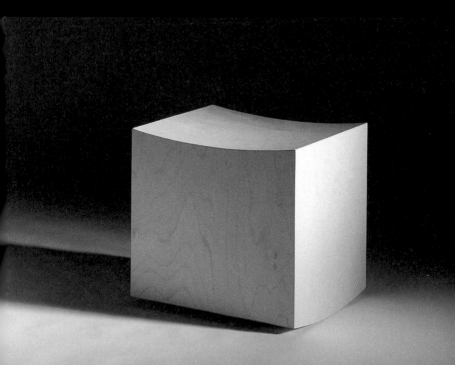

Monane producer: Dietiker Switzerland
designer: Greutmann Bolzern Designstudio
photographer: Charly Fülscher
www.dietiker-switzerland.ch

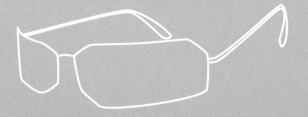

02

Accesorios

En realidad todos nosotros somos también actores y nos preparamos continuamente para nuestras actuaciones.

Claro está que quien ve mal necesita gafas. ¿Pero cuáles adornan o caracterizan al personaje que hemos escogido? ¿Combinan con el reloj, con el maletín, con el bolso, o con lo que llevamos puesto? Los accesorios son los elementos con los que jugamos y nos arreglamos, nos propor-

We are all really actors at heart, constantly preparing to make our next entrance.

Of course, anyone with eyesight problems needs to wear glasses. But which style will best enhance or express our chosen image? Will it go with this watch, that handbag or briefcase, and with all the other bits and pieces?

Accessories

cionan un aspecto determinado y nos dan confianza en todas nuestras actuaciones.

En determinadas ocasiones es necesario dejarse aconsejar o estar informado de lo que hay en el mercado.

Aquí son las tendencias y las modas las que caracterizan los gustos y las cosas, por eso es especialmente importante saber qué es lo que está de actualidad. A menudo las marcas juegan un papel considerable cuando

Accessories are what we play with and what we use for adornment; they express our style and give us self-confidence for all our entrances. They act as stage sets for our self-image and appearance. This means that we may occasionally need a little advice or, at the very least, an overview of what is available.

As trends and fashion have a particularly strong influence on objects and taste in this sector, it is all the more important to understand what is actually

queremos orientarnos en este mundo tan complejo porque prometen calidad y singularidad.

Una mirada más detenida muestra que en esta oferta el gusto (sobre lo que según Inmanuel Kant no se puede discutir porque es muy personal) no es siempre lo más importante. Incluso en un buen diseño pueden reconocerse nuevas o ampliadas funciones y aplicaciones. Tener esto en cuenta puede simplificar la elección y dar alas a nuestra vida.

happening. Brands often play a significant role, providing orientation in the general confusion, because trademarks offer quality and high visibility.

On close examination, it is not simply taste (according to Immanuel Kant, too personal a matter to allow for any argument) that is the leading player. Good design has a role in enabling us to recognize innovative or extended functionality and handling. If we take this into consideration, even only occasionally, it can simplify choice and inject some inspiration into our lives.

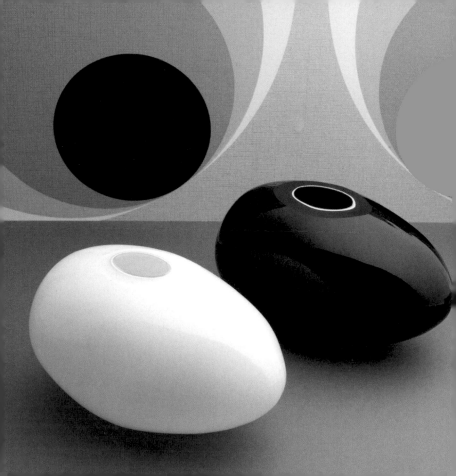

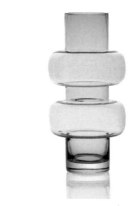

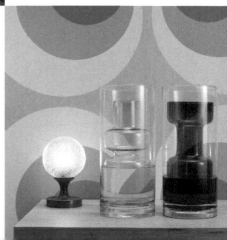

opposite 60ies – Lava Eggs
producer: Leonardo/Glaskoch
www.leonardo.de

above 60ies – Zoom
top right 60ies – Satellite
right 60ies – Subway

producer: Leonardo
www.leonardo.de

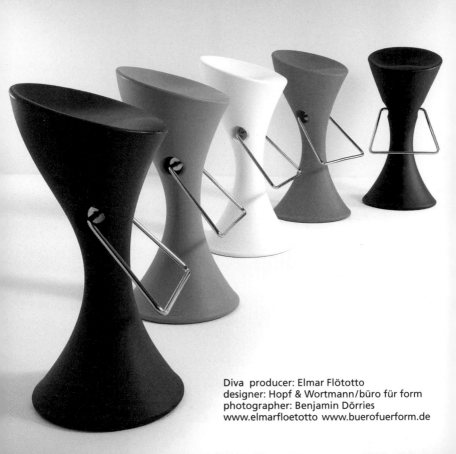

Diva producer: Elmar Flötotto
designer: Hopf & Wortmann/büro für form
photographer: Benjamin Dörries
www.elmarfloetotto.de www.buerofuerform.de

right Tritrac Eggtimer **below** Mark & Coin Key Ring
producer: Adhoc GmbH designer: Sol.Design
photographer: Ursula Raapke www.sol-design.net

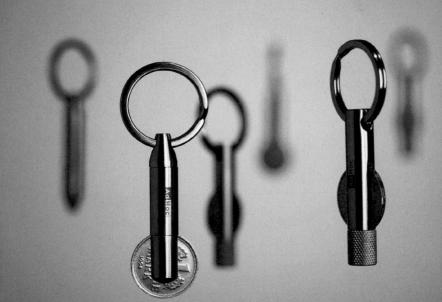

Ventilux
producer: Next Home Collection e.K.
designer:
Reinhard Zetsche & Folker Königbauer
www.next.de www.octopus-design.de
www.designpartners.de

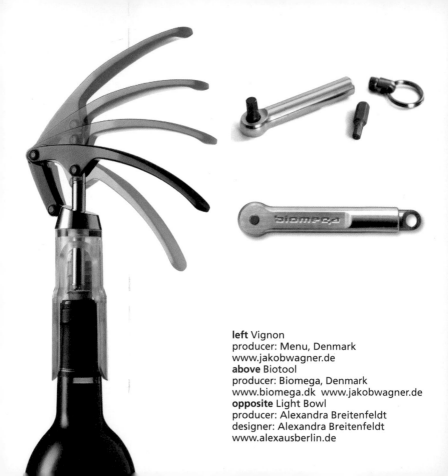

left Vignon
producer: Menu, Denmark
www.jakobwagner.de
above Biotool
producer: Biomega, Denmark
www.biomega.dk www.jakobwagner.de
opposite Light Bowl
producer: Alexandra Breitenfeldt
designer: Alexandra Breitenfeldt
www.alexausberlin.de

145

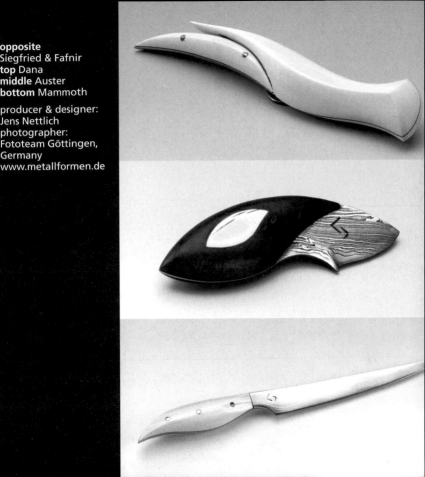

opposite
Siegfried & Fafnir
top Dana
middle Auster
bottom Mammoth

producer & designer:
Jens Nettlich
photographer:
Fototeam Göttingen,
Germany
www.metallformen.de

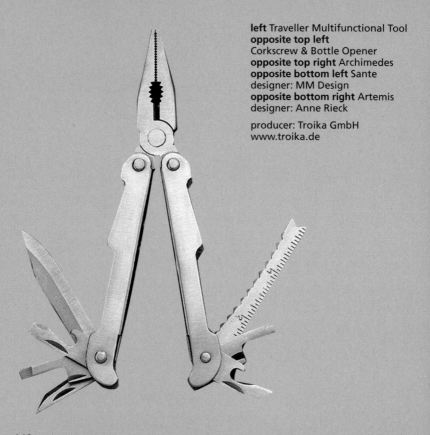

left Traveller Multifunctional Tool
opposite top left
Corkscrew & Bottle Opener
opposite top right Archimedes
opposite bottom left Sante
designer: MM Design
opposite bottom right Artemis
designer: Anne Rieck

producer: Troika GmbH
www.troika.de

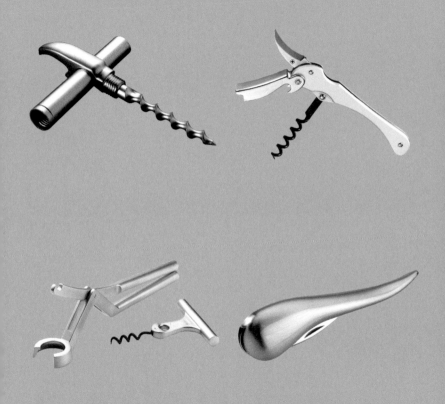

150

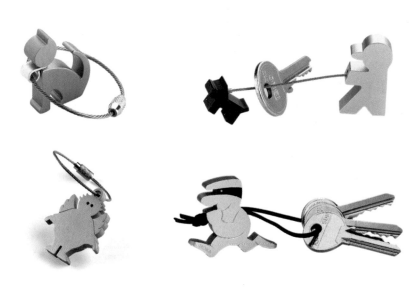

opposite top Sally/Harry
opposite bottom
Angel/Jumping Lady
top Kitty/Friends
above Angelina/Key Robber
right El Bandito

producer: Troika GmbH
www.troika.de

151

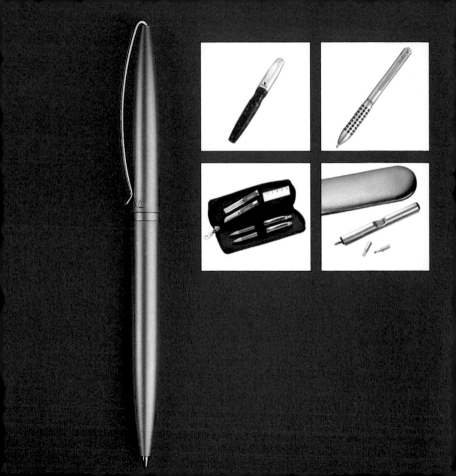

opposite left Slim
opposite top Ocean/Switch
opposite below Arctic/Mini Spirit Level
below and right Magic Pen

producer: Troika GmbH www.troika.de

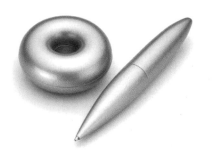

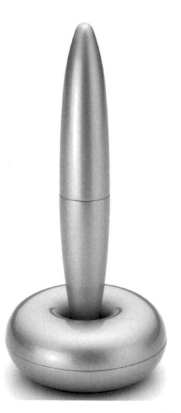

opposite Penholder Danese producer Harri Koskinen Friends of Industry Ltd.
www.harrikoskinen.com
below Ashtray producer Auerhahn Bestecke designer MM Design Edition
www.auerhahn-bestecke.de www.mmdesignedition.de

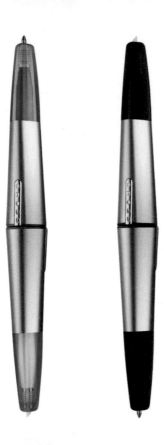

left and opposite bottom right
Vice Duo
**above, opposite top and
opposite bottom left** Ion Metal

producer: A.T. Cross www.cross.com

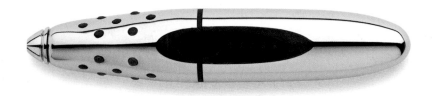

157

above Paravent
opposite bottom
Carrybag
designer: Katja Horst
right Redondo

producer:
Reisenthel Accessoires
www.reisenthel.de

159

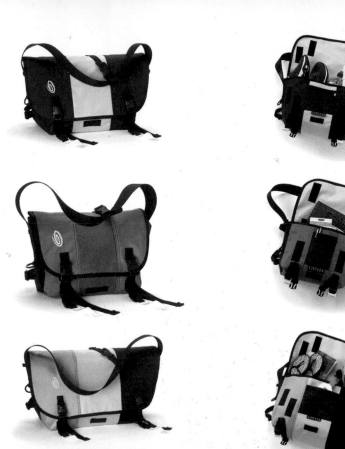

Messenger
producer: Timbuk2
www.timbuk2.com

above Conga/Megalopolis **below** Scorpia/Speedy **opposite** Scorpia
producer: Boblbee AB www.boblbee.com

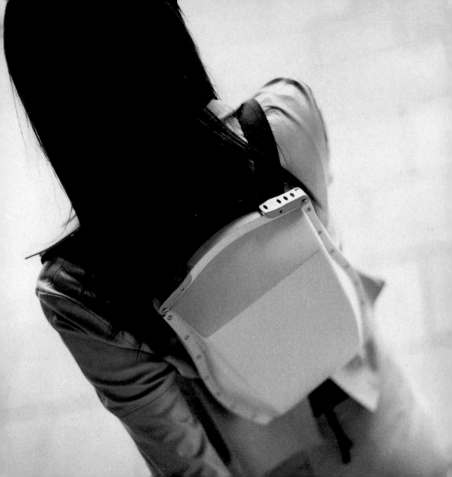

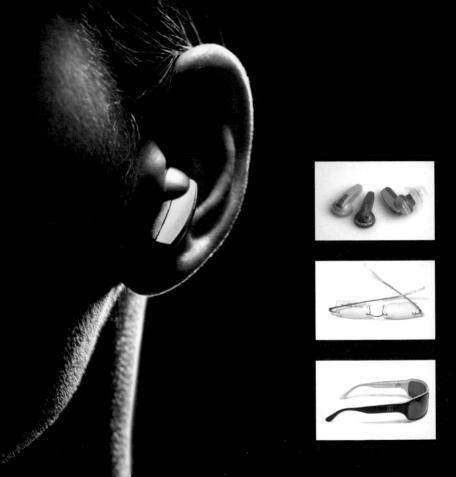

opposite left and opposite top right
Personal Sound Device producer: Microsound
opposite middle Peak One producer: Eye Eye Denmark
opposite bottom Biowulf producer: Eye Eye Denmark
below Memory Boards producer: Georg Jensen

designer: Designit A/S www.designit.com

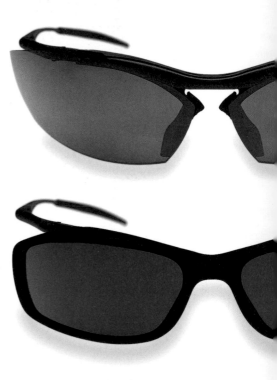

top and above Transfusion Kit producer: Zerorh+
designer: Renata Fusi, Silvana Mollica, Paolo Canotto
photographer: Fabrica, Treviso www.zerorh.com

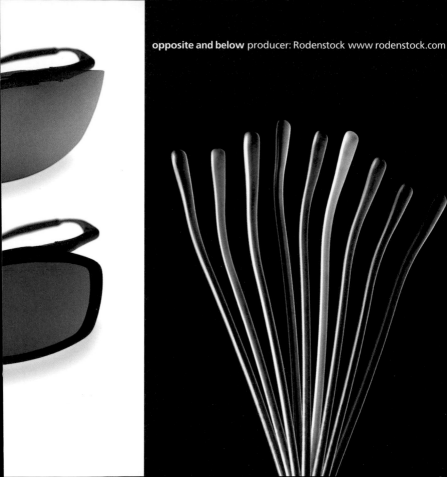

opposite and below producer: Rodenstock www.rodenstock.com

Urban Survival Mask
producer: Bézenville
Paris Urbain
www.bezenville.com

Branie Belt producer: Orang Tiga
designer: Clemtone Design www.branie.com

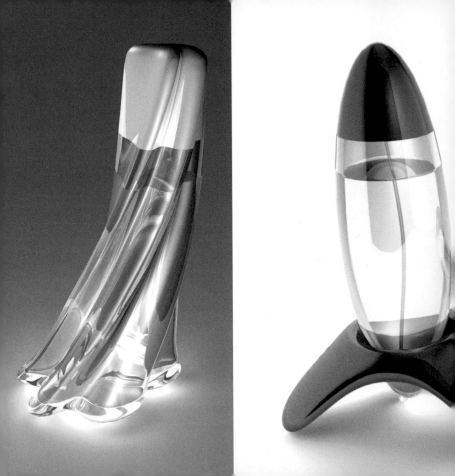

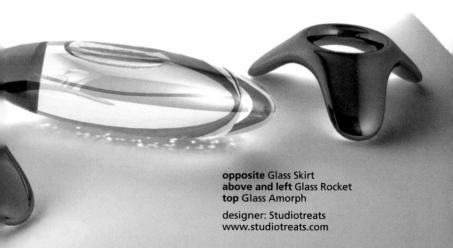

opposite Glass Skirt
above and left Glass Rocket
top Glass Amorph

designer: Studiotreats
www.studiotreats.com

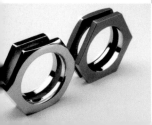

top Butterfly / Courier 10 /
Flame
above Honeymoon / PIT
left Honeymoon
right Sweetheart

designer: Eve-Design
www.eve-design.ch

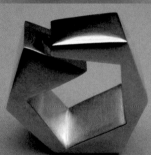

above left and right
Replay Double Metal
middle Sweetheart/
Replay Simple
bottom left
Replay Double Ebony
bottom middle and right
Sweetheart

designer: Eve-Design
www.eve-design.ch

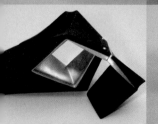

left and below Ceramica
producer: Rado Switzerland
www.rado.com
opposite Cooking Thermometers
producer: Polder
designer: Stuart Harvey Lee –
Prime Studio
www.primestudio.com

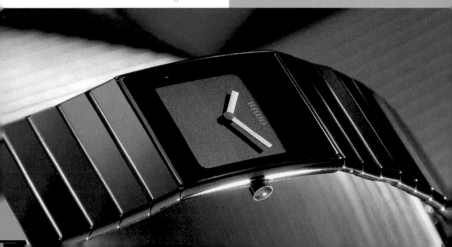

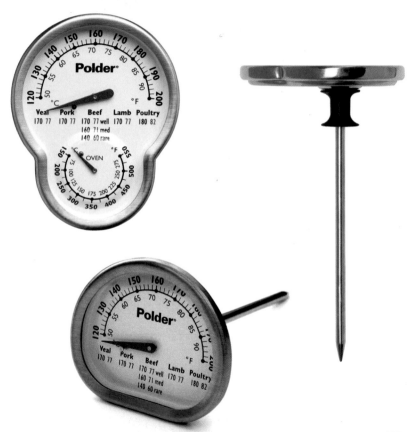

179

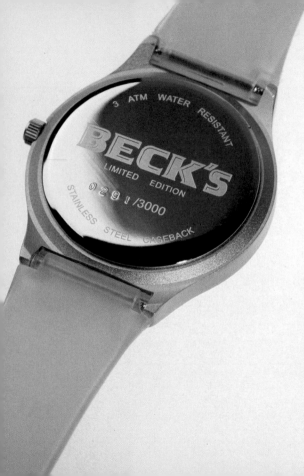

left Beck's Pop Art
below Beck's Selected

designer: GfG/
Gruppe für Gestaltung
www.gfg-bremen.de

opposite left
G-Shock Multi Face
opposite top right
Pro Trek Mount McKinley
opposite bottom right
Wrist Camera WQV-10

producer: Casio
www.casio-europe.com

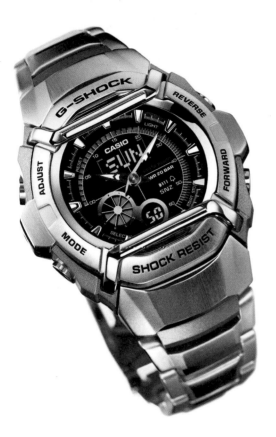

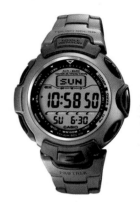

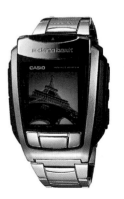

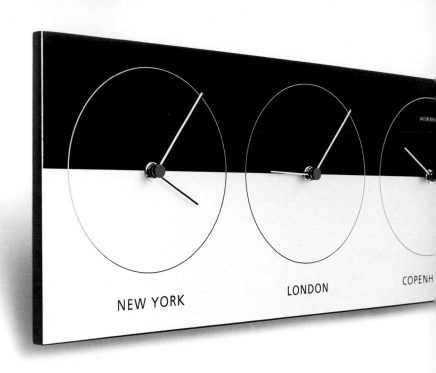

above World Clock **opposite top** Weatherstation **opposite bottom** Scale
producer: Jacob Jensen designer: Jacob Jensen Design www.jacobjensen.com

182

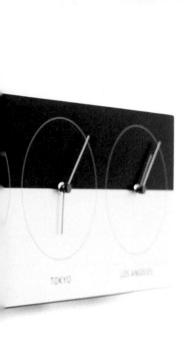

TOKYO LOS ANGELES

183

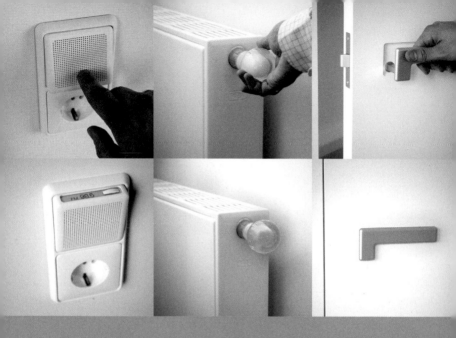

Heimspiel Series producer: Ideo London photographer: Ideo www.ideo.com

184

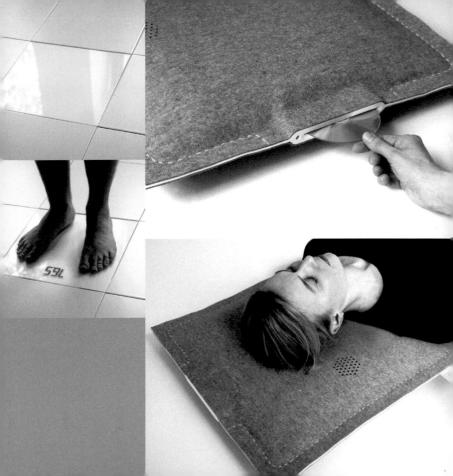

Cocina y baño

Antiguamente la cocina era un espacio muy acogedor para toda la familia pero después, durante los años veinte y los sesenta del siglo pasado, se transformó en un lugar industrializado donde reinaban la pura eficacia y la rapidez. Esto cambió a partir de los años ochenta: Primeramente se introdujeron en las viviendas muchos elementos de las cocinas profesionales de los restaurantes (cómodos fogones, grandes

In earlier times the kitchen was an important social area for the whole family. Then (in the 1920s and again in the 1960s) it became an industrialized space designed purely for efficiency and economy of space and effort. Since the 1980s, this has all changed: many elements of the professional restaurant kitchen moved into the home environment (luxurious cooking stoves, large refrigerators and so on). This enhanced the status of

Kitchens and bathrooms

frigoríficos, etc.). De este modo mejoró la forma de cocinar en las casas y las cocinas se transformaron en nuevos espacios para la familia y los invitados. La cocina se convirtió en un lugar en el que sentirse a gusto y en el que convivir.

Un proceso similar experimentaron los cuartos de baño. Las pequeñas habitaciones destinadas exclusivamente a la higiene se transformaron en espacios para la relajación o, como se dice hoy en día, para el cuidado corporal. Actualmente el baño es el lugar donde encontrarse consigo mismo y descansar. Son espacios en los que podemos alejarnos del estrés y en los que el diseño nos ofrece todo tipo de placeres: nuevas duchas, estimulantes bañeras y muchas cosas más.

domestic cookery and transformed the kitchen once again into a new kind of living space for both family and guests. The kitchen has become a place to relax and to be together.

A similar process happened with the bathroom. What had been a small room strictly for personal hygiene purposes became a space for relaxation – or, as many today like to call it, 'wellness.'

The bathroom is now a room for being at one with oneself, for physical re-vitalization. Here, we can escape from stress, and design offers us all manner of indulgences: new kinds of showers, exhilarating baths and much more. Incidentally, bathrooms and kitchens have one problem in common, the so-lution of which was a complex task for designers and for the sales strategies

Curiosamente los baños y las cocinas planteaban un problema de difícil solución para los diseñadores y para las estrategias de ventas de las empresas. Su diseño y construcción se convirtió, a partir de la década de 1960, en algo fijo. Las bañeras y las duchas se encajaban en los azulejos y las cocinas integradas se convirtieron en el modelo estándar. Una estructura tan inamovible era inalterable y excluía las formas flexibles porque el rediseño de un baño o de una cocina completa era muy costoso. La nueva tendencia, incluye también las diferentes formas de las conexiones (electricidad, tuberías…), vuelve a dirigirse hacia las composiciones a partir de elementos individuales: bañeras independientes, duchas abiertas, placas variables, etc. Como podemos ver esto nos ofrece una variada gama de posibilidades para diseñar los espacios.

of businesses: since the 1960s at the latest, both rooms had been furnished with built-in elements. Bathtubs and showers were firmly fixed to tiling, and the fitted kitchen became the standard. Fixed structures such as these became rigidly monumental, preventing any flexibility of form, because it was simply too expensive even to attempt a partial reorganization of a bathroom or a fitted kitchen.

For this reason, as well as utilizing the variation of utility connections available (power supply, plumbing …) the new trend focuses on ensembles of individual objects: freestanding bathtubs, unenclosed showers, variable combinations of cooking hot plates, and so on. As we can see here, this provides people with a wide range of possibilities.

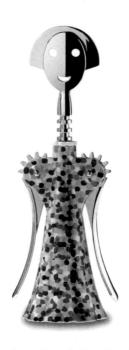
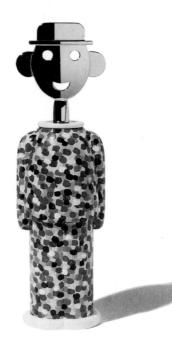

above Anna G. Proust and Sandro M. Proust – Corkscrews
designer: Alessandro Mendini
opposite Tea and Coffee Service
designer: William Alsop

producer: Alessi www.alessi.com

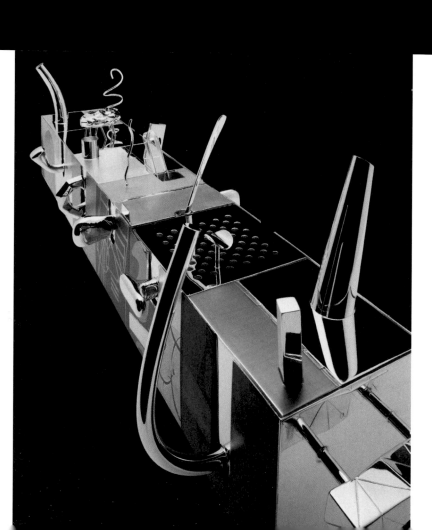

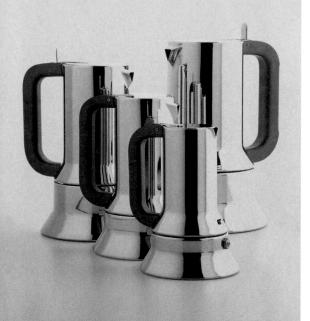

left Espresso Coffee
Maker in Steel
Mirror Polished
designer:
Richard Sapper
opposite Blow up
– Citrus Basket
designer:
Fratelli Campana

producer: Alessi
www.alessi.com

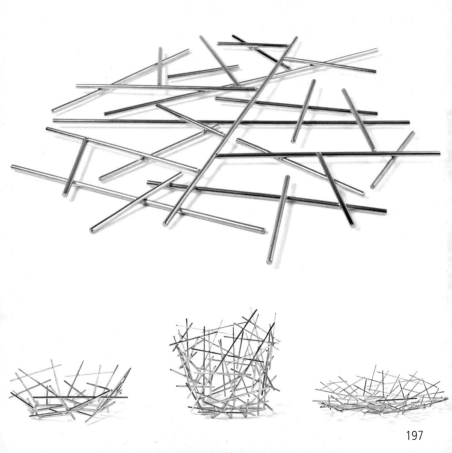

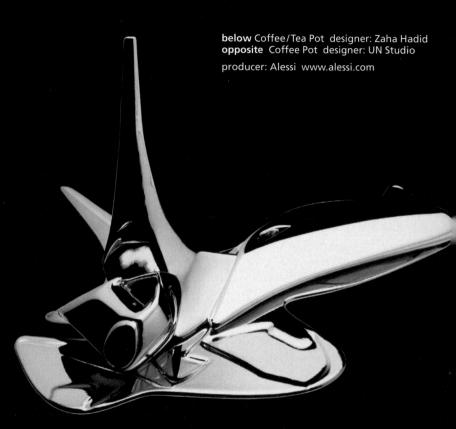

below Coffee/Tea Pot designer: Zaha Hadid
opposite Coffee Pot designer: UN Studio

producer: Alessi www.alessi.com

198

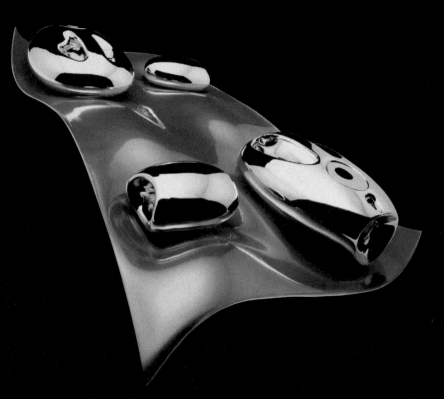

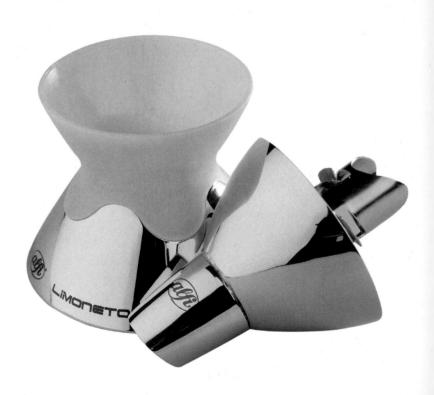

200

opposite Limoneto – Lemon Squeezer designer: Katana Design
above Toscana – Insulating Jug designer: Julian Brown

producer: Alfi www.alfi.de

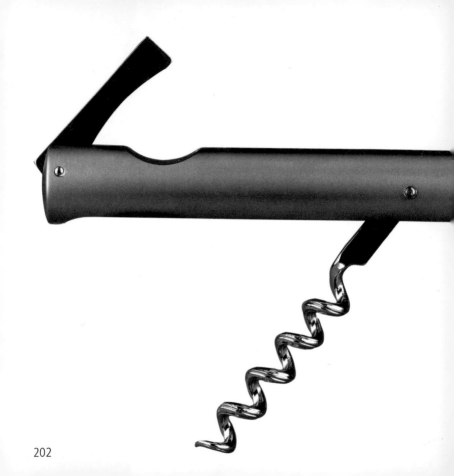

202

opposite Impuls – Corkscrew **below** Focus – Champaign Stopper
designer: Berendsohn AG www.berendsohn.com

203

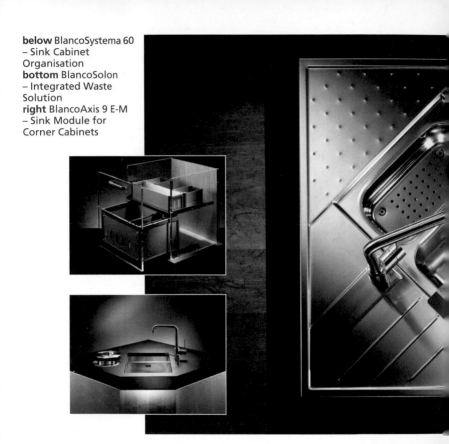

below BlancoSystema 60
– Sink Cabinet
Organisation
bottom BlancoSolon
– Integrated Waste
Solution
right BlancoAxis 9 E-M
– Sink Module for
Corner Cabinets

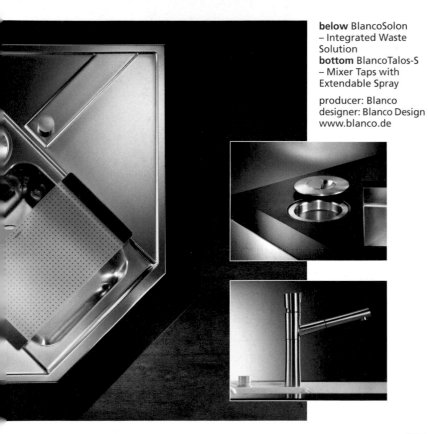

below BlancoSolon
– Integrated Waste
Solution
bottom BlancoTalos-S
– Mixer Taps with
Extendable Spray

producer: Blanco
designer: Blanco Design
www.blanco.de

above Fondo – Porcelain Thermo Pod producer: Mülheimer Werkstätten
designer: Cattany Design, Thomas Cattany www.cattany.de www.werkstatt-design.de
opposite The Faucet Friend designer: Charles Floyd, San Francisco www.charlesfloyd.net

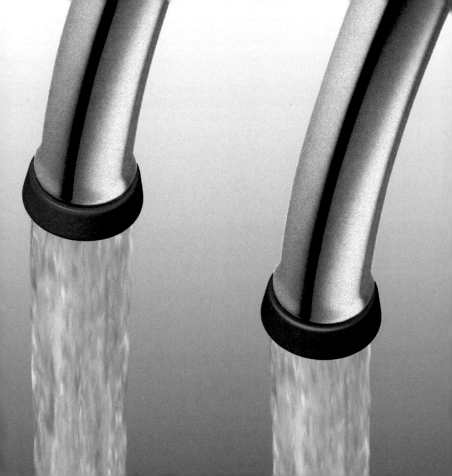

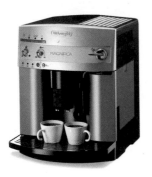
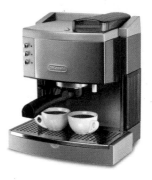
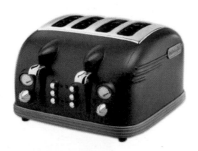
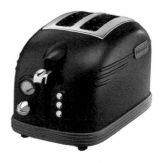

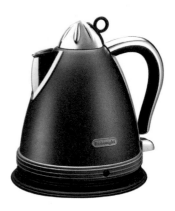

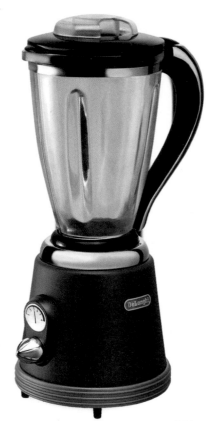

opposite top left
Magnifica – EAM 3200 S
opposite top right
Pump Espresso Maker – EC 750
opposite bottom left and right
Metropolis – Toaster 4-Slice
above Metropolis – Electric Kettle
right Metropolis – Mixer

producer: De Longhi
www.delonghi.com

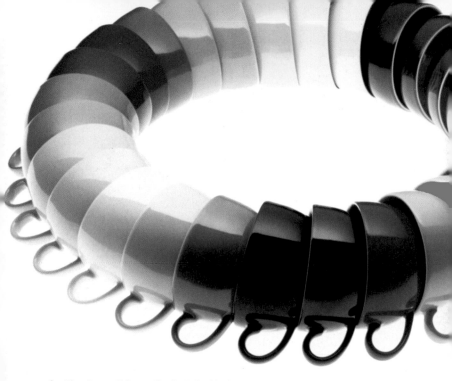

opposite Fine Bone China – Classic Cylindrical
producer: B.T. Dibbern/C.M. Hohenberg designer: Dibbern Design Studio
above Solid Color producer: B.T. Dibbern/Porzellanfabrik Schönwald
designer: B.T. Dibbern

photographer: Hans Hansen, Hamburg www.dibbern.de

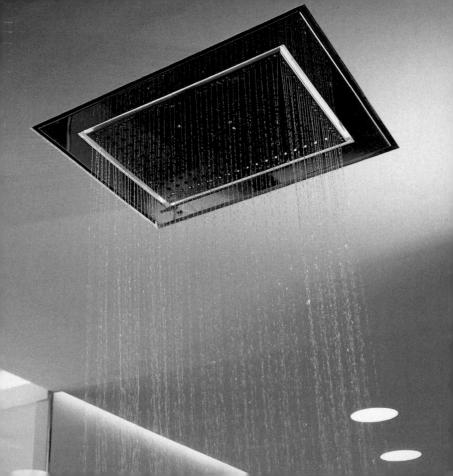

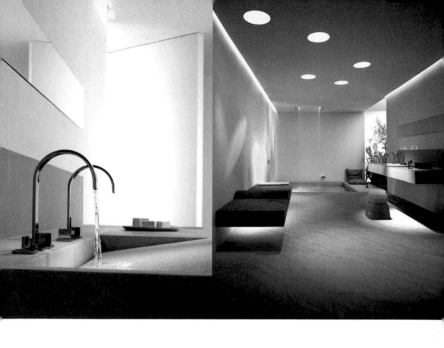

opposite, above left and right MEM producer: Aloys F. Dornbracht GmbH
designer: Sieger Design www.dornbracht.com

215

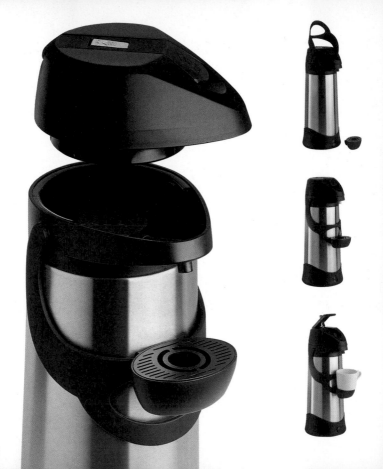

216

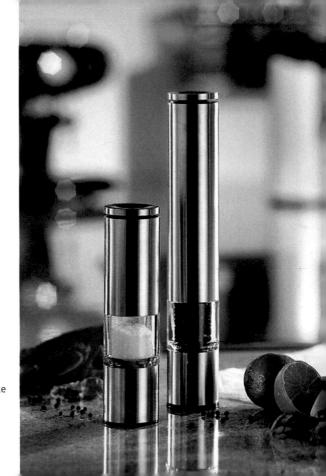

opposite Presto
right Contura

producer: Emsa Werke
designer: Razorbite
Design Studio,
Mike Ellams, U.K.
www.emsa.com

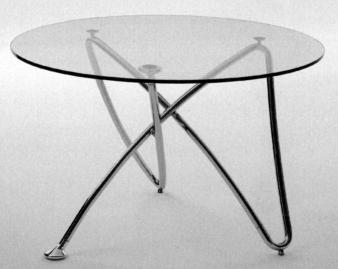

opposite top left Ori producer: Bonaldo designer: Toshiyuki Kita www.bonaldo.it
opposite top right Bague producer: Foscarini
designer: Patricia Urquiola and Eliana Gerotto www.foscarini.com
opposite bottom H20 producer: Bonaldo designer: Massimo Iosa Ghini www.bonaldo.it

below left Electric Hand Blender with Graduated Beaker **below right** Electric Grater
producer: Guzzini designer: George Sowden, Hiroshi Ono www.fratelliguzzini.com

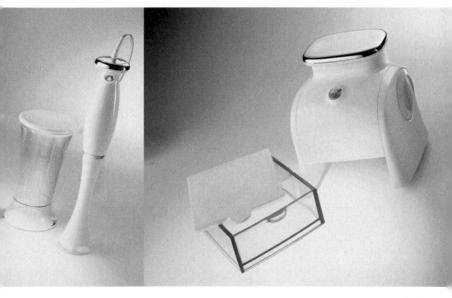

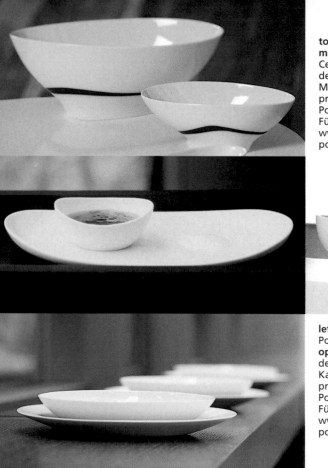

top Twist
middle and below
Central Park
designer:
Mikaela Dörfel
producer:
Porzellanmanufaktur
Fürstenberg
www.fuerstenberg-
porzellan.com

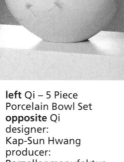

left Qi – 5 Piece
Porcelain Bowl Set
opposite Qi
designer:
Kap-Sun Hwang
producer:
Porzellanmanufaktur
Fürstenberg
www.fuerstenberg-
porzellan.com

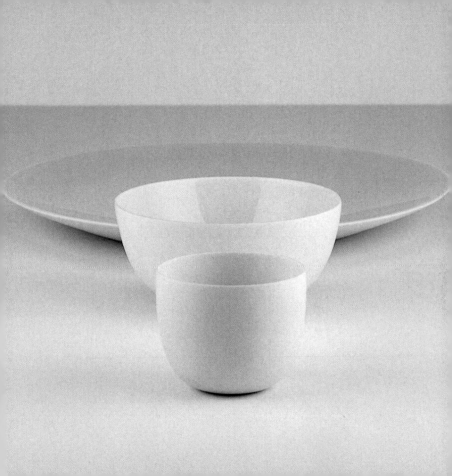

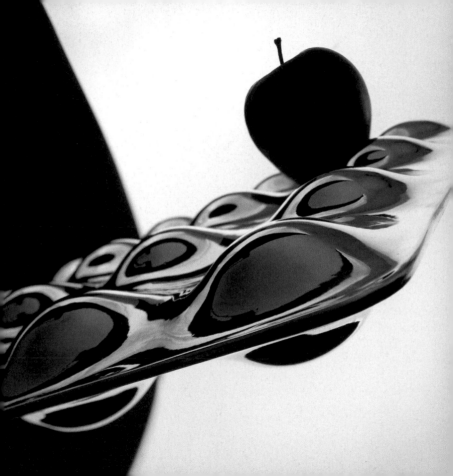

opposite Fruitscape – Fruit Holder
below Mami – Kettle with Magnetic Heat Diffusion Bottom
right Mami – Oil Cruet in 18/10 Stainless Steel

producer: Alessi designer: Stefano Giovannoni
www.stefanogiovannoni.it www.alessi.com

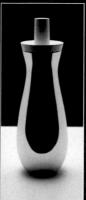

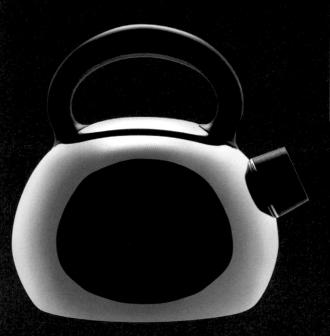

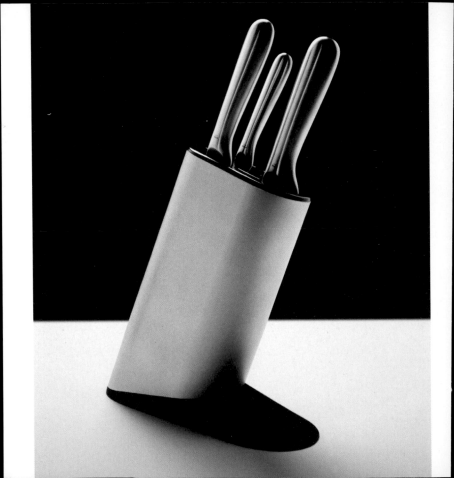

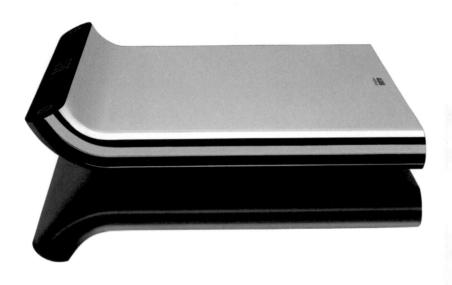

opposite Mami – Knives Block producer: Alessi www.alessi.com
above Electronic Kitchen Scales producer: Alessi www.alessi.com

designer: Stefano Giovannoni www.stefanogiovannoni.it

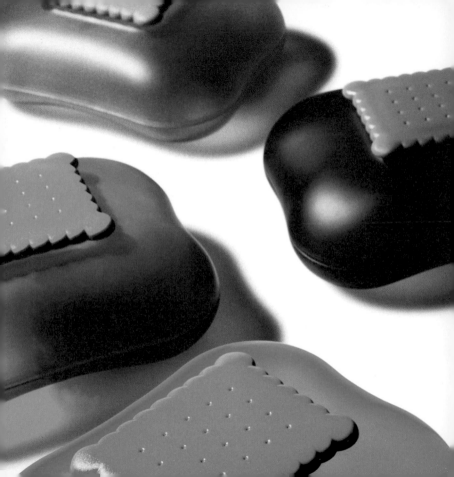

opposite Mary Biscuit – Biscuit Box
producer: Alessi www.alessi.com
right Fruit Mama – Fruit Holder
producer: Alessi www.alessi.com
below Calla producer: Domodinamica
www.domodinamica.com

designer: Stefano Giovannoni
www.stefanogiovannoni.it

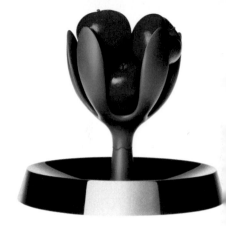

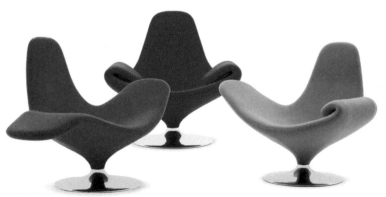

227

opposite Takeawaytray above Table Furniture
designer: Jonathan Miller jonathanmiller@hotmail.com

opposite Abra Cadabra designer: Cornelia Müller
above Five Senses – Montage designer: Barbara Schmidt
below left Five Senses – Pepper & Salt designer: Barbara Schmidt
below right Five Senses – Montage designer: Barbara Schmidt

producer: Kahla www.kahlaporzellan.com

opposite Yo-Fix – Wrapping Wheel designer: Contur_x
above Elvis – The Swinging Tape Dispenser designer: Serge Atallah

producer: Koziol www.koziol.de

233

Can-Pull producer: Boa
designer: Priestman Goode
www.priestmangoode.com

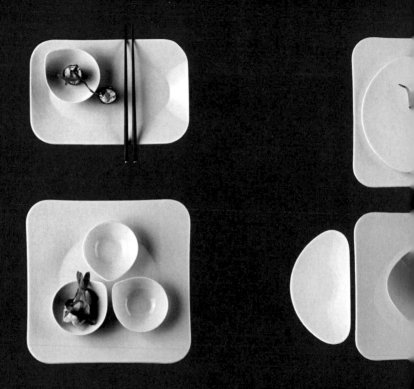

Studio Line Free Spirit producer: Rosenthal AG
designer: Robin Platt www.rosenthal.de

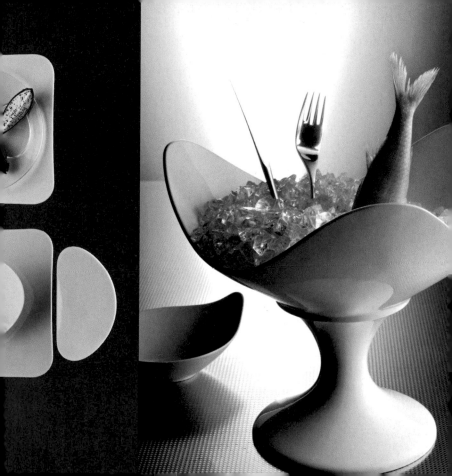

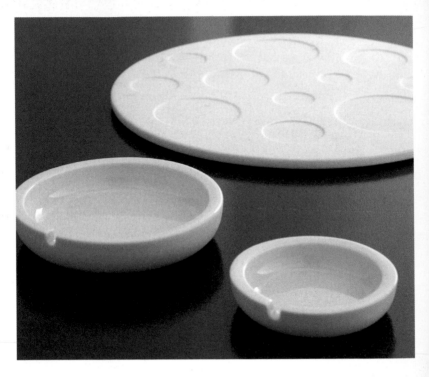

above JM-Tools designer: Jasper Morrison
opposite Coup designer: Thomas (Rosenthal Group) www.thomas-porzellan.de

producer: Rosenthal AG www.rosenthal.de

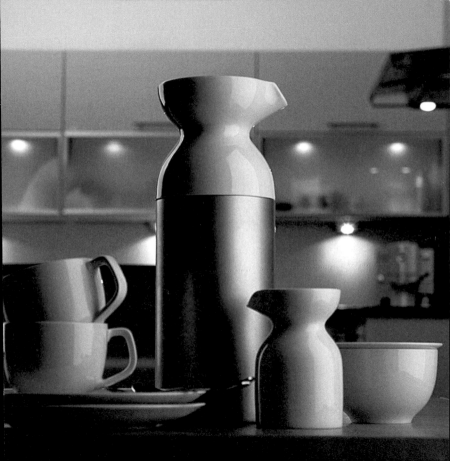

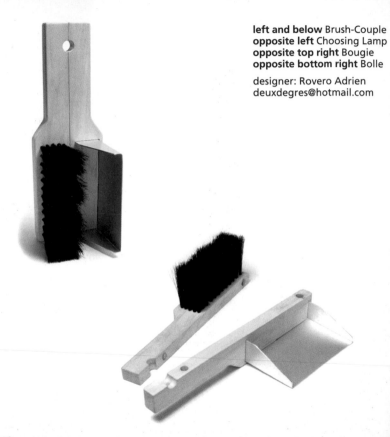

left and below Brush-Couple
opposite left Choosing Lamp
opposite top right Bougie
opposite bottom right Bolle

designer: Rovero Adrien
deuxdegres@hotmail.com

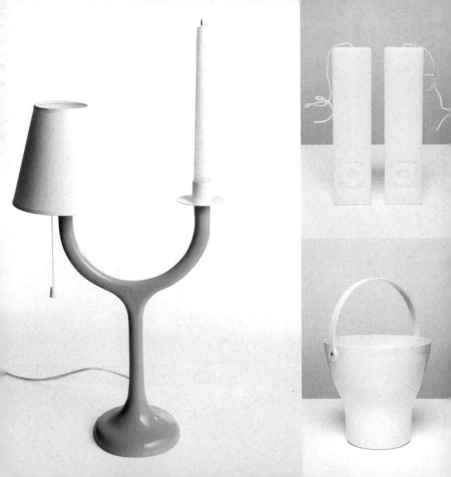

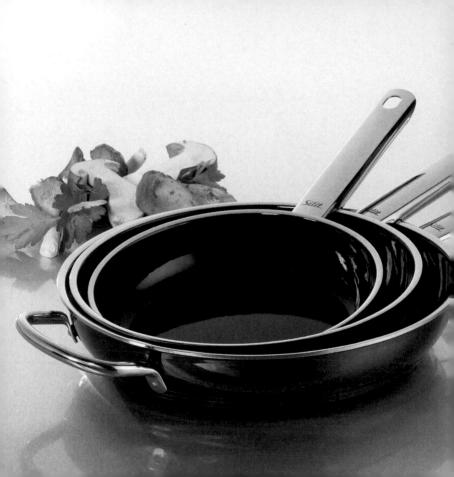

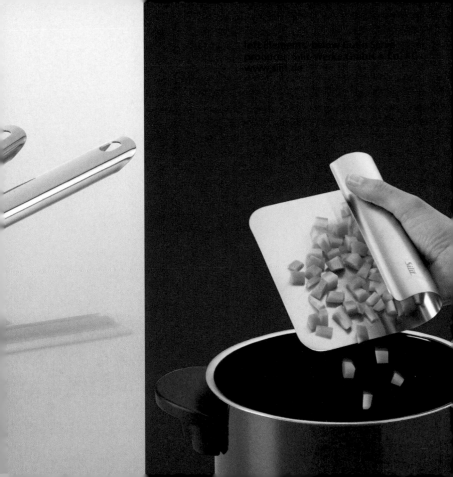

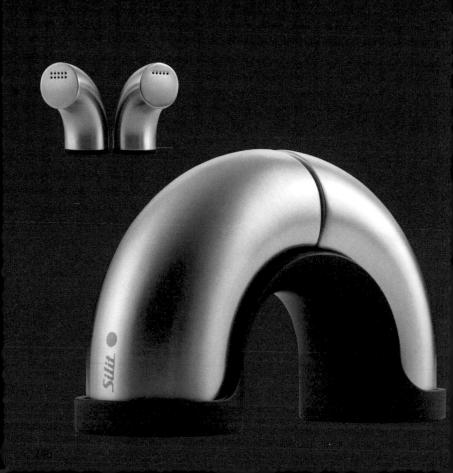

Innocate Line – Pure Temptation
Right Tension
producer: Silit Werke GmbH & Co.KG
www.silit.de

Silit

Silit

Silit

Silit

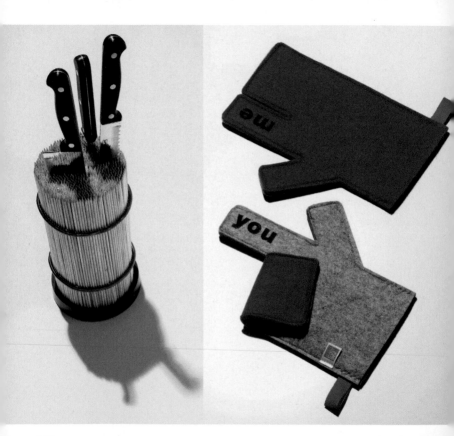

opposite left Knifeblock
producer: Wendelstein
Werkstätten Rosenheim
designer: Jörg Gätjens
opposite right Pot Holder
producer:
Berufsbildungswerk München
designer: Schlicht Nilshon Design
below Clothes Dryer
producer: Wendelstein
Werkstätten Rosenheim
designer: Factor Product
Designagentur
right Clothes Pin Bag
producer:
Berufsbildungswerk München
designer: Side by Side
www.sidebyside-design.de

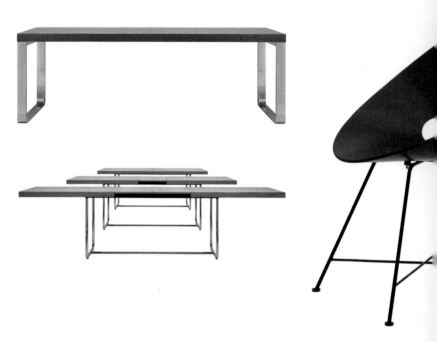

top S 1230 designer: Thonet
above S 1071 designer: Glen Oliver Löw
right S 664 designer: Eddie Harlis

producer: Gebrüder Thonet GmbH, Frankenberg
photographer: Michael Gerlach www.thonet.de

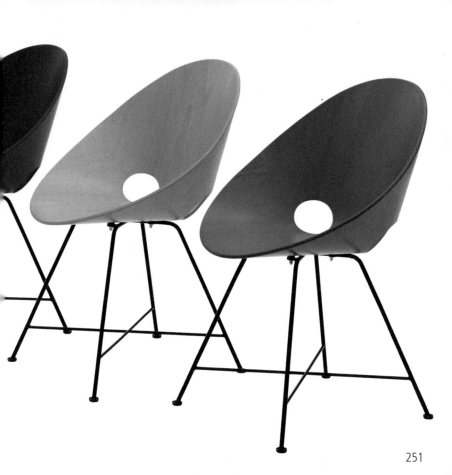

251

above Series of Brushes
producer: Hartmut Dierenbach
photographer: Harald Reich
top right Konus Beer Glasses
producer: Schott
photographer: Harald Reich
right Options Hotel Porcelain
producer: Bauscher
opposite top left and bottom left
Rapsody Faucet/Fluvia Faucet
producer: Rapetti, Italy
photographer: Harald Reich
opposite right MultiAction –
Two Component Toothbrush
producer: Jordan AS, Norway
photographer: Jürgen Bubeck

designer: Ottenwälder & Ottenwälder
www.ottenwaelder.de

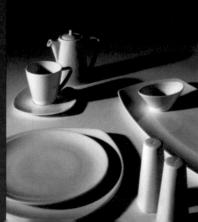

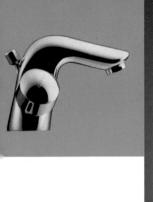

below left Sugar Bowl Brazil **middle** Salad Servers
right Salt & Pepper Set designer: Mario Taepper

producer: Tramontina Haushaltswaren GmbH
www.tramontina.de

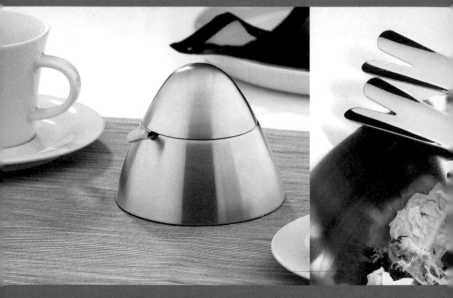

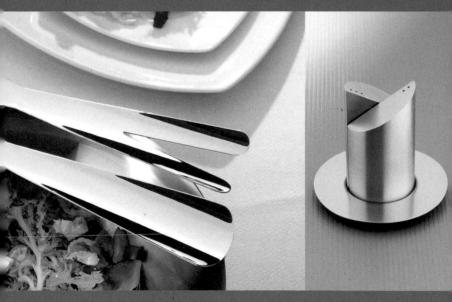

255

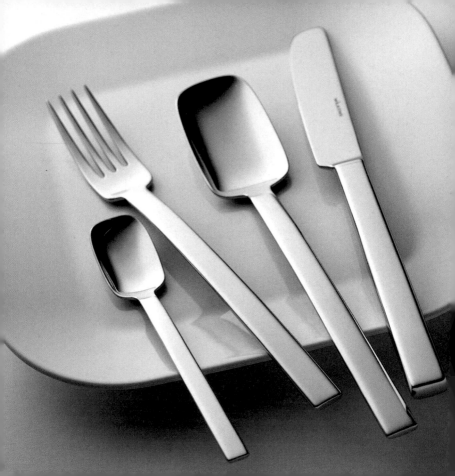

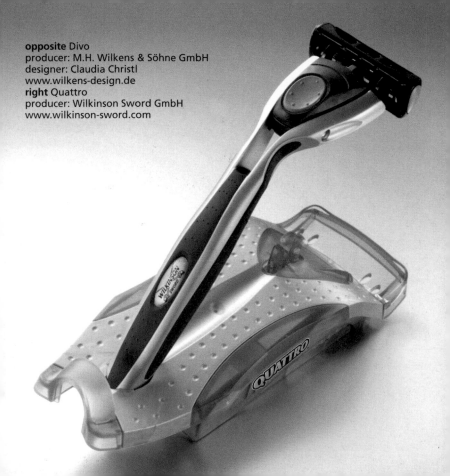

opposite Divo
producer: M.H. Wilkens & Söhne GmbH
designer: Claudia Christl
www.wilkens-design.de
right Quattro
producer: Wilkinson Sword GmbH
www.wilkinson-sword.com

opposite top Twin Boxes
below Sharp Star
top left Expressions Ovals
top right Decorating Bag & Icing Ball

producer: Tupperware
www.tupperware.com

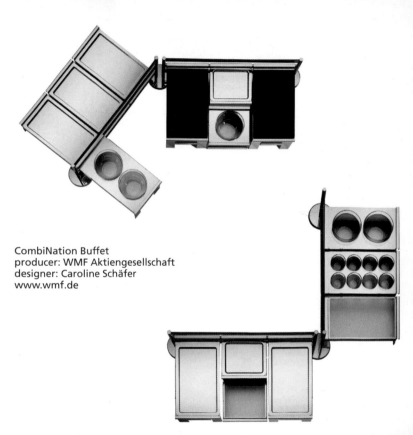

CombiNation Buffet
producer: WMF Aktiengesellschaft
designer: Caroline Schäfer
www.wmf.de

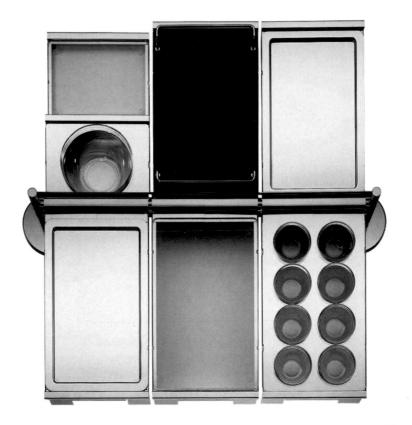

261

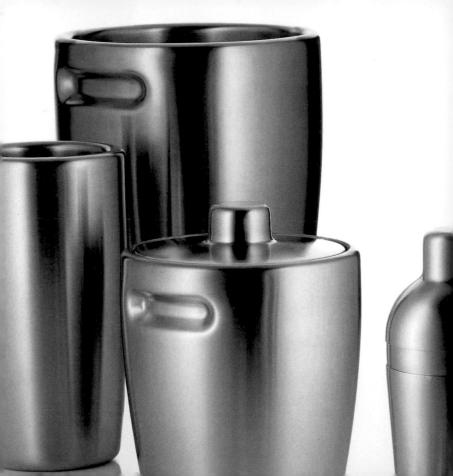

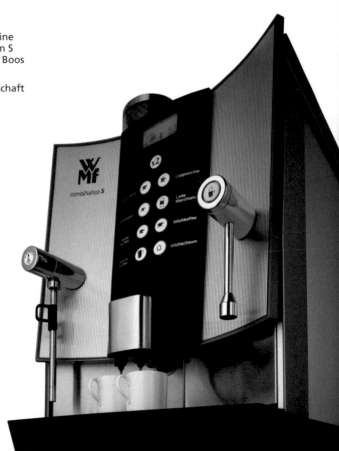

opposite Lounge
designer: James Irvine
below CombiNation S
designer: Reinhard Boos

producer:
WMF Aktiengesellschaft
www.wmf.de

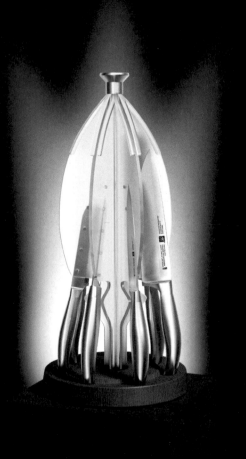

opposite left TWIN Kondo **opposite right** TWIN Select Kitchen Gadgets
below left TWIN Origami **below right** TWIN Collection Cheese Knives

producer: Zwilling J.A. Henckels AG www.zwilling.com

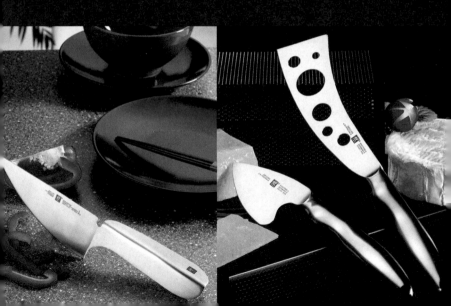

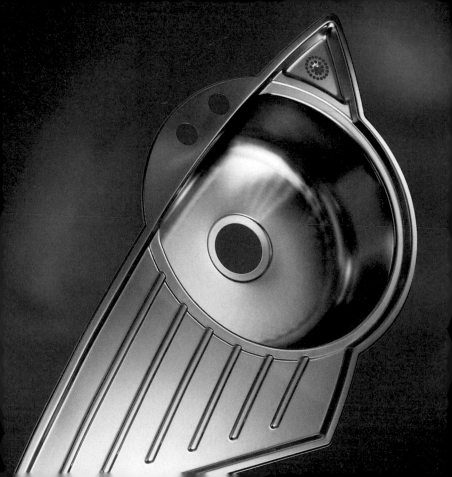

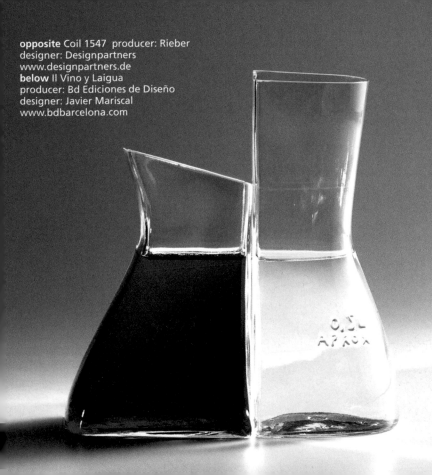

opposite Coil 1547 producer: Rieber
designer: Designpartners
www.designpartners.de
below Il Vino y Laigua
producer: Bd Ediciones de Diseño
designer: Javier Mariscal
www.bdbarcelona.com

above Air designer: Arabia www.arabia.fi **below** All Steel designer: iitala www.iitala.com
producer: Harri Koskinen Friends of Industry Ltd. www.harrikoskinen.com
opposite Pia designer: Lambert GmbH www.lambert-home.de

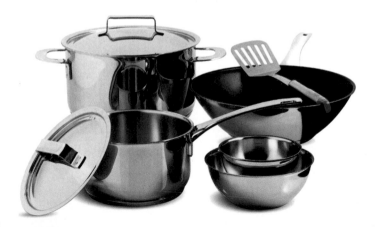

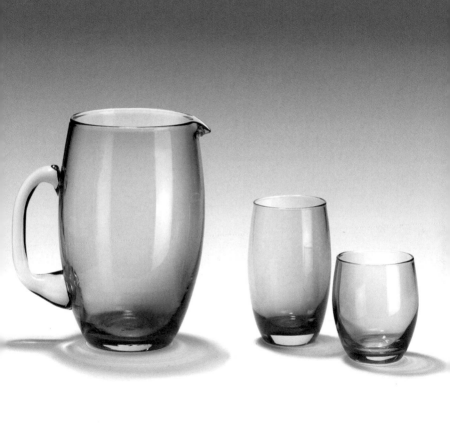

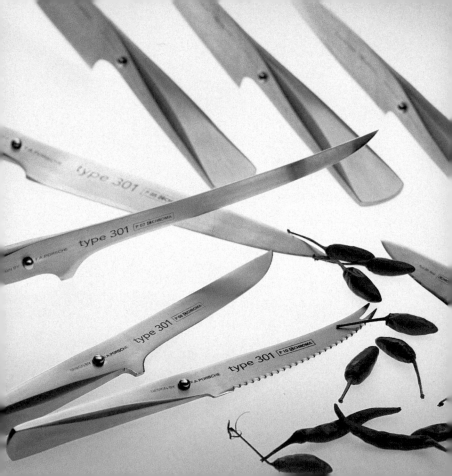

opposite Type 301 producer: Chroma Cutlery Inc. designer: Porsche Design
www.porsche-design.at
below Palmhouse producer: Cherry Terrace, Japan designer: Mario & Claudio Bellini
photographer: Leo Torri www.atelierbellini.com

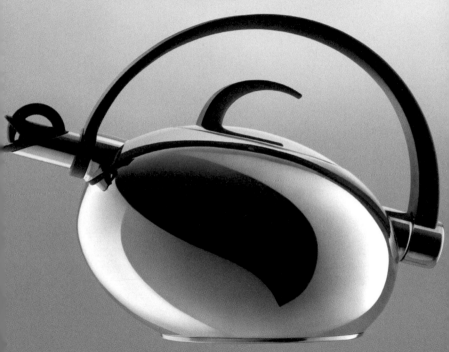

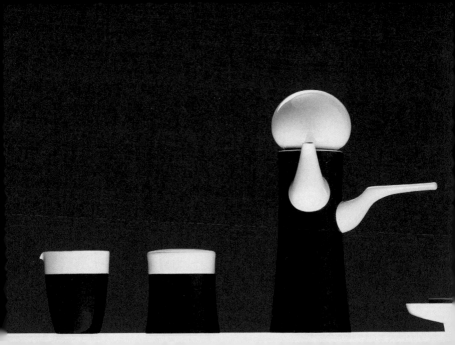

left Stambul designer: Wolf Karnagel
below Berlin designer: Enzo Mari

producer: KPM – Königliche Porzellan-
Manufaktur Berlin GmbH www.kpm.de

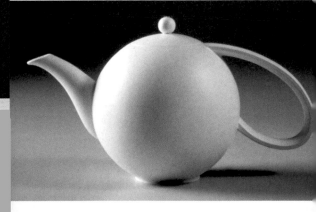

273

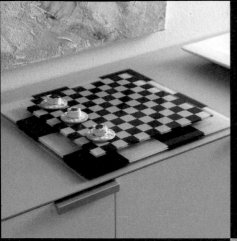

left and below 60ies – Checked
producer: Leonardo/Glaskoch
www.leonardo.de
opposite Chiara
designer: Nicole Goetti

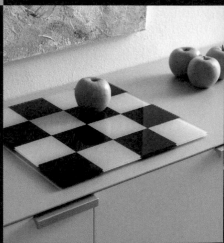

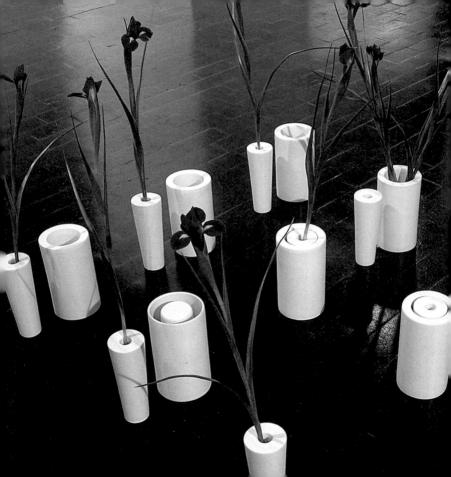

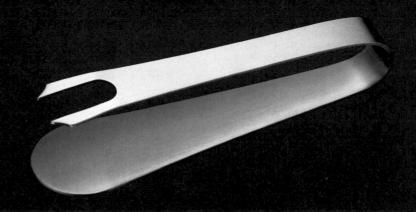

above Fastfood Tongs producer: Carl Mertens
below left Sugar Bowl producer: Auerhahn
below right Adam & Eve Salad Servers producer: Carl Mertens
opposite Plus Minus producer: Tramontina Haushaltswaren GmbH

designer: MM Design Edition www.mmdesignedition.de

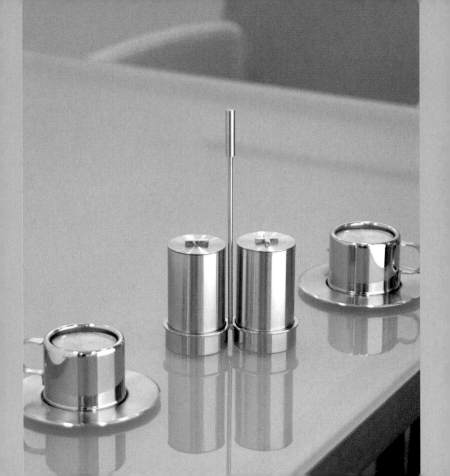

above Salt & Pepper Set producer: Carl Mertens
opposite top Salt & Pepper Mills producer: Tramontina Haushaltswaren GmbH
opposite bottom left Tea Warmer producer: Tramontina Haushaltswaren GmbH
opposite bottom right Cake Server producer: Tramontina Haushaltswaren GmbH

designer: MM Design Edition www.mmdesignedition.de

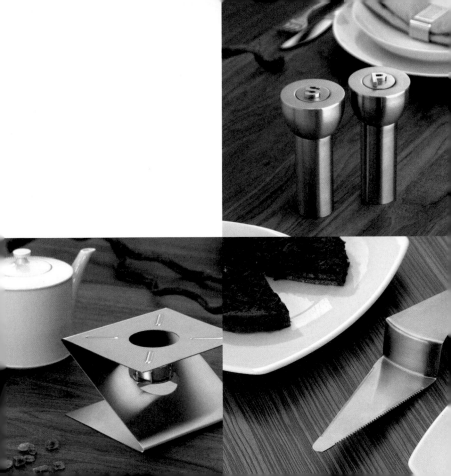

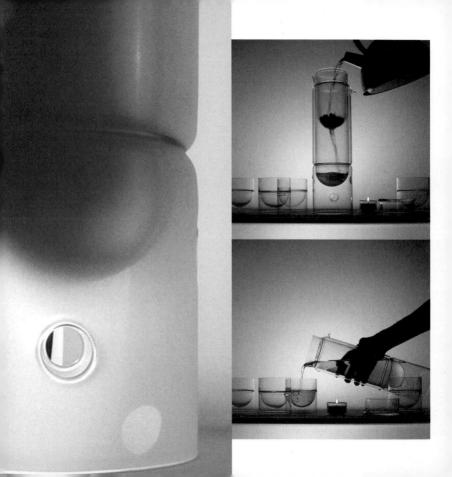

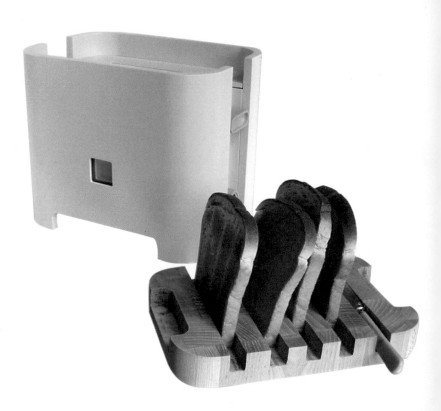

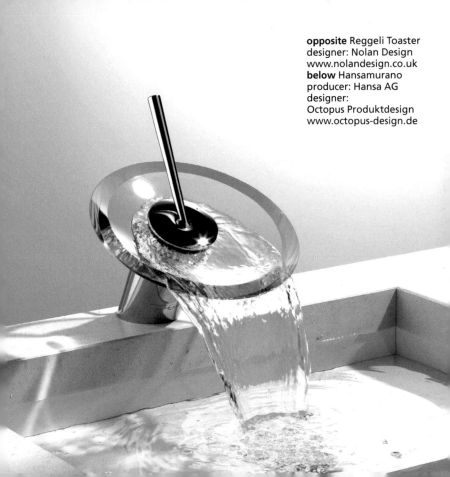

opposite Reggeli Toaster
designer: Nolan Design
www.nolandesign.co.uk
below Hansamurano
producer: Hansa AG
designer:
Octopus Produktdesign
www.octopus-design.de

top left Knäckebrotbox producer: Silit-Werke GmbH & Co. KG www.silit.de
above Clip & Close producer: Emsa Werke
www.emsa.com
left Chopping Board producer: Boa
designer: Priestman Goode
www.priestmangoode.com
opposite top left Flipper Toothbrush Holder
producer: ORCA Innovation Sdn Bhd
www.orcainnovation.com.my
opposite bottom left Gliss – Soapdish
producer: ORCA Innovation Sdn Bhd
www.orcainnovation.com.my
opposite right XL 1062 E
producer: De Longhi www.delonghi.com

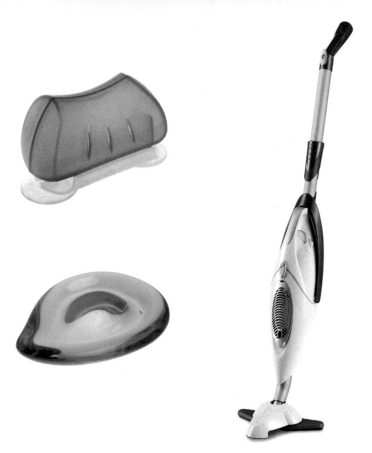

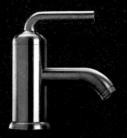

above left Freeline
producer: Sam Vertriebs GmbH & Co. KG
designer: Designschneider
www.designschneider.de
above middle Sculpture
producer: KWC Armaturen
designer: NOA
www.kwc.ch www.noa.de
above right Statura Insulating Flask
producer: Emsa Werke www.emsa.com
left Formaggio, Cheese Grater with Box
producer: Silit-Werke GmbH & Co. KG
www.silit.de
right Garlic Press producer: Silit-Werke
GmbH & Co. KG www.silit.de
bottom left TwoInOne Salt & Pepper Set
producer: WMF Aktiengesellschaft
designer: MM Design Edition
www.wmf.de
www.mmdesignedition.de

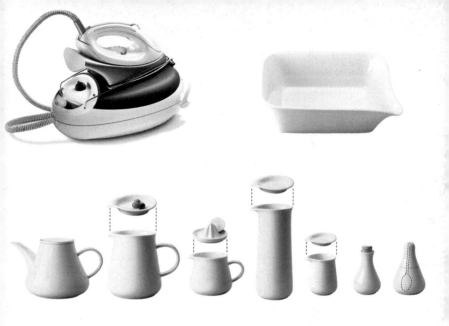

top left VVX 800
producer: De Longhi www.delonghi.com
top right and middle Five Senses
producer: Kahla/Thüringen Porzellan GmbH
designer: Barbara Schmidt
www.kahlaporzellan.com
right Format producer: Wupperring
designer: Designschneider
www.designschneider.de

left Tundra – Trivet
above
Uma – Incent Burner
opposite Strawbowl

producer:
Alessi S.p.A., Italy
designer:
Kristiina Lassus
www.kristiinalassus.com

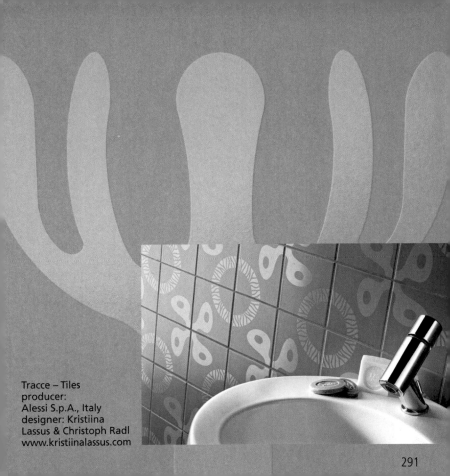

Tracce – Tiles
producer:
Alessi S.p.A., Italy
designer: Kristiina
Lassus & Christoph Radl
www.kristiinalassus.com

291

Systema producer: KWC Armaturen designer: NOA www.kwc.ch www.noa.de

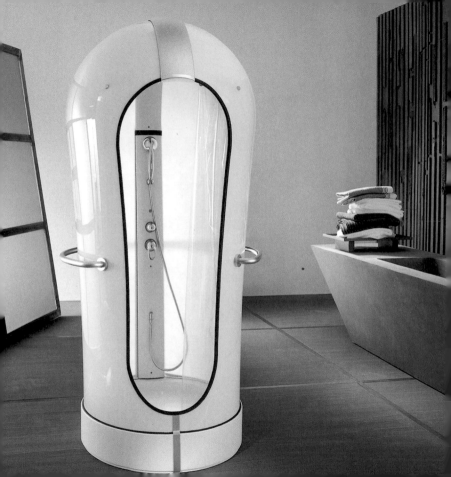

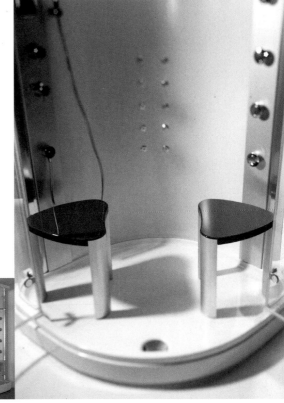

opposite Pharo Cocoon
producer: Hansgrohe
designer: Jochen Schmiddem
www.schmiddem-design.de
www.hansgrohe.de
below and right Dampfdusche
producer: Duscholux
designer: Michael Schmidt,
Dirk Bolduan
www.code2design.de

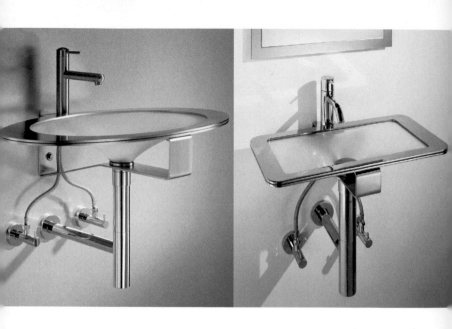

Tension producer: High Tech
designer: Michael Schmidt, Dirk Bolduan
www.code2design.de

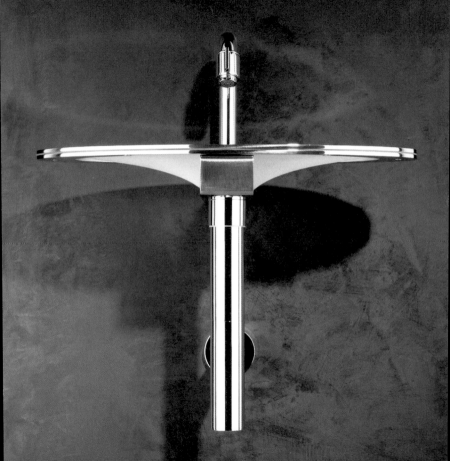

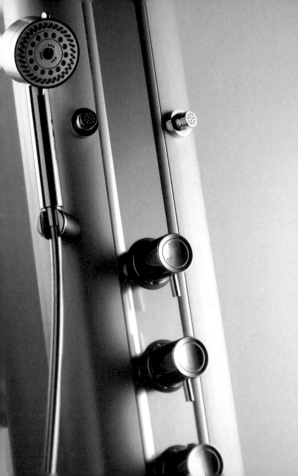

left Live Evolution
opposite Pure

producer: Duscholux
designer: Michael
Schmidt, Dirk Bolduan
www.code2design.de

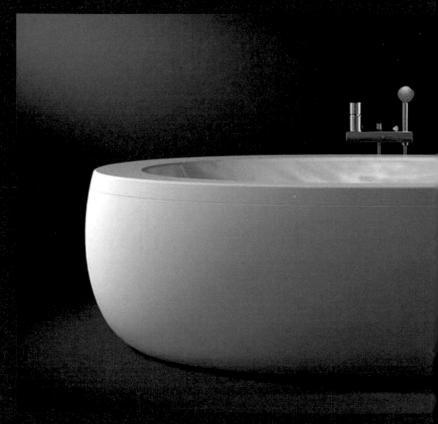

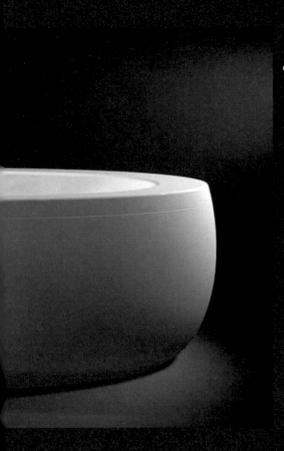

Bath Tub
producer: Laufen AG,
Il Bagno Alessi
designer: Stefano Giovannoni
www.stefanogiovannoni.it
www.ilbagno.alessi.com

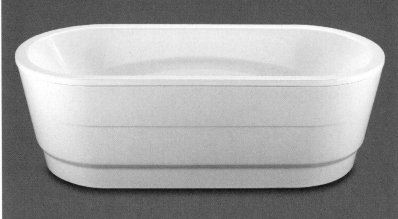

above Vaioduo oval designer: Phoenix Design, Stuttgart, Tokio
below and opposite Megaform oval designer: Sottsass Associati, Mailand

producer: Kaldewei www.kaldewei.de

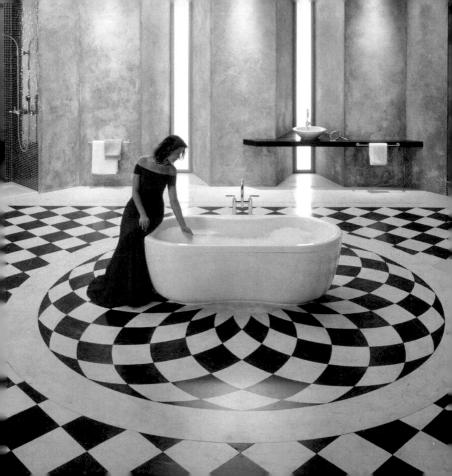

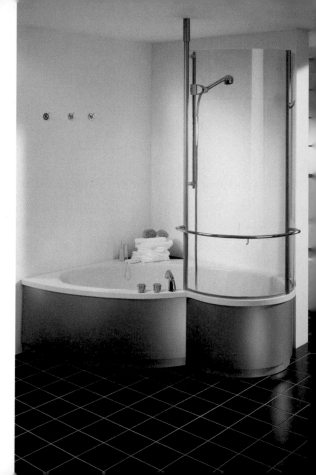

top
BettePool Oval
above
BettePur Hexagonal

producer: Bette,
Delbrück, Germany
designer: Jochen
Schmiddem, Berlin
www.bette.de

304

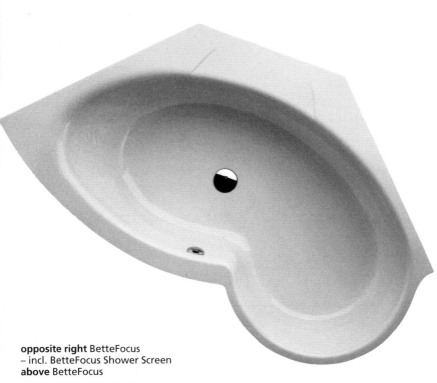

opposite right BetteFocus
– incl. BetteFocus Shower Screen
above BetteFocus

producer: Bette, Delbrück, Germany
designer: Jochen Schmiddem, Berlin www.bette.de

producer: Axia Srl designer: Lino Codato
photographer: Alberto Narduzzi www.axiabath.it

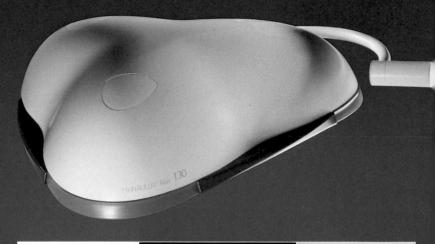

HANAULUX® blue 130

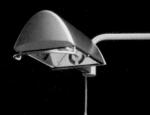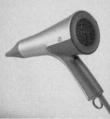

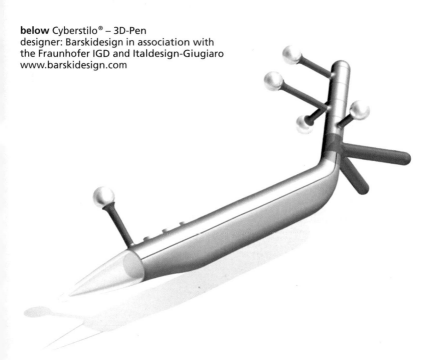

below Cyberstilo® – 3D-Pen
designer: Barskidesign in association with
the Fraunhofer IGD and Italdesign-Giugiaro
www.barskidesign.com

opposite top Hanaulux Blue – Surgical Luminaire Program producer: Heraeus
opposite bottom left Bora P – Surgical Suction Device producer: Medap
opposite bottom middle Hanautherm – Surgical Radiant Heater producer: Heraeus
opposite bottom right Aeroxx – Professional Blowdryer producer: Wella

designer: Barskidesign www.barskidesign.com

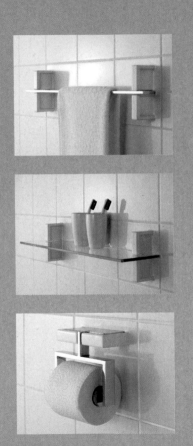

2 in 1 producer: Villeroy & Boch AG designer: Jan Kleihues www.kleihues.com

311

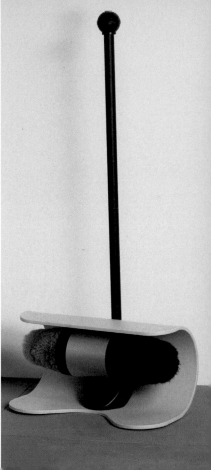

above Virgola
– Shower Cabin Glass Cleaner
producer: Vismaravetro s.r.l.
www.vismaravetro.it
right Arlecchino – Shoe Polisher
producer: Nito Arredamenti s.r.l.
www.rapsel.it
opposite Ra producer: Mamoli
Robinetterie S.p.A. www.mamoli.it

designer: Pedrizetti Associati
www.pedrizetti.it

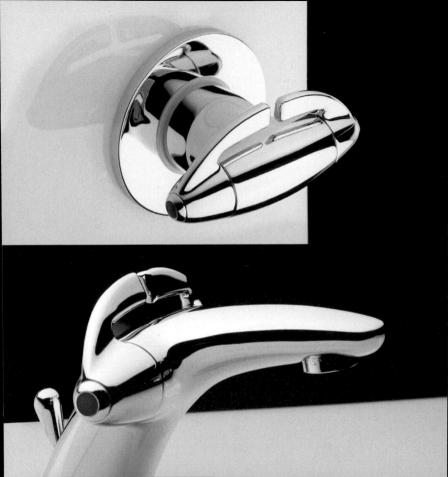

opposite Zoom left Puris
below Cross

producer:
Schell GmbH & Co. KG
www.schell-armaturen.de

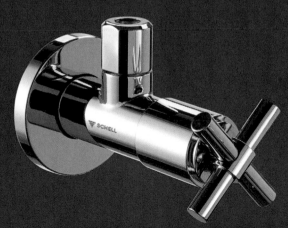

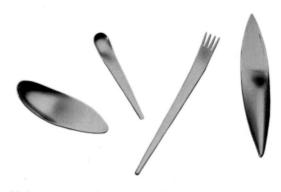

above and below Zeug producer: Mono designer: designschneider www.mono.com

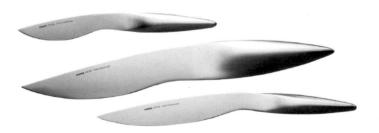

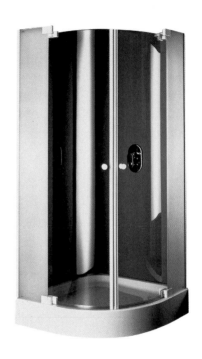

above left Meandala Studie producer: designschneider
designer: Michael Schneider www.designschneider.de
above right Clever Viertelkreis producer: Hoesch
designer: designschneider www.hoesch.de

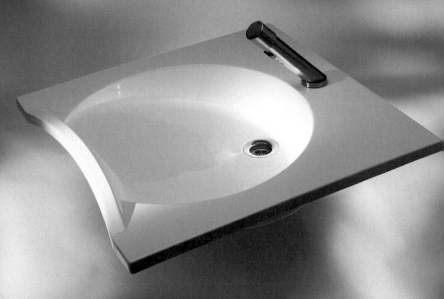

Tangible producer: Niethammer, Gernsheim designer: Sol.Design
photographer: Ursula Raapke www.sol-design.net

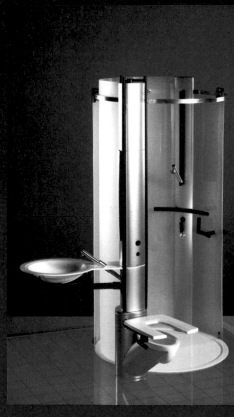

Viva
Bathroom Accesoires
producer:
Colombo Design
designer:
Bartoli Design

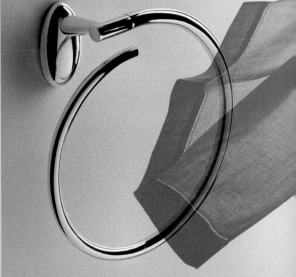

320

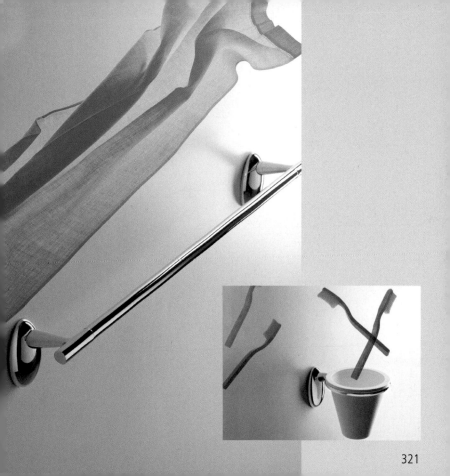

321

04

Hágase la luz

Continuamente estamos rodeados de luz, incluso de noche. Nos alegra y nos deprime, guía y dirige nuestros caminos, ilumina y alumbra las calles y las casas.

Por eso es normal que hoy se utilice la luz artificial para crear: Es más clara o más oscura, ilumina mucho o poco, puede seguirnos, informarnos y crear estados de ánimo.

Even at night we are constantly surrounded by light. It stimulates and depresses us, guides us and lights our way, provides light and illumination on the streets and at home.

It is of course obvious that all artificial light is designed light. It can be brighter or dimmer, light up much or little, it can track, elucidate, and create moods.

Let there be light!

Todo el mundo lo sabe: Un foco no es una vela por eso las cosas que se desarrollan bajo su luz son diferentes. La luz crea ambientes gracias a su sensualidad. La percibimos con los ojos y con todo el cuerpo, reaccionamos continuamente a su claridad y calor. Además: La luz se ilumina también a sí misma creando una imagen que atrae nuestra atención.

Las diseñadoras y los diseñadores son conscientes de ello y por eso, desde hace siglos, crean nuevas fuentes y objetos de luz, en algunas ocasiones centrándose en el objeto iluminado y, en otras, en el elemento que irradia la luz.

En la actualidad llegan incluso más lejos porque han comprendido, (algo que especialmente los encargados de la iluminación de escenarios saben

326

As everyone knows, a spotlight is not a candle and in the beam of a spotlight different things happen. Light creates atmosphere because it is above all sensory: we perceive it with our eyes and entire bodies, and react constantly to its brightness and warmth. In addition, light is always self-illuminating, providing in itself a point or even a sculpture as a focus for our attention.

Designers know this and have for centuries created new light sources and objects, sometimes focusing on that which is being illuminated, sometimes emphasizing the light source itself.

In the meantime, some have gone even further and now recognize that light can be a major element in the creation of artificial environments,

desde hace mucho), que la luz puede dar forma a los mundos artificiales. Ya sea creando unas paredes adornadas con flores o simplemente una pared verde, un ambiente idílico o de trabajo, el diseño de la luz hace posibles las más variadas atmósferas sin ningún tipo de dificultad…

La luz posee un infinito potencial creativo y casi todos los diseñadores han creado con ella diferentes modelos porque trabajar con la luz es algo claramente divertido.

a quality that has been effectively used in stage lighting for a long time. Whether it is floral 'wallpaper' or simply a green wall, idyllic surroundings or work atmosphere, designed lighting enables the problem-free creation of any kind of ambience.

Thus light offers an almost unlimited potential for design, and for this very reason most designers have been creative in this field. Interaction with light is clearly something to enjoy.

right and below Tubi
producer: Christine Kröncke
Interior Design
designer: Taepper Design

opposite Panam
producer: Serien, Germany
designer:
Hopf & Wortmann/büro für form
photographer: Christoph Lison
www.buerofuerform.de
www.serien.com

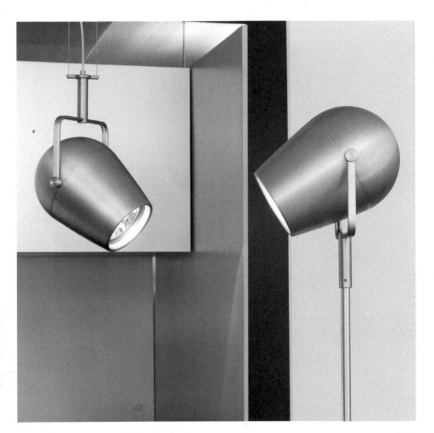

331

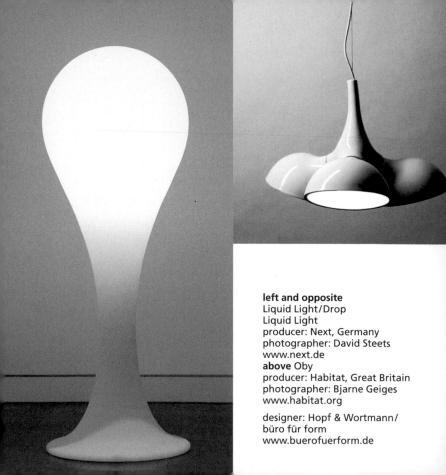

left and opposite
Liquid Light/Drop
Liquid Light
producer: Next, Germany
photographer: David Steets
www.next.de
above Oby
producer: Habitat, Great Britain
photographer: Bjarne Geiges
www.habitat.org

designer: Hopf & Wortmann/
büro für form
www.buerofuerform.de

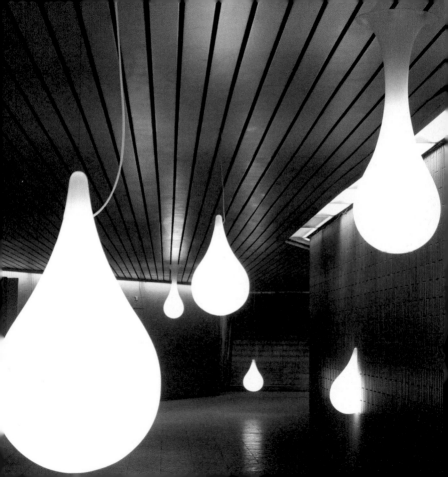

I´m "dicke Trude"...

...sqeeze to switch me on and off...

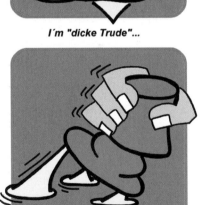

I stick on every smooth surface...

... recharge me on my base!

Dicke Trude producer: Next, Germany designer: Hopf & Wortmann/büro für form
photographer: David Steets www.next.de www.buerofuerform.de

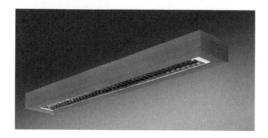

above and right Beef/Concrete
designer: Ivan Missinne
below Ice
designer: Anthony Duffeleer

producer: Dark Lightning Company
www.dark.be

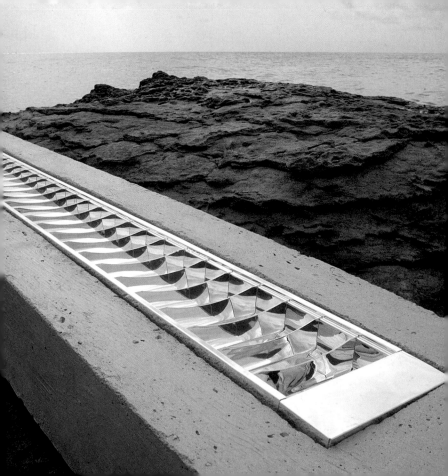

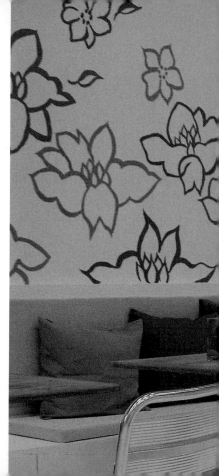

above Bridge
designer: Georges Seris
right Crosslight
designer: Jan Melis & Ben Oostrum

producer: Dark Lightning Company
www.dark.be

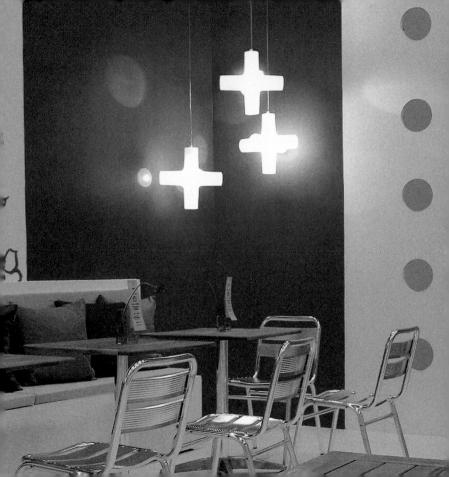

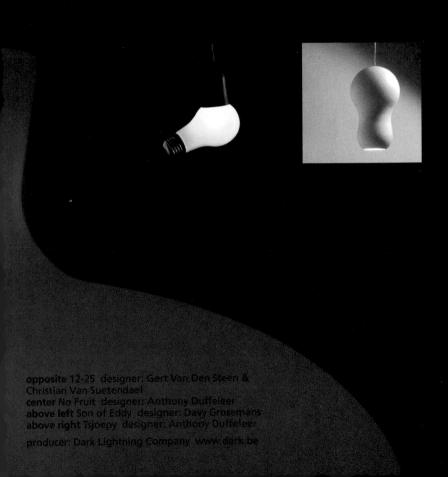

opposite 12-25 designer: Gert Van Den Steen &
Christian Van Suetendael
center No Fruit designer: Anthony Duffeleer
above left Son of Eddy designer: Davy Grosemans
above right Tsjoepy designer: Anthony Duffeleer

producer: Dark Lightning Company www.dark.be

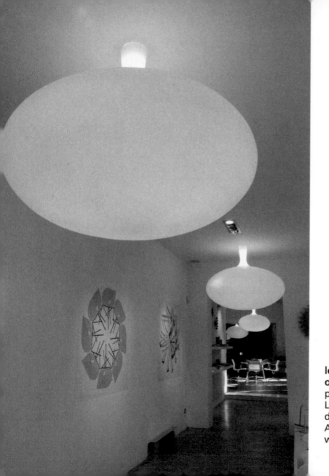

left No Fruit
opposite Hype
producer: Dark
Lightning Company
designer:
Anthony Duffeleer
www.dark.be

343

left Quinta
opposite Eclipse
producer: Erco
Leuchten GmbH
Lüdenscheid
www.erco.com

345

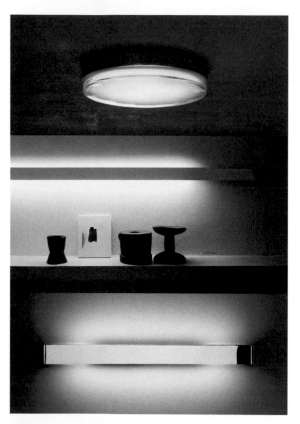

top Plaza
designer:
Antonio Citterio
middle Riga
designer: Antonio
Citterio & Oliver Löw
bottom All Light
designer:
Rodolfo Dordoni
opposite
2097/30 & 2097/50
designer: Gino Sarfatti

producer: Flos
www.flos.net

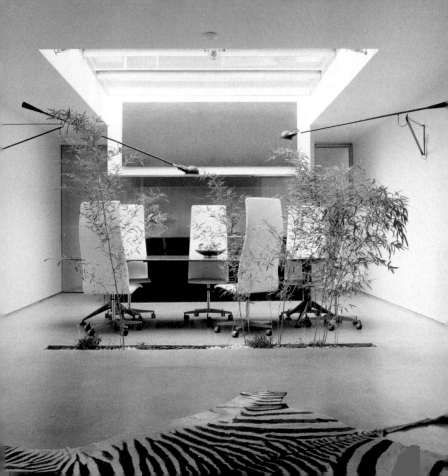

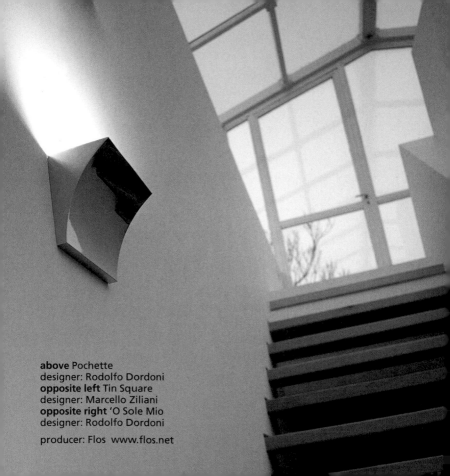

above Pochette
designer: Rodolfo Dordoni
opposite left Tin Square
designer: Marcello Ziliani
opposite right 'O Sole Mio
designer: Rodolfo Dordoni

producer: Flos www.flos.net

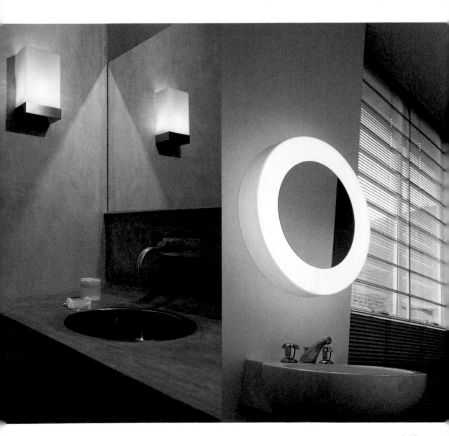

349

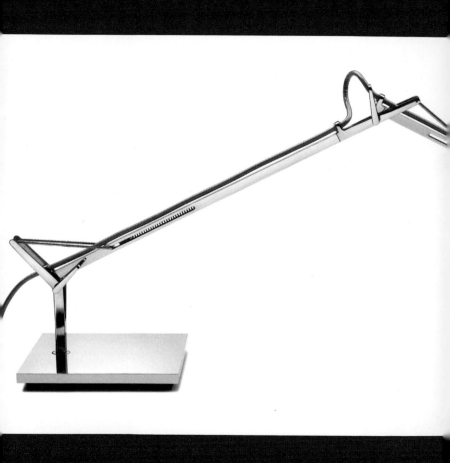

Kelvin T producer: Flos designer: Antonio Citterio & Toan Nguyen www.flos.net

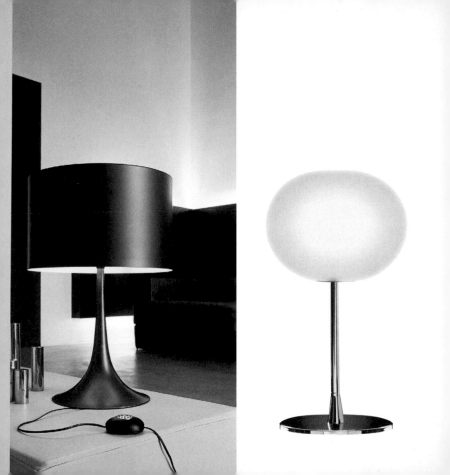

opposite left Spun Light T1 designer: Sebastian Wrong
opposite right Glo-Ball T1 designer: Jasper Morrison
below left and right Miss K designer: Philippe Starck

producer: Flos www.flos.net

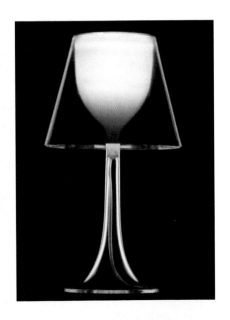

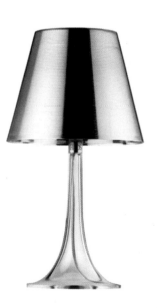

353

right LED Bench
designer: Ingo Maurer
bottom from left to right
Aka Tsuki
designer: Matthias
Liedtke
Magic Eyes
designer: Klaus Stammel
& Olaf Probst
Subway Station
Westfriedhof, Munich
designer: Ingo Maurer

producer:
Ingo Maurer GmbH
www.ingo-maurer.com

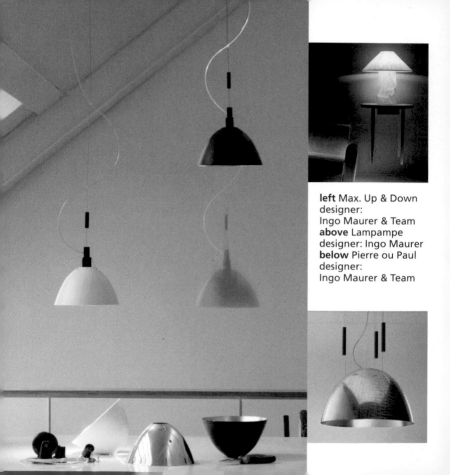

left Max. Up & Down
designer:
Ingo Maurer & Team
above Lampampe
designer: Ingo Maurer
below Pierre ou Paul
designer:
Ingo Maurer & Team

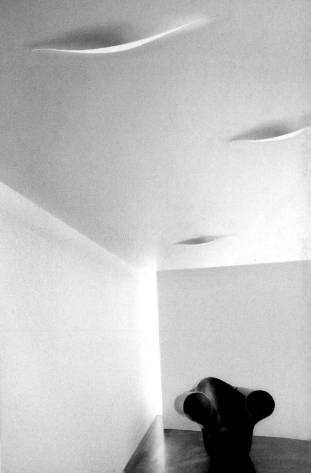

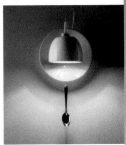

above Tooling
designer: C. Matthias
below Light au Lait
designer: Fabien Dumas
right Schlitz Up
designer: Ingo Maurer

producer:
Ingo Maurer GmbH
www.ingo-maurer.com

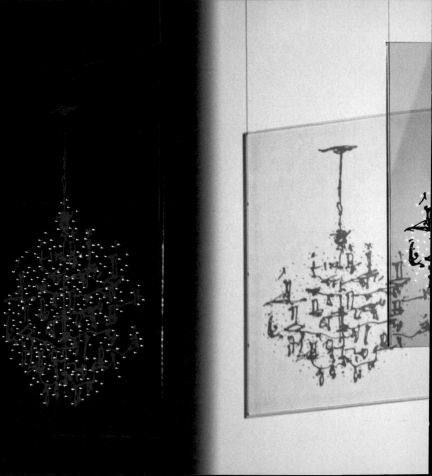

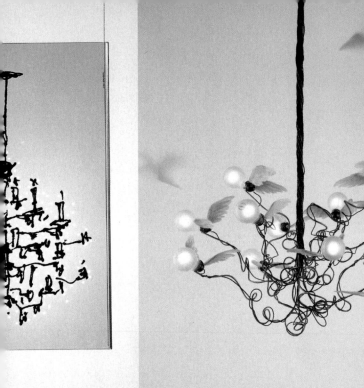

opposite Luester **above** Birdie
producer: Ingo Maurer GmbH
designer: Ingo Maurer www.ingo-maurer.com

left "Stardust"
bottom left "Wörter"

Galeries Lafayette
Maison, Paris –
Lightning Installation
for the Hall
producer:
Ingo Maurer GmbH
designer: Ingo Maurer
www.ingo-maurer.com

opposite
"Reaching for the
Moon" – Installation
for an Exhibition
producer:
Ingo Maurer GmbH
designer: Ingo Maurer
www.ingo-maurer.com

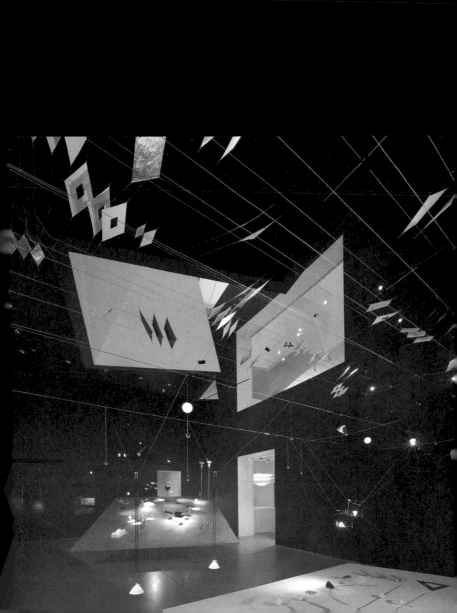

below left top Kiss by designer Ingo Maurer
below right Birdling by designer Ingo Maurer
opposite top left Lucelino by designer Christian Verbuerg / Ingo Maurer
opposite top right Zettel'z by designer Ingo Maurer
below left Porca Miseria! by designer Ingo Maurer
opposite bottom right Vitra Design Museum, Weil am Rhein, designer Ingo Maurer

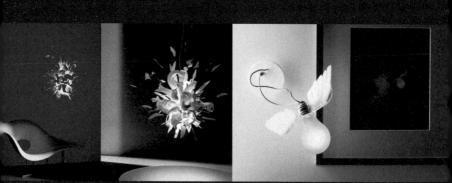

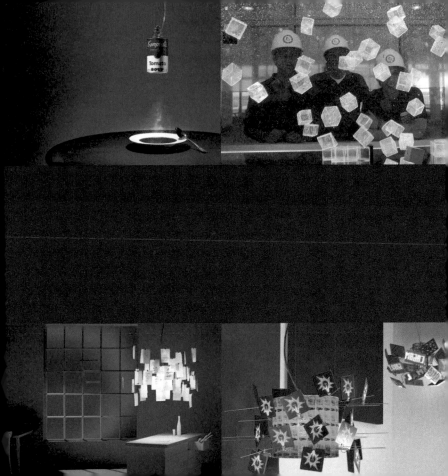

Lumicube
producer: Kolibri
www.lichtideen.de

364

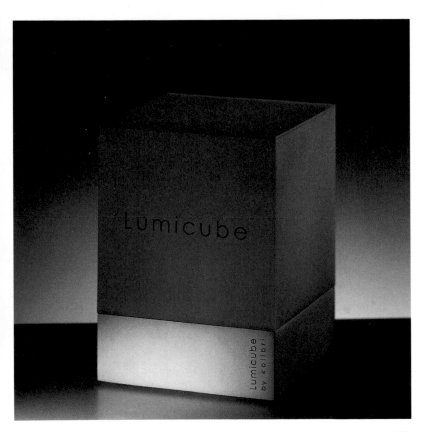

above and below Baby Zoo collection
producer: Flos designer: Laurene Leon Boym
www.flos.it www.boym.com
right Crystal Rugs Chandelier producer: Swarovski
designer: Constantin & Laurene Leon Boym
www.crystalpalaceproject.com www.boym.com

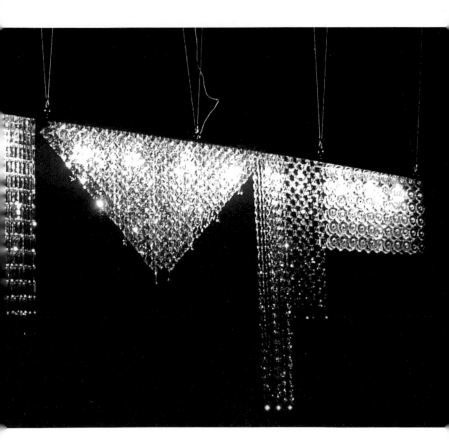

367

opposite
LED Lichtobjekt
right
LED Lichtobjekt M
producer: LFF Leuchten
GmbH, Solingen
designer:
Achim Jungbluth
www.lff.de

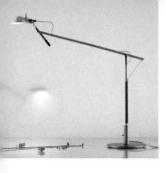

below left and right
Bridge
producer: Dark
Lightning Company
designer: Georges Seris
www.dark.be

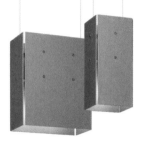

above Prototype, 2003
producer:
Ingo Maurer GmbH
designer: Ingo Maurer
www.ingo-maurer.com

below Cybe
producer:
Dark Lightning Company
designer: Peter Van
Ooteghem www.dark.be

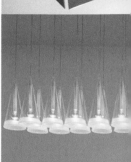

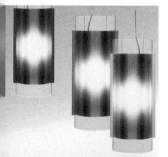

right Fucsia
producer: Flos
designer:
Achille Castiglioni
www.flos.net

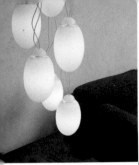

below
Campari Light
producer: Ingo Maurer
GmbH
designer:
Raffaele Celentano

above Brera S
producer: Flos
designer:
Achille Castiglioni
www.flos.net

right aTooL
designer: C. Matthias
producer:
Ingo Maurer GmbH
www.ingo-maurer.com

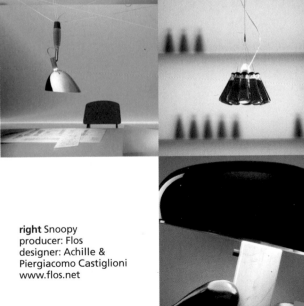

right Snoopy
producer: Flos
designer: Achille &
Piergiacomo Castiglioni
www.flos.net

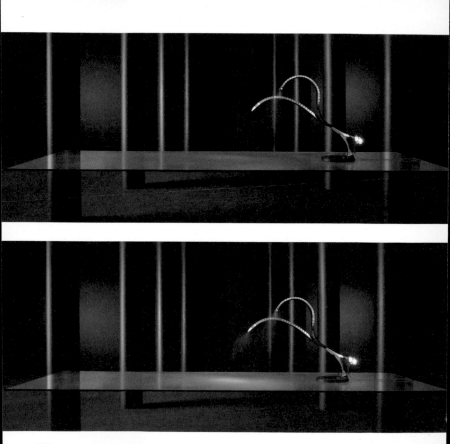

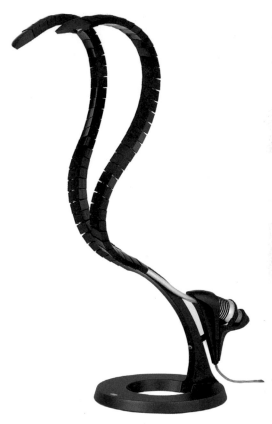

Ra Table Lamp
producer: Lumina Italia Srl
designer: Ettore Cimini
www.lumina.it

above and below Serie Xaruc
right Serie Retro

producer: Pujol Iluminación
www.pujoliluminacion.com

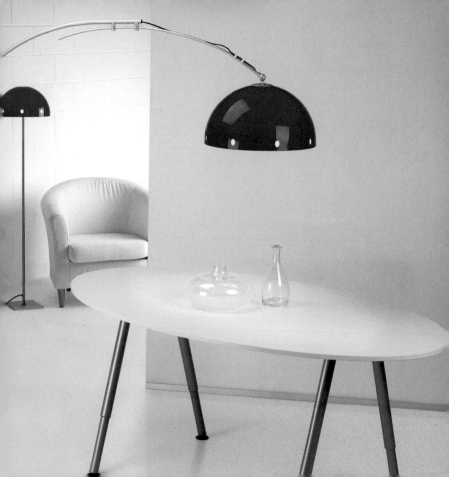

above Jones **opposite** Take Five
producer: Serien Raumleuchten GmbH www.serien.com

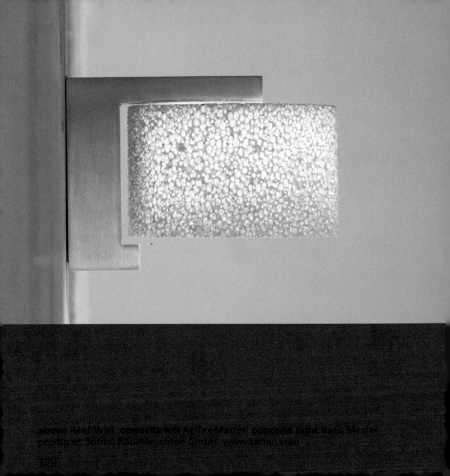

above Reef Wall, opposite left Reflex Master, opposite right Base Master
producer: Serien Raumleuchten GmbH, www.serien.com

378

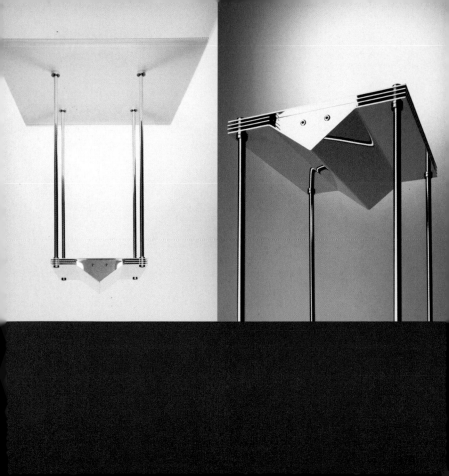

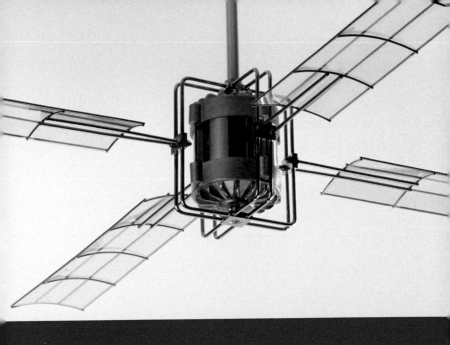

opposite left and right Zoom **above** Ventilator
producer: Serien Raumleuchten GmbH www.serien.com

381

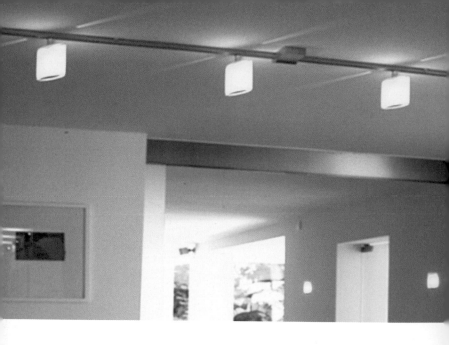

above Casabina **opposite** Iliron
producer: SiglLicht GmbH www.sigllicht.de

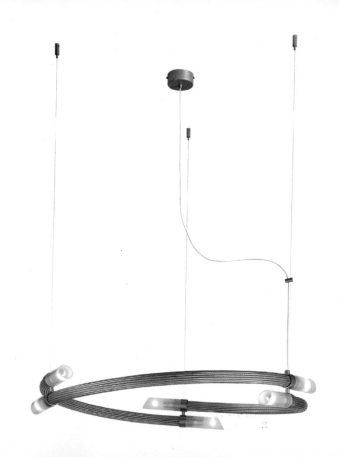

opposite Adele **below** 7x7
right Bobino

producer: Terzani
designer: Jean François Crochet
www.terzani.com

387

388

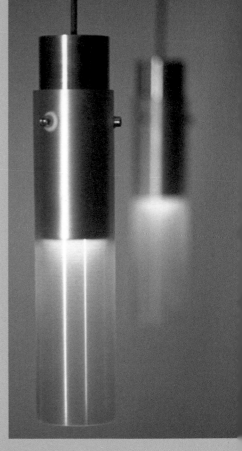

opposite 6 A.M.
right Tornado

producer & designer: Soupculture
www.soupculture.de

389

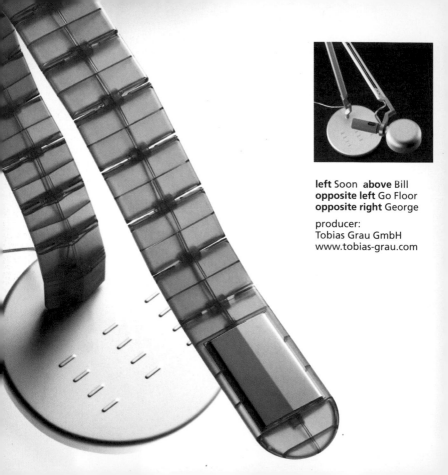

left Soon **above** Bill
opposite left Go Floor
opposite right George

producer:
Tobias Grau GmbH
www.tobias-grau.com

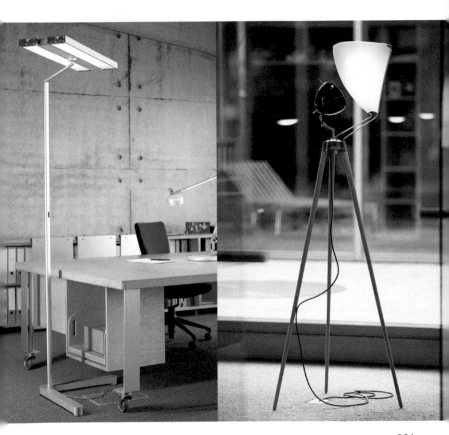

391

above and left Dart Light
producer: Alexandra Breitenfeldt
designer: Alexandra Breitenfeldt
www.alexausberlin.de

opposite Solar II
producer: Zumtobel Staff
designer: Iosa Ghini
www.zumtobelstaff.com
www.iosaghini.it

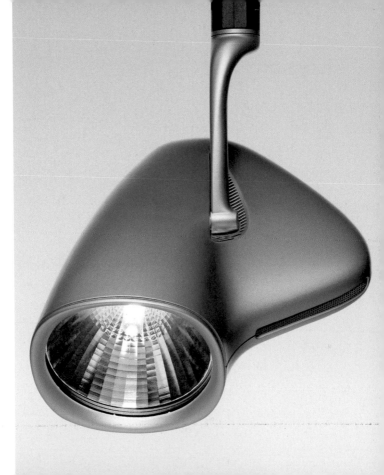

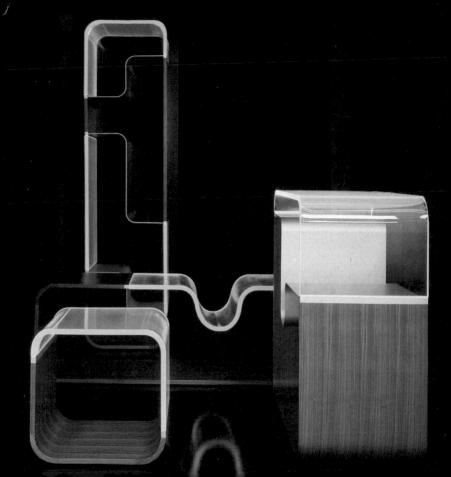

opposite Litebox producer: Emdelight
below Leuchtfeuertisch producer: Lotos

designer: Hadi Teherani www.haditeherani.de

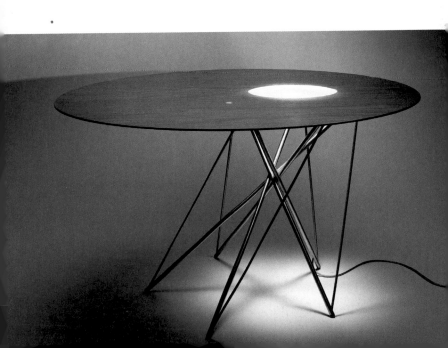

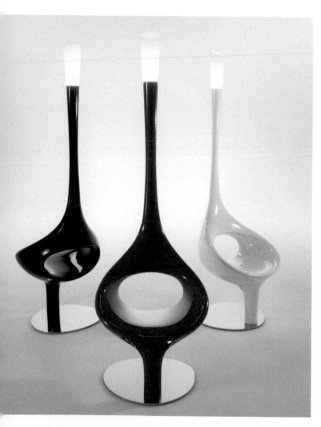

left Asana
designer:
Giorgio Gurioli
below Sama
opposite top Tat
opposite bottom
Shakti Sky
designer: Marzio
Rusconi Clerici

producer: Kundalini
www.kundalini.it

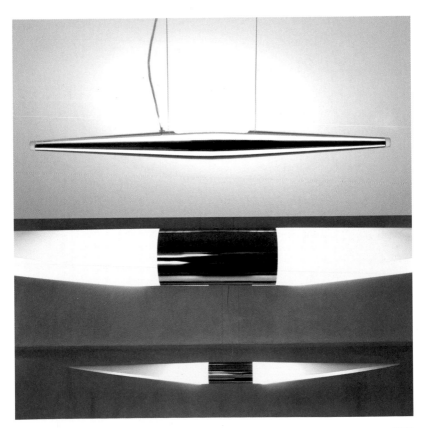

397

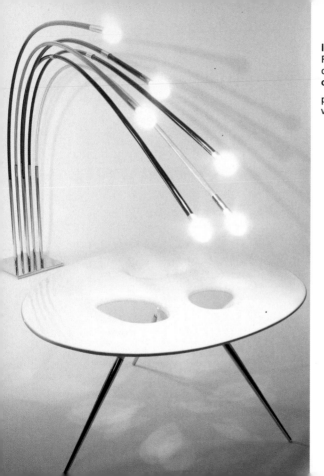

left and opposite right
Ray Bow
designer: Gregorio Spini
opposite left Ojas

producer: Kundalini
www.kundalini.it

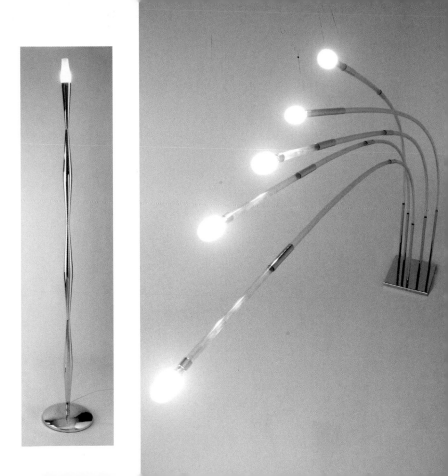

opposite Dolmen designer: Philippe Daney
right Tulipe designer: Pascal Mourgue
below Eol designer: Thibault Desombre
producer: Roset Möbel GmbH www.ligne-roset.de

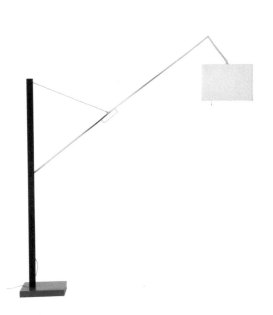

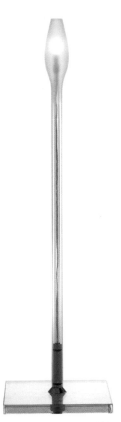

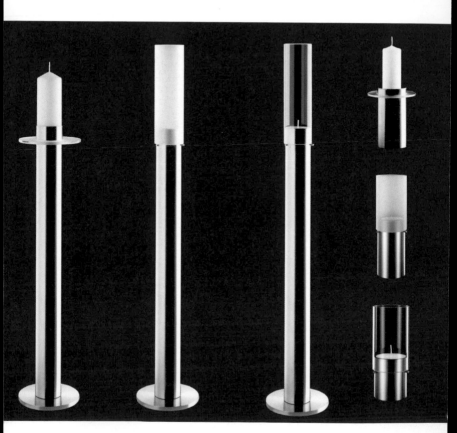

402

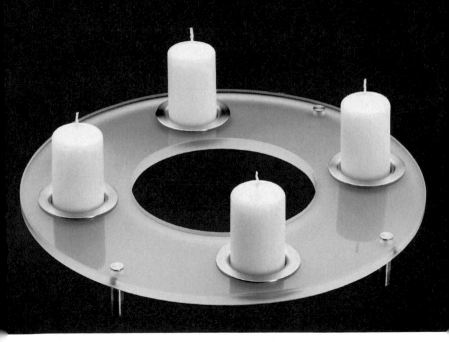

Tabula Nova producer: Carl Mertens
designer: MM Design Edition
www.carl-mertens.com
www.mmdesignedition.de

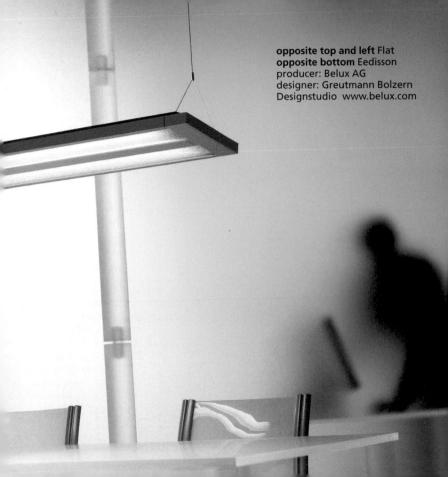

opposite top and left Flat
opposite bottom Eedisson
producer: Belux AG
designer: Greutmann Bolzern
Designstudio www.belux.com

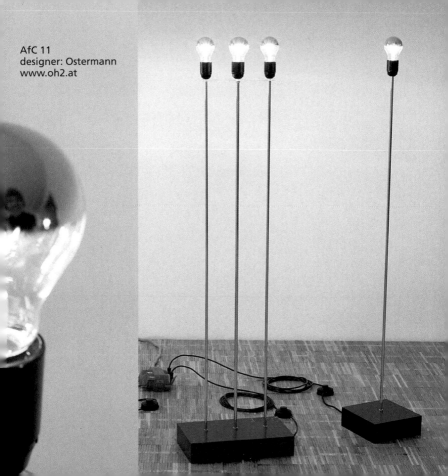

AfC 11
designer: Ostermann
www.oh2.at

opposite Ambience
producer: Aguadé Cerámica
right Candle on a String
producer: Present Time B.V.

designer: Sol.Design
www.sol-design.net

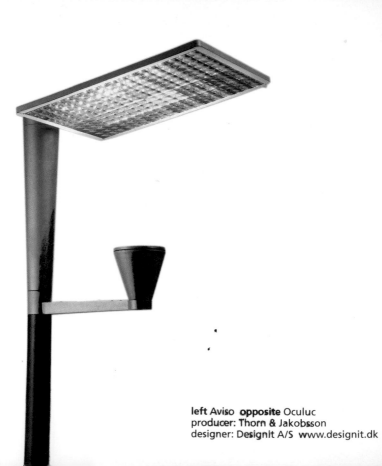

left Aviso **opposite** Oculuc
producer: Thorn & Jakobsson
designer: Designit A/S www.designit.dk

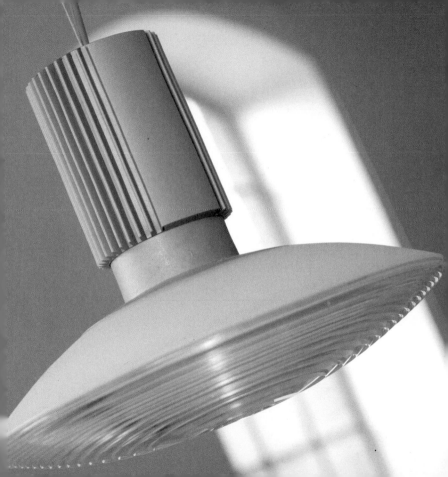

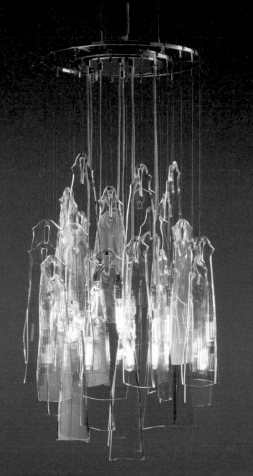

left La Fenice
producer: El Schmid
designer:
Lambert GmbH
www.lambert-home.de
opposite Shiny Tara
producer: Ellips
www.ellips.de

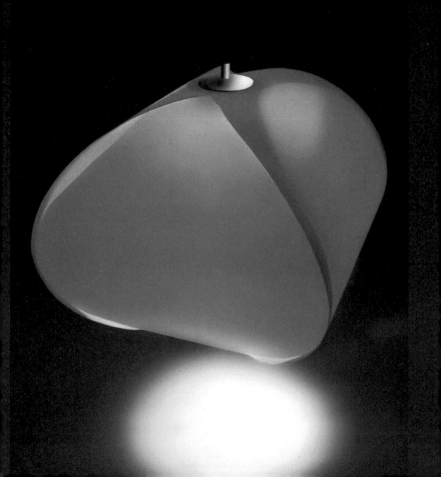

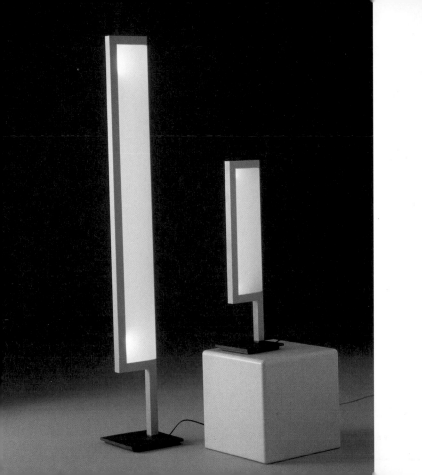

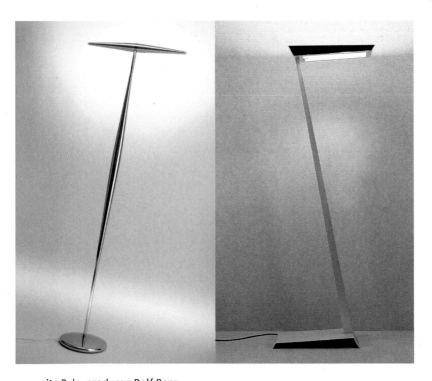

opposite Palo producer: Rolf Benz
designer: Rolf Benz & Joachim Nees www.rolf-benz.de
above left Tat producer: Kundalini www.kundalini.it
above right Balance producer: Spectral designer: Hadi Teherani www.haditeherani.de

Muebles para la oficina

Si retrocedemos en la historia, podremos observar que han existido numerosos conceptos en el diseño de las oficinas. Desde la India, donde el trabajador simplemente se sentaba en la calle y colocaba delante de él un cartel con la palabra «gerente» en su interior, hasta los despachos que todos conocemos de las películas de Hollywood: infinitas mesas y filas de sillas con mujeres tecleando diligentemente (el «secretario» se había

In historical terms – taking into account differences in societal development – there have already been many concepts for office design. This extends from the Indian who simply sits by the side of the road displaying a signboard with 'Manager' inscribed on it to the type of office we know mainly from Hollywood movies: row upon row of desks and chairs occupied by industriously typing ladies (by this time the

Office furniture

convertido ya en un mueble y su profesión era desempeñada ahora por las mujeres). Después llegaron los despachos pequeños, más tarde los situados en grandes espacios y, desde hace algún tiempo, gracias a las posibilidades que nos ofrece la tecnología digital, se habla de los despachos flexibles y de su diseño: unidades pequeñas y móviles instaladas sobre ruedas que pueden ser trasladadas al lugar donde se quiere o se debe trabajar.

El tema es muy complicado porque el trabajo, por lo menos el que se desarrolla en el despacho, sufre continuas redefiniciones y exige una enorme variedad en el diseño de los espacios y de los objetos. Además hay que tener en cuenta la especial relevancia del concepto de la «jerarquía plana» y de la organización personal del trabajo.

420

role of the male secretary had already been taken over by women). Then came cellular offices, then open-plan offices and for some time now —as a result of the opportunities offered by digitalization – there has been much talk of flexible offices even with designs for them – small mobile units on wheels which can be taken to wherever one wants or has to work.

This is of course a complex topic. Work, particularly office work, is currently subject to constant redefinition, which stimulates an enormous variety of designs for workspaces and equipment. In addition, issues raised by 'flatter hierarchies' and personal customization of work play a significant role.

En las páginas siguientes queda patente esta variedad porque no se trata simplemente del diseño de los muebles sino del trabajo en la oficina.

Quien trabaja ahí sabe hasta qué punto las mesas estimulan o dificultan la comunicación, o cuántas decisiones no han podido tomarse por culpa de una silla coja, o cuanta rabia o alegría pueden despertar algunos aparatos en las personas. Solo una atenta mirada descubre estas pequeñas pero decisivas diferencias y su significado.

This diversity will become clear on the following pages, which deal not only with furniture, but the design of office work itself.

Those who work in this environment know how much a table can help or hinder communication, how many decisions may not have been taken because of a wobbly chair, and how much human rage or enthusiasm some machines can provoke. It is only on close examination that the significance of such fine but crucial distinctions is revealed.

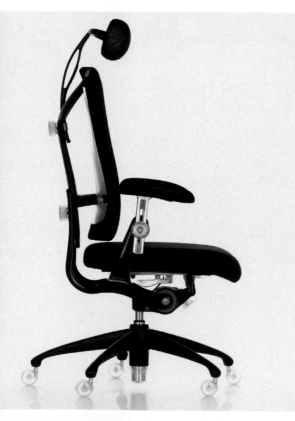

left Ypsilon
producer:
Vitra International AG,
Germany
designer:
Mario & Claudio Bellini
photographer:
Hans Hansen
www.atelierbellini.com
opposite Scriba
producer: Ycami, Italy
designer: Claudio Bellini
photographer:
Francesca Ripamonti
www.atelierbellini.com

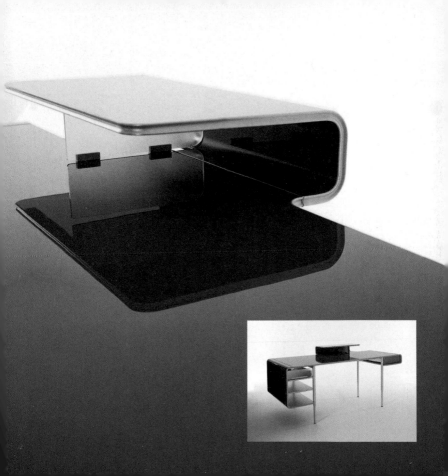

right Podio
producer: Haworth, USA
photographer: Andrea Zani
below TW Collection
producer: Frezza S.p.A., Italy
photographer: Fausto Trevisan

designer: Claudio Bellini
www.atelierbellini.com

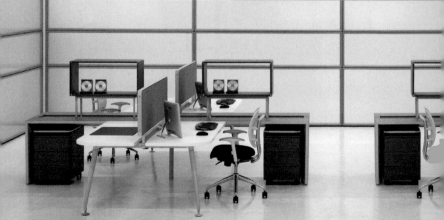

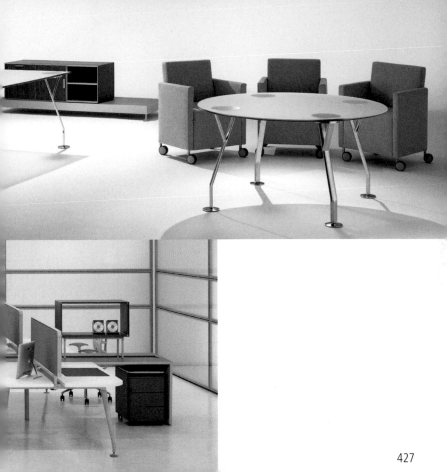

427

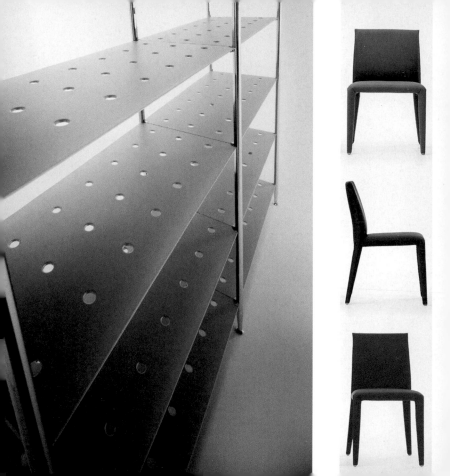

opposite left Air producer: Caimi Brevetti S.p.A., Italy
designer: Mario & Claudio Bellini photographer: Stefan Barzaghi – Interno 20
opposite right Vol Au Vent producer: B&B Italia S.p.A., Italy
designer: Mario Bellini photographer: Fabrizio Bergamo
below TW Collection producer: Frezza S.p.A., Italy
designer: Claudio Bellini photographer: Fausto Trevisan

www.atelierbellini.com

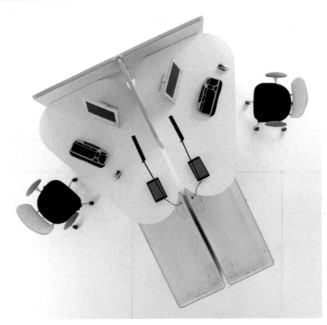

429

above Rotor producer: Boffi **below** Bantam producer: Boffi **opposite** Suede
designer: Beat Karrer www.beatkarrer.net

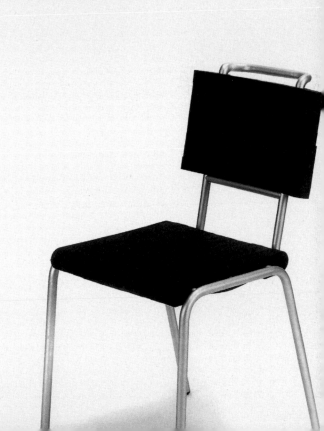

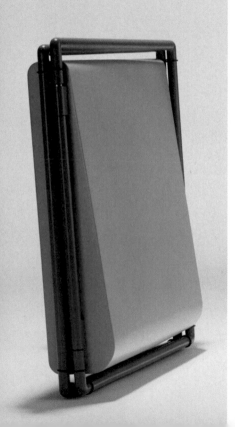

Take Away
designer: Beat Karrer
www.beatkarrer.net

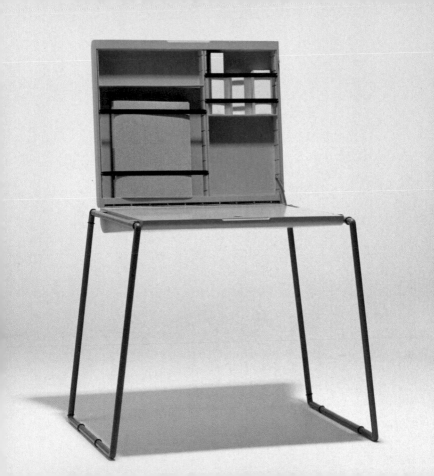

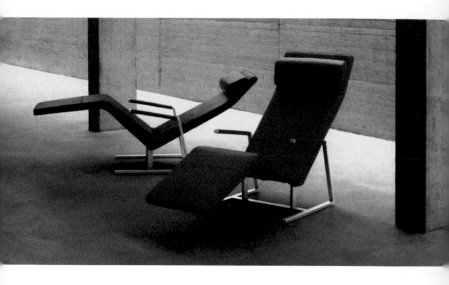

above Marchand Relax producer: Wellis AG photographer: Felix Streuli
www.teambywellis.com
opposite Happening producer: Steelcase, France photographer: Frank Tielemans

designer: Christophe Marchand www.christophemarchand.ch

434

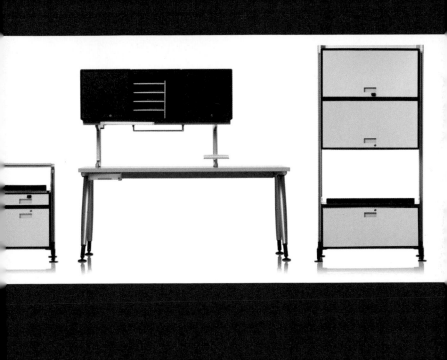

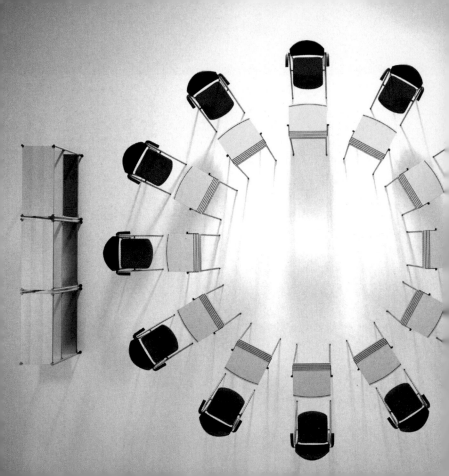

left Seminario
right Salto
bottom right Cambio

producer: Drabert GmbH
designer: Daniel Figueroa
www.drabert.de

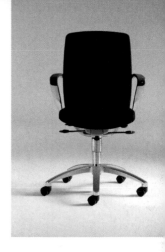

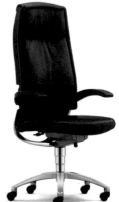

above Mio designer: Daniel Figueroa
opposite Tosila designer: Drabert & Büro Staubach

producer: Drabert GmbH www.drabert.de

438

above and left Visius
designer: eckedesign
www.eckedesign.de
opposite YoYo coffee table
producer: Moroso, Italy
designer: Jakob Wagner design
www.moroso.it www.jakobwagner.de

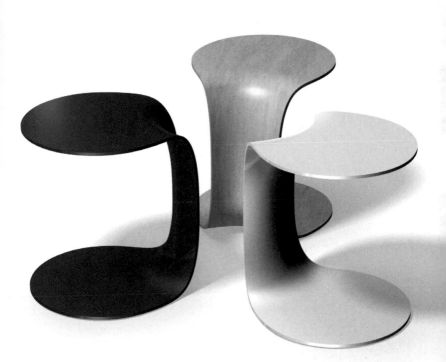

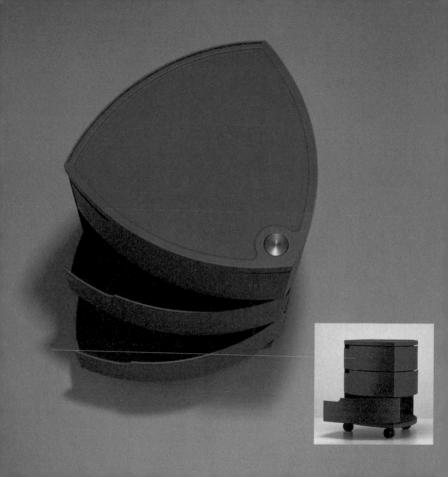

opposite and below G02 producer: Sitag designer: Greutmann Bolzern Designstudio
photographer: Hannes Eisenhut www.sitag.com

443

D3 producer: Denz & Co AG designer: Greutmann Bolzern Designstudio
photographer: Michel Comte www.denz.ch

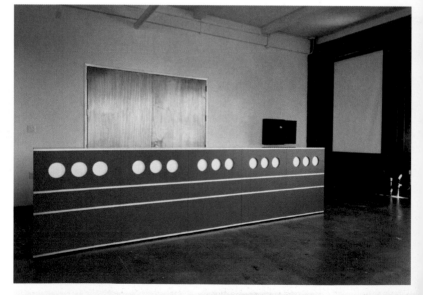

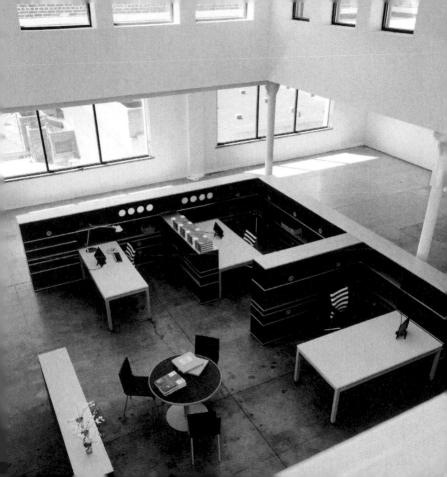

Office and Service Car
producer: Helit
designer: F.A. Porsche
www.helit.de

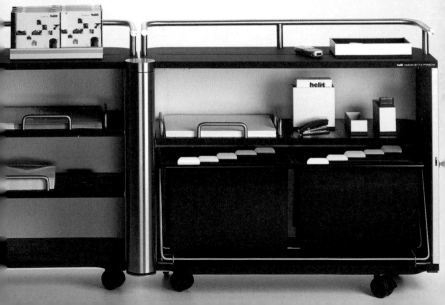

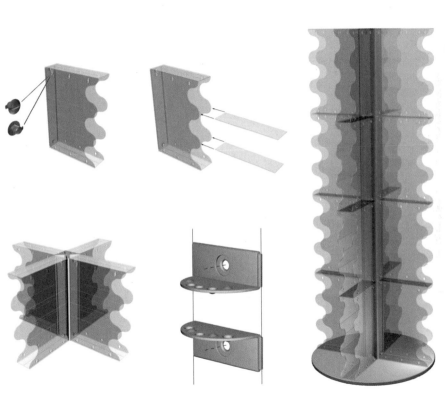

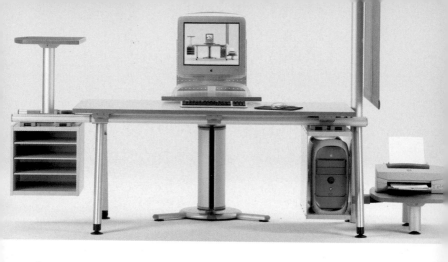

above P.O.S. **below and opposite top right** P.O.S. elegance
producer: Dyes/Haworth designer: Dyes Entwicklungszentrum & Danial Korb
photographer: Lutwin Johannes www.dyes.de

above left in_two designer: Danial Korb photographer: Guido Kaspar
below m_pro_II designer: Team Form AG photographer: Patrick Zier

producer: Art.collection/Haworth www.artcollection.de

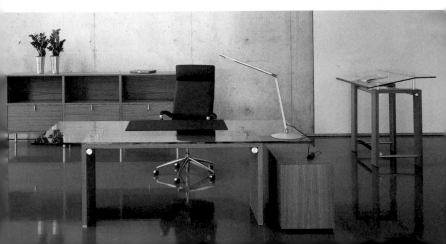

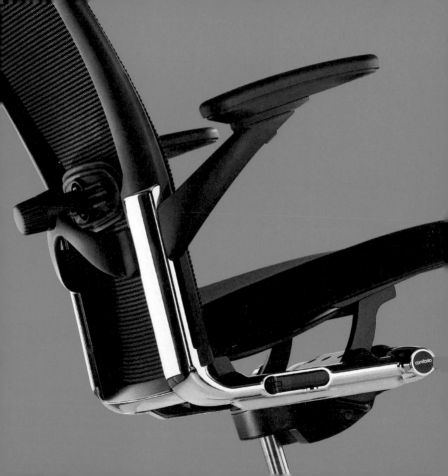

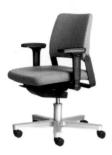

opposite X99
bottom left X88

producer: Comforto/Haworth
designer: ITO Design
photographer:
Rosche Fotostudios
www.comforto.de

top left and middle Rookie
designer: Röder Designteam
right Support
designer: Kerstin Erlenkamp,
Stefan Thielecke,
Röder Designteam

producer: Röder/Haworth
photographer: Bodo Butz
www.roederstuehle.de

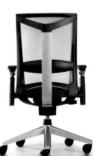

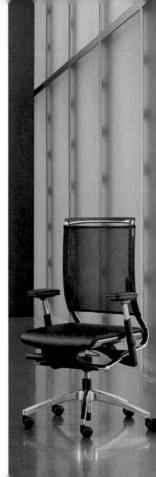

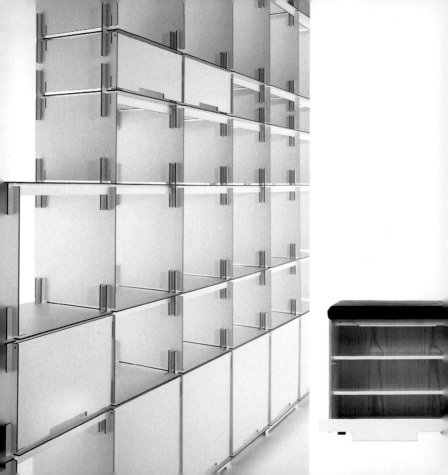

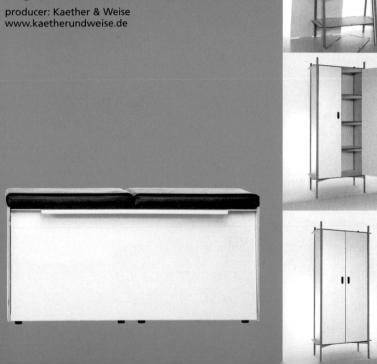

opposite left platten_bau
designer: Florian Petri
below and opposite bottom box_it
designer: Michael Koenig
right build_and_fill
designer: Thorsten Franck

producer: Kaether & Weise
www.kaetherundweise.de

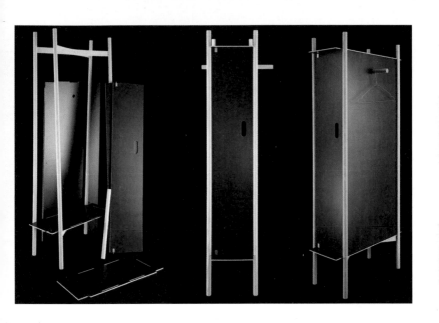

opposite build_and_file **above** lock_away
producer: Kaether & Weise www.kaetherundweise.de

left Think Tank
opposite top Ingwer
opposite bottom
Bubbles

designer: Ostermann
www.oh2.at

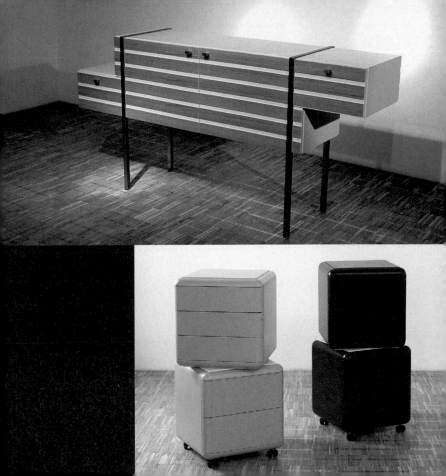

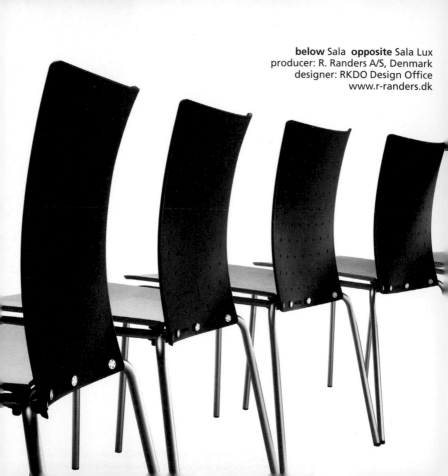

below Sala **opposite** Sala Lux
producer: R. Randers A/S, Denmark
designer: RKDO Design Office
www.r-randers.dk

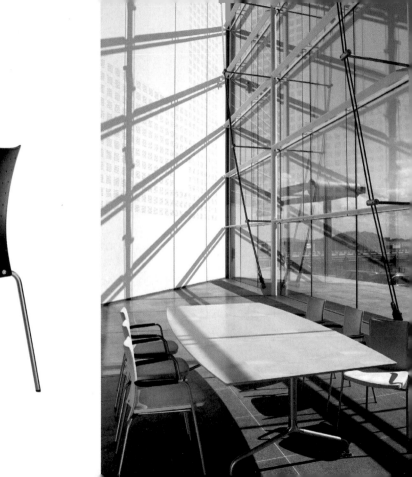

463

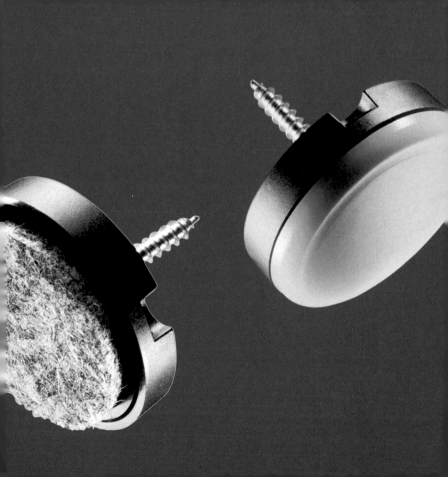

opposite QuickClick **above** Rolly
top right Ro 73 **right** Roller-Mini

producer: Wagner System GmbH
designer: Roland Wagner
photographer: Ralf Heidenreich
www.wagner-system.de

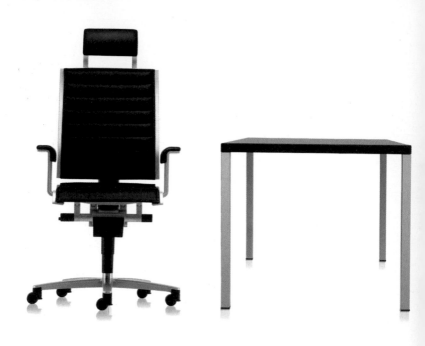

above left Solis F designer: Design Wiege
above right and opposite DinA designer: Udo Schill & Timo Küchler

producer: Wilkhahn www.wilkhahn.com

466

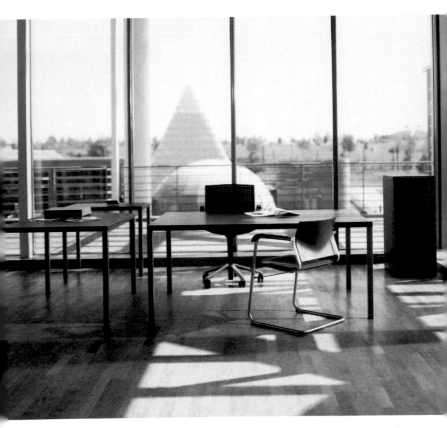

467

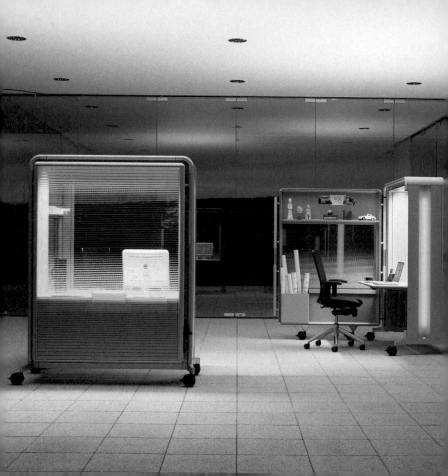

opposite St@ndby-Office producer: König & Neurath
below Silver producer: Interstuhl

designer: Hadi Teherani www.haditeherani.de

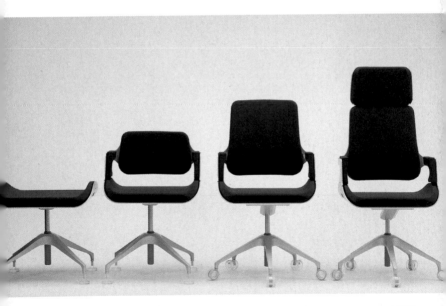

469

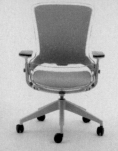

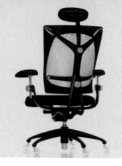

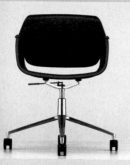

top left PAC (ProActivChair) producer: ICF, Italy
designer: C. Marchand photographer: E. Prandini
www.icfspa.it www.christophemarchand.ch
above Ypsilon producer: Vitra International AG, Germany
designer: Mario & Claudio Bellini
photographer: Hans Hansen www.atelierbellini.com
left G02 producer: Sitag
designer: Greutmann Bolzern Designstudio
photographer: Hannes Eisenhut www.sitag.com
below (left to right) Zara producer: R. Randers A/S
designer: Thore Lassen & Søren Nielsen MDD
www.r-randers.dk

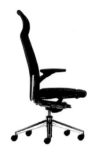

left X99 producer: Comforto/Haworth
designer: ITO Design photographer: Rosche Fotostudios
www.comforto.de
middle (left to right) Rookie producer: Röder / Haworth
designer: Röder Designteam photographer: Bodo Butz
www.roederstuehle.de
bottom left Signo producer: Wilkhahn
designer: Werner Sauer www.wilkhahn.com
bottom right Collection Z producer: Martin Stoll
designer: NOA www.noa.de

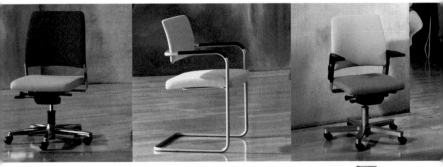

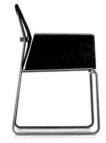

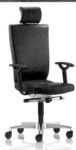

Medios de comunicación y entretenimiento

Antiguamente muchos de los procesos creadores estaban determinados por razones concretas que definían la apariencia de las cosas. Para una máquina de escribir, por ejemplo, sólo existía un margen de libertad limitado porque en ella debían caber las enormes teclas y la palanca y era necesario tener en cuenta las grandes manos masculinas. Por lo tanto su volumen y sus funciones estaban preestablecidas. Lo mismo sucedía con el teléfono,

In earlier times there was a clear logic to many design processes, that is to say, obvious reasons why an object had to look as it did. In the case of the typewriter, for example, there was only a limited amount of creative scope, mainly because the type and type-levers, intrinsically substantial materials, had to be accommodated, and allowances had to be made for the size of the human hand. Thus both size and functionality were fixed. This

Media
and entertainment

con la radio de tubos o con los objetos similares. Las grandes piezas que componían su interior tenían que tener un orden concreto y estar alojadas de una forma práctica. Hoy en día, sin embargo, las piezas son diminutos chips que harían posible la fabricación de un teléfono del tamaño de una uña.

La electrónica y la digitalización han supuesto un cambio radical para el diseño: Ahora el teléfono se diseña a partir de la percepción y de la utilidad del ser humano (y no de la máquina) y el diseño puede alejarse de las exigencias del volumen para desarrollar nuevos significados y funciones.

Esto puede inducir a creer que todo es posible: cualquier forma, cualquier extravagancia y cualquier función. Pero estas nuevas ideas tienen que ser primeramente elaboradas porque a pesar de que a los técnicos electrónicos

476

was also the case with telephones, valve radios and the like. All of their often bulky internal components had to be precisely arranged and appropriately packaged. Today, however, these functional components are tiny chips, and it is technically possible to build a telephone the size of a thumbnail.

The world of design has been completely transformed by electronics and digitalization. Telephone design is now based on such human factors as recognizability and manageability (and no longer on mechanical necessity) – and design itself must now create content for no longer strictly necessary size by developing new meanings and functions.

This, however, makes anything seem feasible: any shape you like, any non-sense and any conceivable function. However, all these options must still

se les pueden ocurrir múltiples proyectos realizables, a menudo existe una carencia de contenido razonable o, por lo menos, plausible. Aquí reside la tarea del diseño: definir contenidos y funcionalidades, establecer una disposición razonable de las teclas, crear pantallas legibles, carcasas adecuadas e instrucciones de uso y manuales de fácil comprensión.

Quizá debamos recordar de vez en cuando que el significado de «informar» es dar forma a algo o formar a alguien.

be designed, and although electronics experts have come up with a wide range of technical possibilities, these often lack reasonable or even plausible form. Here then, design takes on yet another task: to design substance as well as physical features, for example sensible arrangements of keys, readable monitors, appropriate casing and understandable operating instructions and manuals. From time to time it is worth remembering that the word 'information' can also imply forming or shaping a person or object.

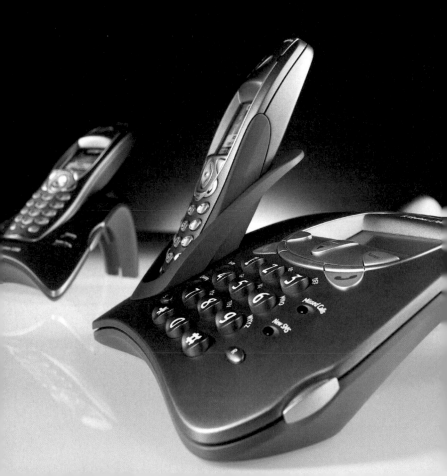

opposite
BT EQUINOX 1300
producer: BT
right
BT EQUINOX 1200
producer: BT
bottom InTune 200 –
Globaltuner Portable
Internet Audio Player

designer: Alloy
www.thealloy.com

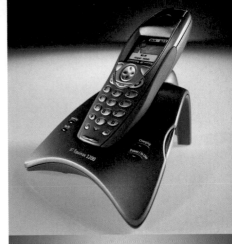

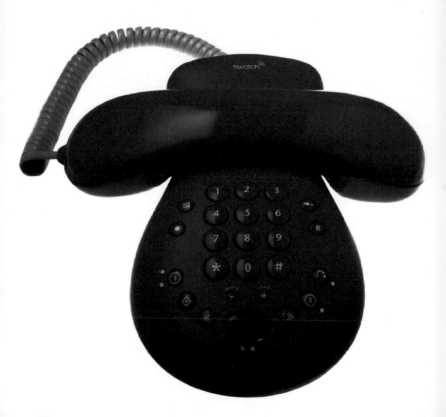

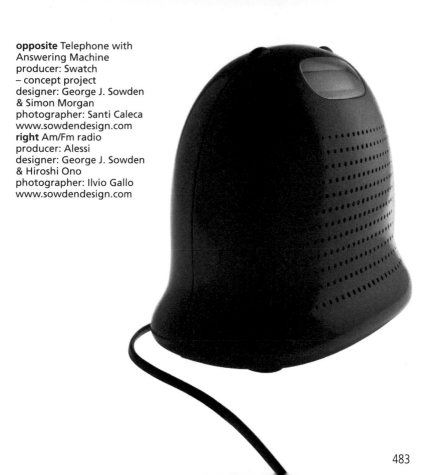

opposite Telephone with
Answering Machine
producer: Swatch
– concept project
designer: George J. Sowden
& Simon Morgan
photographer: Santi Caleca
www.sowdendesign.com
right Am/Fm radio
producer: Alessi
designer: George J. Sowden
& Hiroshi Ono
photographer: Ilvio Gallo
www.sowdendesign.com

483

left and above Elektrogabi
producer: Hitachi Europe GmbH
designer: Designschneider
www.designschneider.de
opposite Dect III
producer: Tele 2 AB, Sweden
designer: Claudio Bellini
photographer: Naohiko Mitsui
www.atelierbellini.com

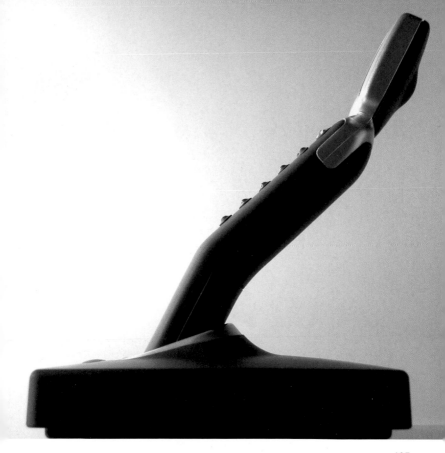

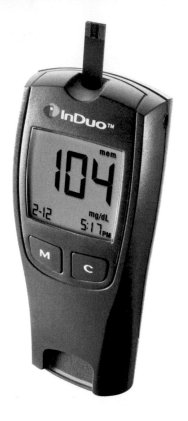
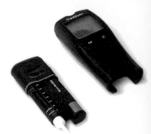

left and above Combined
Blood Glucose Monitoring
and Insulin Dosing System
producer: Novo Nordisk, DK
opposite ISDN telephone
producer: Bang & Olufsen

designer: Designit
www.designit.com

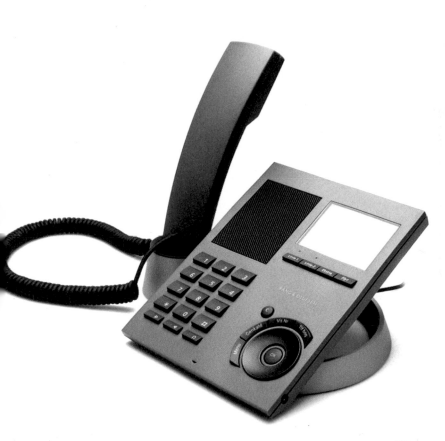

487

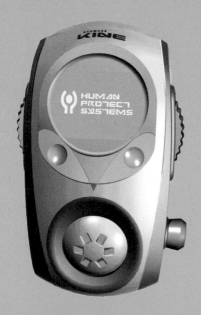
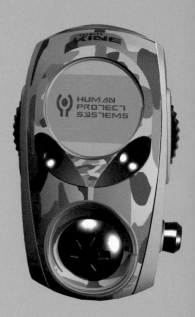

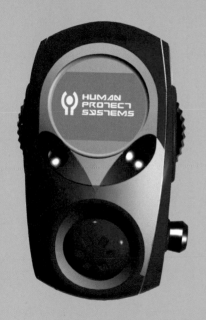

KINE (Kids Network)
designer:
Dennis Stratmann,
Martin Heck
photographer:
pixel44_designerservices
www.pixel44.de

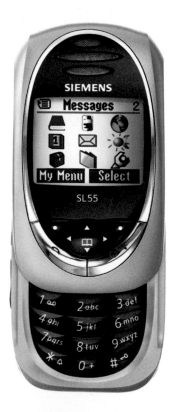
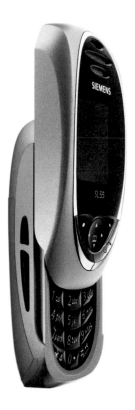

490

opposite SL 55 producer: Siemens **below** Xelibri 1 producer: Xelibri Siemens
designer: Designafairs www.designafairs.com

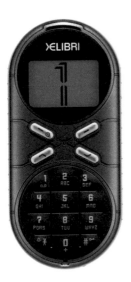 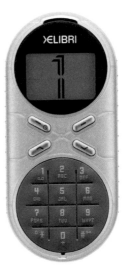

491

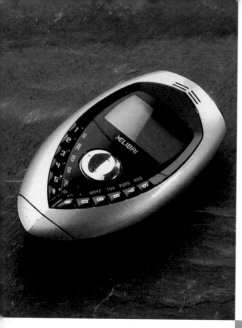

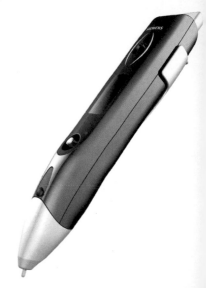

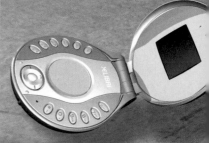

above 4 – GSM Mobile Phone
producer: Xelibri Siemens
top right Pen Phone producer: Siemens
right 63 – GSM Mobile Phone
producer: Xelibri Siemens
opposite 3 – GSM Mobile Phone
producer: Xelibri Siemens

designer: B/F Industrial Design
www.bf-design.de

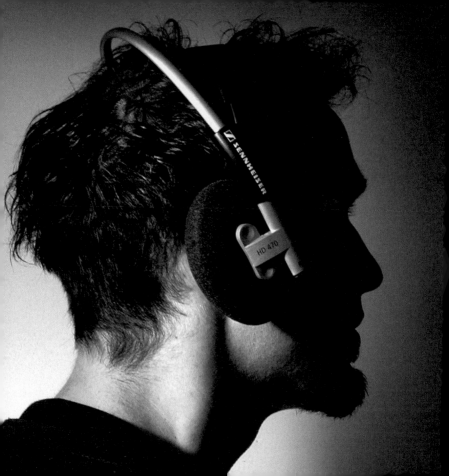

opposite HD 470 producer: Sennheiser **below** Frenco Measurement
designer: B/F Industrial Design www.bf-design.de

left AmiNET – Low-Cost
Ethernet Set Top Box for Use
in Networked Environments
designer:
Amino-Communications
www.aminocom.com
opposite Cybercompanion –
Augmented Reality Device
for Working in Outer Space
producer: accavia GmbH
designer: i/i/d Institut
für Integriertes Design,
Bremen – Prof. D. Rahe,
R. Hamadmad, F. Lieser
www.accavia.de

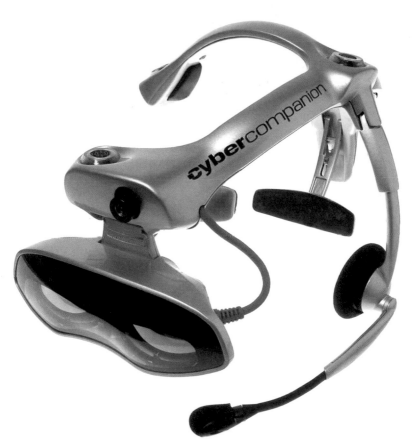

497

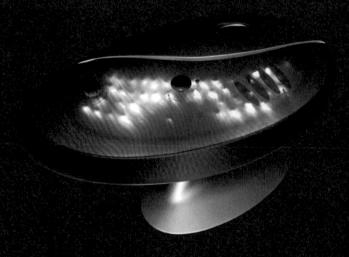

Personal Pond producer: Toyota/Lexus designer: ECCO Design www.eccoid.com

498

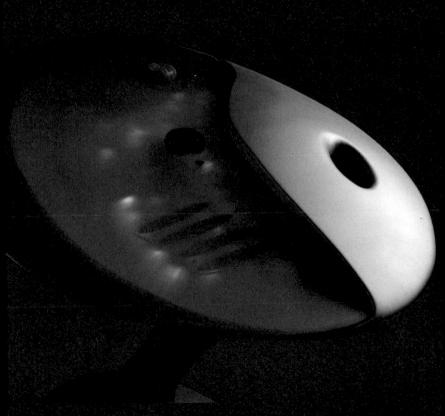

agent
menu

bioscan
health

bioscan
health

bodytemperature
health

camera
menu

112
emergency
msnu

04 THU
19'48'09
menu

foncall
charles

charles
telefonbook

500

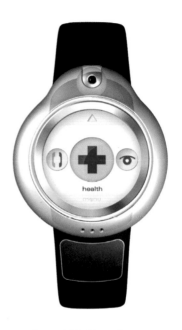

opposite and left Menu Buttons – can be managed intuitively as the Menu Items are displayed like Beads on a Necklace
above Minder – Bracelet-like Part of the Mobile Health and Communication Unit

designer: Michael Schmidt, Dirk Bolduan
www.code2design.de

501

above Interchanger – Module of Best Ager
Mobile Health and Communication Unit
right Chatpen producer: Sony-Ericson

designer: Michael Schmidt, Dirk Bolduan
www.code2design.de

502

Liebste Hanna,
wie geht es Dir. Im Augenblick bin ich am Luganer See und
genieße die herrliche Aussicht auf den See un

LIEBSTE HANNA,
WIE GEHT ES DIR. IM
AUGENBLICK BIN ICH
AM LUGANER SEE
UND GENIESSE DIE
HERRLICHE AUSSICHT
AUF DEN SEE UN

below Virgin Pulse Personal CD Player
right Virgin Pulse Cordless Phone/Answering Machine
opposite Virgin Pulse TVDVD Player

producer: Virgin, USA
designer: ECCO Design
www.eccoid.com

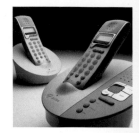

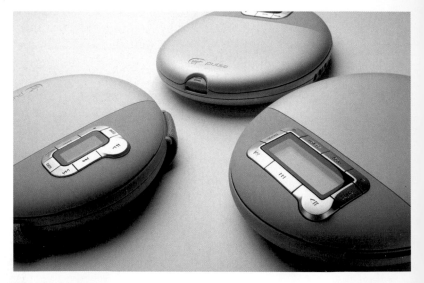

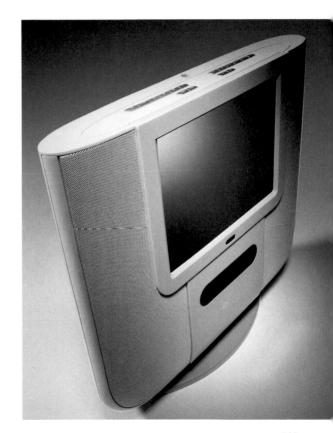

505

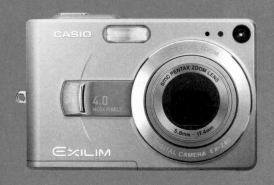

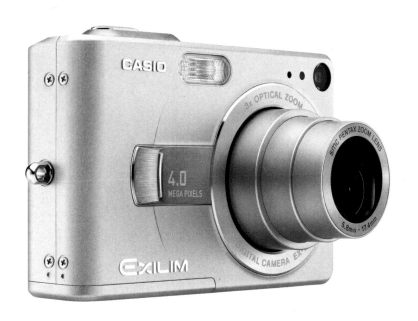

Exilim EX-Z40 producer: Casio www.exilim.com

509

top left Exilim – EX-P600 /
producer: Casio www.exilim.com
above Exilim – EX-Z40
producer: Casio www.exilim.com
left Casio QV-R51 producer: Casio
www.casio-europe.com
opposite LCD TV Tharus
producer: Grundig
designer: Alexander Neumeister
photographer: Michael Braune
www.neumeister-partner.de

512

above and opposite bottom left Spheros 37 HD
opposite bottom middle Articos 55 HD
opposite bottom right Xelos SL 20

producer: Loewe AG designer: Phoenix Design www.loewe.de

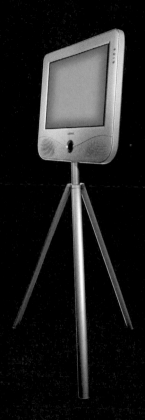

Mimo 15
producer: Loewe AG
designer: Phoenix Design
www.loewe.de

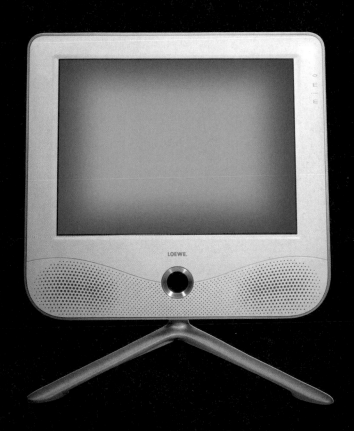

LOEWE.

515

left and below Headset
producer: Logitech
opposite Cintiq
producer: Wacom

designer: Ziba design
www.ziba-europe.com

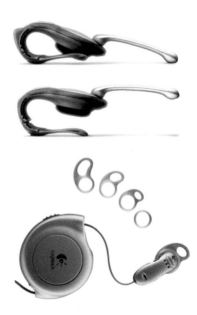

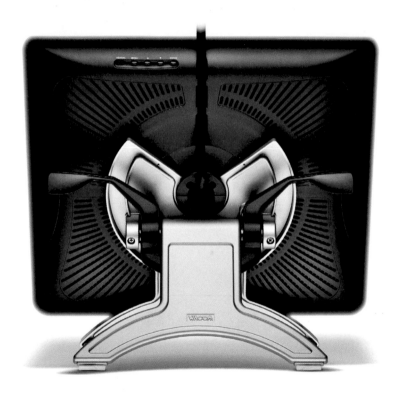

517

left Data Bank – Digital Databank
producer: LaCie Group S.A., France
below Desktop Computer,
LCD-Monitor and Notebook
producer: VPR Matrix, USA

designer: Porsche Design
www.porsche-design.at

521

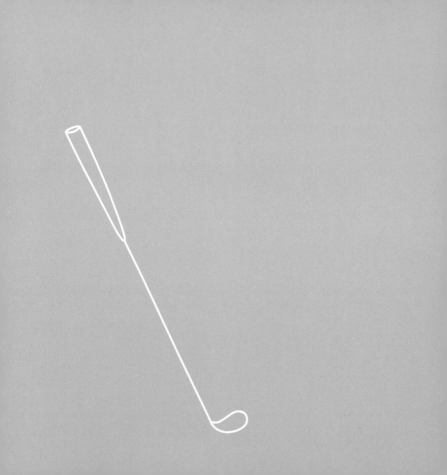

Deporte, ‹Hobby›

¿Saben los escaladores hasta qué punto el diseño les está ayudando a alcanzar la cima? ¿Y son conscientes los ciclistas que están corriendo sobre ideas desarrolladas por el diseño? Incluso el fútbol oficial está diseñado.

Es especialmente en los populares ámbitos del deporte, del entreteni-miento y de las actividades de tiempo libre donde encontramos a un gran

Are mountaineers aware of just how much design helps them scale the summits, or cyclists conscious that they are tearing along on design concepts? Even the official football is specially designed! Particularly in the highly popular sport, hobby and leisure activity sectors, there are countless numbers of designers eager to collaborate with manufacturers and engineers to develop new sports and games, along with all

Sports and hobbies

número de diseñadores que desarrollan una frenética actividad y que, además de descubrir nuevos juegos y tipos de deportes con el apoyo de las empresas y los ingenieros, crean todos los medios necesarios para convertirlos en realidad. La variedad es infinita y abarca desde la máquina para el jardín hasta el juguete, o desde la taladradora hasta el más moderno monopatín.

Aquí el reto para el diseño no consiste solamente en dotar a estos objetos de una apariencia atractiva o adecuada, o en aumentar el valor del juego o del tiempo libre; además tiene que garantizar y mostrar su seguridad.

Como en los demás campos del diseño, aquí es también es necesario, por un lado, realizar estudios exactos sobre los materiales, las propiedades y

the equipment needed to play them. There are no limits to diversity here, from garden tools through toys to power drills and, of course, the latest model of the ever-popular skateboard.

Along with the tasks of designing an attractive or even a merely acceptable appearance for these objects and enhancing the value of play and leisure, design has a very specific challenge to highlight and guarantee safety.

As in all other fields of design, this demands close study not only of materials, their capabilities and production potential, but also of all the economic implications of costs, the market and so on. There must also be a great deal of functional testing, above all in the areas of durability,

527

las posibilidades de fabricación, y, por otro, dar respuesta a las cuestiones económicas sobre el mercado, los costes, etc. Además tienen que realizarse numerosas pruebas para comprobar la seguridad, la resistencia y la rápida comprensión de todas las funciones en caso de peligro. La precisión en el diseño es algo imprescindible. Y lo mismo sucede con el juguete porque a nadie le gustaría que, en mitad del juego, éste dejara de funcionar.

safety and rapid comprehension of all functions, particularly in potentially dangerous situations.

Precision in design is indispensable. In addition — and in a slightly different sense — this also applies to the games that we all so often play: after all, who wants to find out when they are already halfway through a game that it doesn't work?

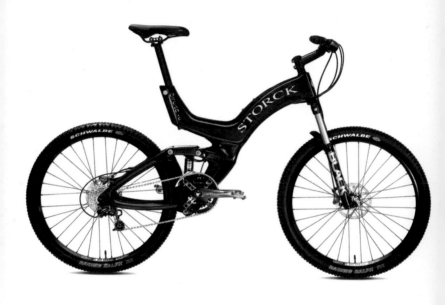

above Organic **opposite** Carbonbar – Ergonomic Carbonbar
producer: Storck Bicycle designer: Markus Storck
photographer: Thomas Hahn www.storck-bicycle.de

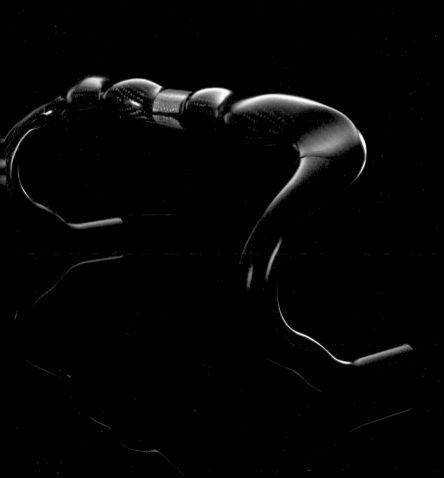

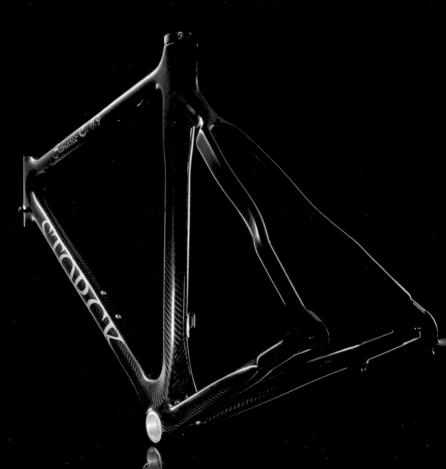

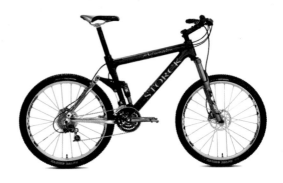

opposite Scenario C 0.9 – Ultra Light Carbon Frame
above Adrenalin Carbon **below** Scenario C 1.1

producer: Storck Bicycle designer: Markus Storck
photographer: Thomas Hahn www.storck-bicycle.de

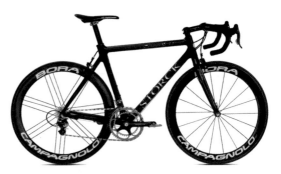

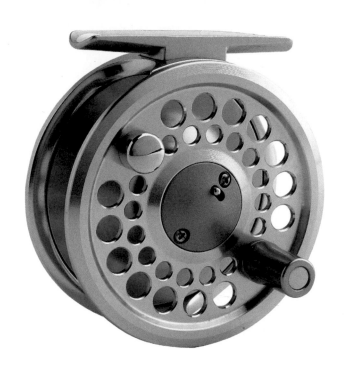

above Ultegra **opposite** Stella FW producer: Shimano www.shimano.com

534

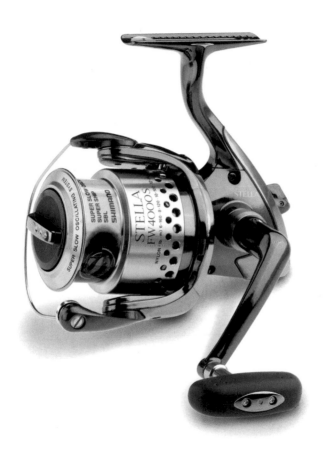

535

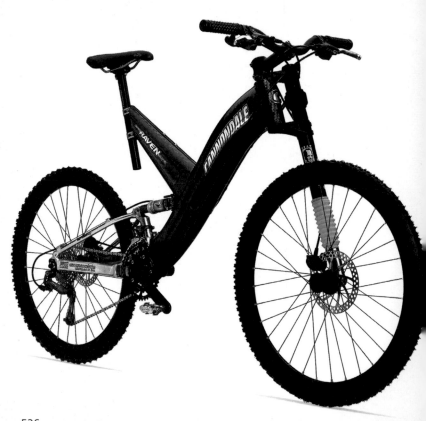

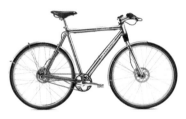

opposite ORaven40000SXNEW
top, above and right
Gemini, Street Rohoff, Volefty

producer: Cannondale
designer: Javier Alberich
www.cannondale.com

FELT – Freeride
Mountainbike
producer:
FELT GmbH
designer:
Dennis Stratmann
photographer:
Daniel Geiger
www.pixel44.de
www.danielgeiger.net

539

below, opposite bottom and opposite top left Faltrad top
opposite top middle Tandem **opposite top right** Tourenrad

producer: Bernds designer: Thomas Bernds
photographer: Stephan Röcken/Patrick Pantze GmbH www.bernds.de

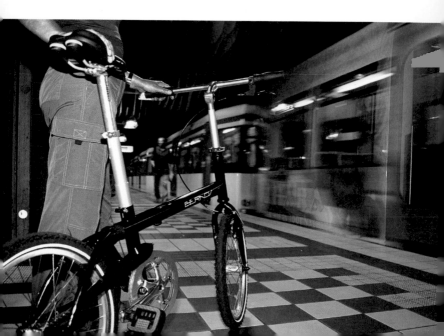

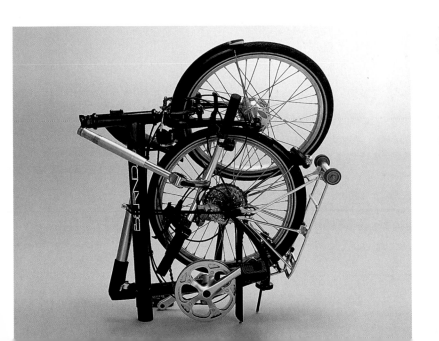

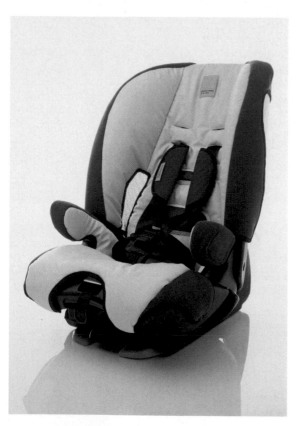

left
Children's Car Seat
producer:
Concord GmbH
designer:
KPG Design GmbH
photographer:
Ernesto Martens
www.kpg.de
opposite
Zampano. Human
Powered Vehicle
producer:
Tretauto GmbH
designer:
KPG Design GmbH,
Designmanuf.
H. Polenz, G.Kunz
photographer:
Peter Schumacher
www.kpg.de

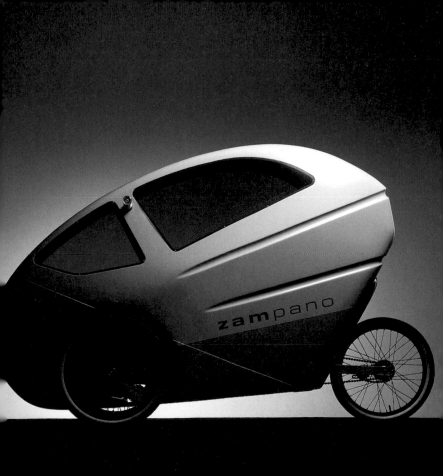

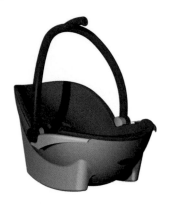

Lifesaver XL – Babys Bucket Seat
producer: Hauck GmbH & Co. KG, Sonnefeld
designer: Nexxon Design
www.nexxon-design.de

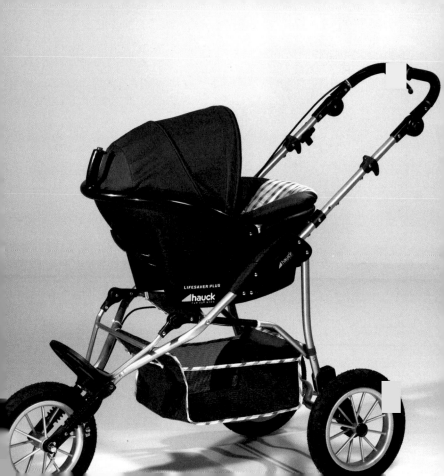

opposite Powerflower – The Water Dispenser producer: Koziol
designer: Reinhard Zetsche & Folker Königbauer
www.octopus-design.de www.designpartners.de
below Citywheeler designer: Michael Schmidt, Dirk Bolduan
www.code2design.de

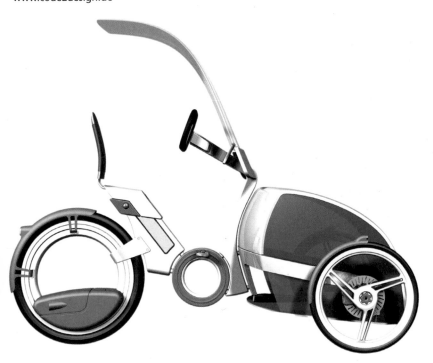

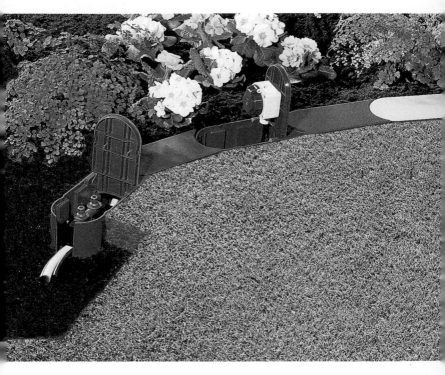

above Quinto – New Multi Functional Lawn-Edging System
opposite bottom Functional Unit With Water Tap/Illumination Light Unit/Spot Light Unit

producer & designer: Marley Deutschland GmbH www.marley.de

549

opposite left Laura – Outer Plant Pot **opposite right** Adonis – Outer Plant Pot
above Statement – Outer Plant Pot

producer: WIBO designer: Ottenwälder und Ottenwälder
photographer: Harald Reich www.ottenwaelder.de

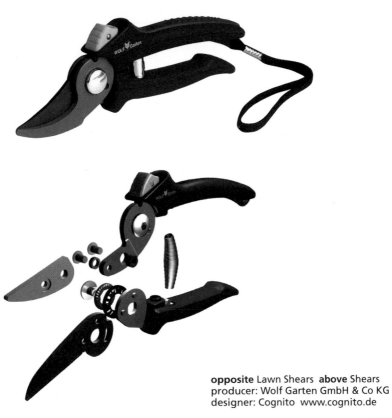

opposite Lawn Shears **above** Shears
producer: Wolf Garten GmbH & Co KG
designer: Cognito www.cognito.de

553

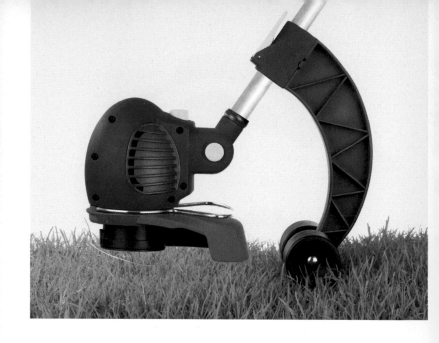

Lawn Mower producer: Wolf Garten GmbH & Co KG
designer: Cognito www.cognito.de

554

above Electric Hedge Dippers photographer: Wolfgang Seibt
opposite Electric Chainsaw photographer: Katana-Design

producer: Ikra Mogatec designer: Christoph Ludwig, Axel Karremann – Katana-Design
www.ikra.de

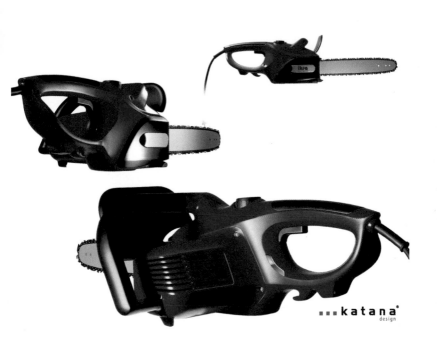

...katana°
design

557

above left Telescopic Transfer Shovel above middle Telescopic Digging Shovel
above right Telescopic Garden Fork below left and opposite Hedge Shears
below middle and right producer: Fiskars

producer: Fiskars designer: Olavi Lindén www.fiskars.com

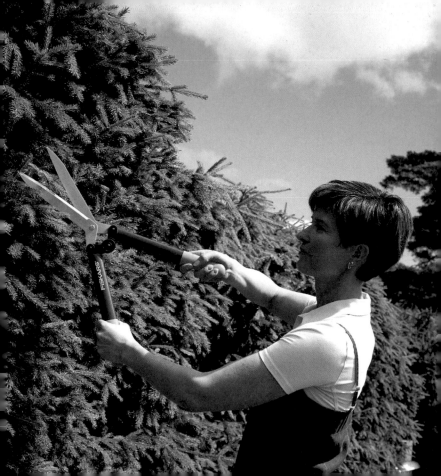

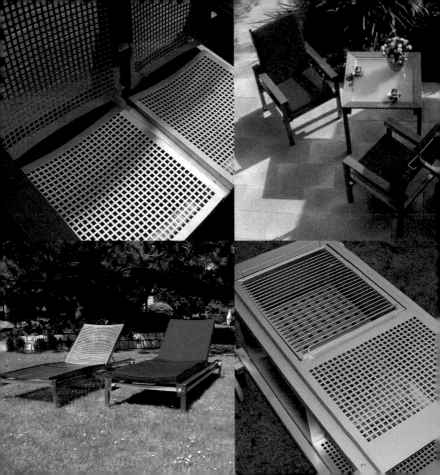

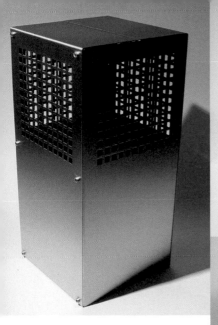

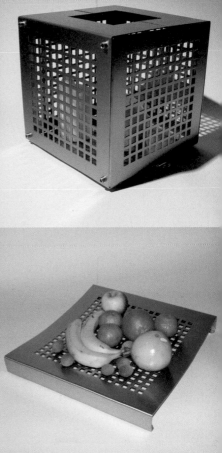

opposite
Garden Bench/Garden Table Glass/
Sun Lounge/Garden Barbecue
above and right
Ground Light Frame/Wind Protected
Candle Holder/Multifunctional Bowl

producer: Lifesteel
designer: Reinhard Schubert
www.lifesteel.de

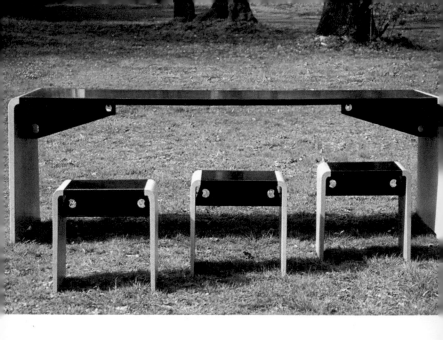

above Concrete – Outdoor Table and Stools
opposite Stool Family – Bar Furniture Family

producer: Soupculture designer: Soupculture
www.soupculture.de

562

563

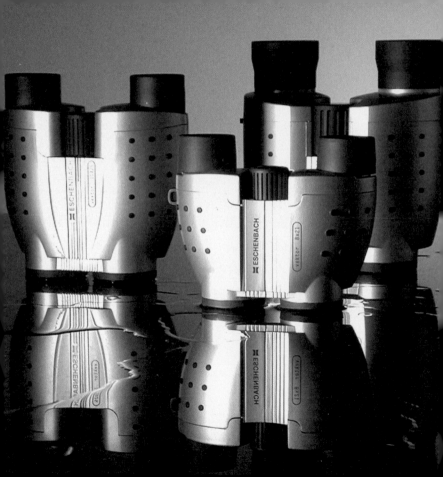

opposite Vektor producer: Eschenbach
designer: B/F Industrial Design www.bf-design.de
above r2 producer: VS Vereinigte Spezialmöbel
designer: rahe + rahe design photographer: VS www.rahedesign.de

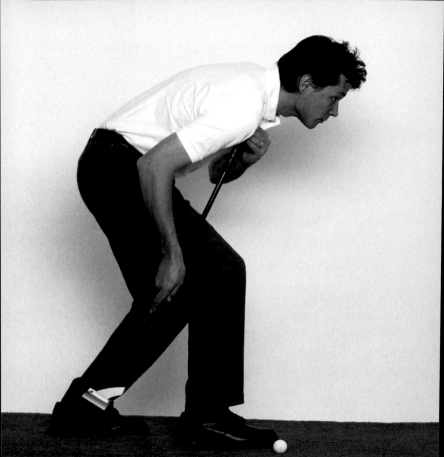

opposite and right
The One – Putter
producer: Scientific
Golfers AB
designer: Ergonomidesign,
David Crafoord
www.scientificgolfers.com
left Orca Strandbag –
Golfbag
producer: Concept Study
with KinBag AB
designer: Ergonomidesign,
Anna Carell
photographer:
Kent Johansson
bottom left Koenigsegg
CC 8 S – Perfor
producer: Koenigsegg AB
photographer: Jeffery Richt
www.koenigsegg.com

left and below Computer Darts – Product for Relaxation
designer: Rovero Adrien www.sailsboardsrotterdam.com

above and right Fingermax + Fingerbrush
producer: Fingermax GmbH
designer: Horst und Christine Just, büro für form
photographer: David Steets www.fingermax.de

opposite Ida **left** Love
middle Soccer/Tuna
bottom Crazy/Mouse

producer: Elefanten GmbH
designer: Werksdesign
www.elefanten.de

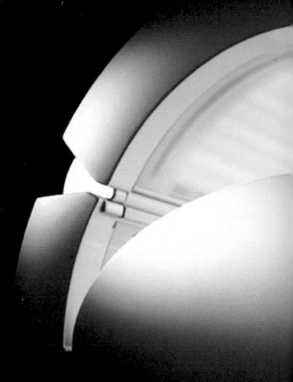

S-Class Tanning Bed
producer: uwe
designer: Ottenwälder
und Ottenwälder
photographer:
Vischer & Bernet
www.ottenwaelder.de

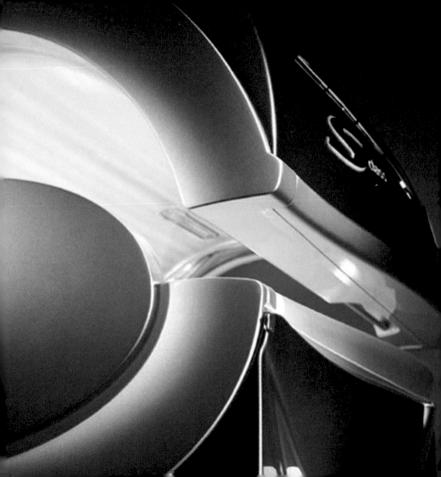

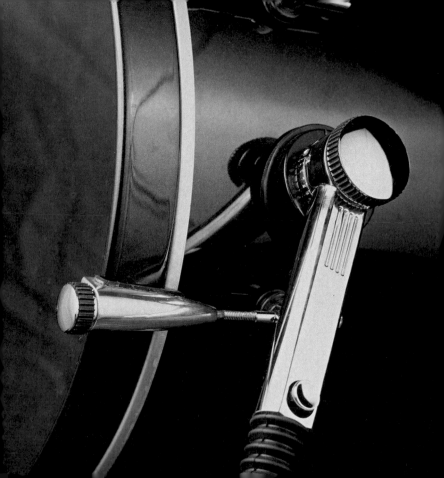

opposite Sonor Drum-Spitze **below** Sonor-Giant-Step-2
producer: Sonor designer: Plusdesign-project, Hubert Günther, Stefan Schreiber
www.plus-design.de

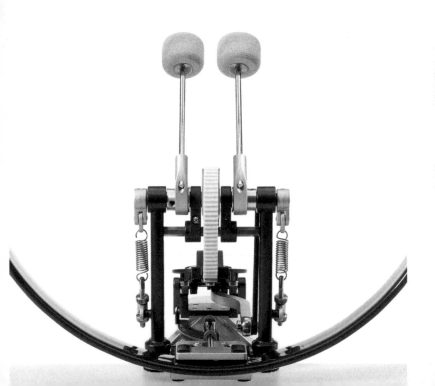

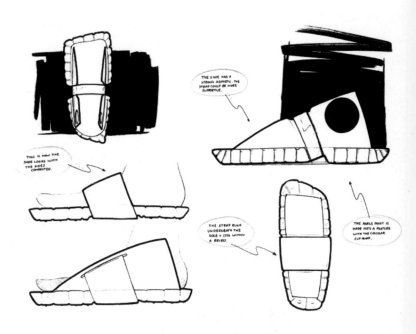

The shoe had a stronger aesthetic. The strap could be more supportive.

This is how the shoe looks with the sides combined.

The strap runs underneath the sole & sits within a recess.

The ankle point is made into a feature with the circular cut-away.

above Flat-Pack Shoe Sketches **opposite** Flat-Pack Shoe Prototype
designer: David Hickman www.davidhickmanuk@yahoo.com

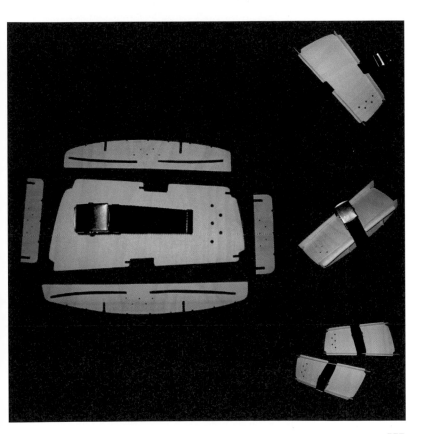

577

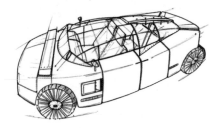

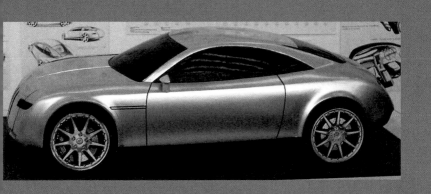

opposite left Concept Sketch – "Creating a Footwear/Vehicle Synergy"
designer: D. Hickman
opposite right Exterior Sketch for Jaguar
designer: David Hickman
above Group Project set out to Develop a Three Seat Jaguar Concept
designer: D. Hickman, S. Crawford, B. Bordone, J. Punter

www.davidhickmanuk@yahoo.com

Concept Sketch – Rear Engine, Single Seat Vehicle
designer: David Hickman www.davidhickmanuk@yahoo.com

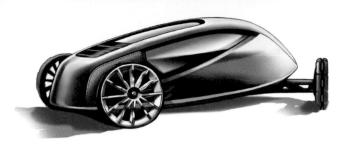

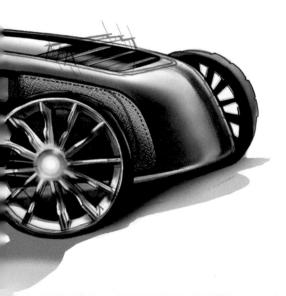

581

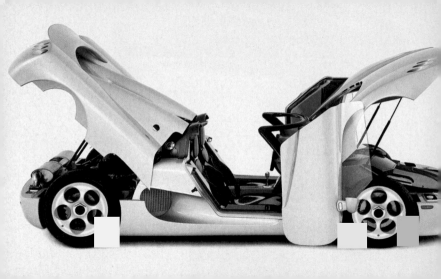

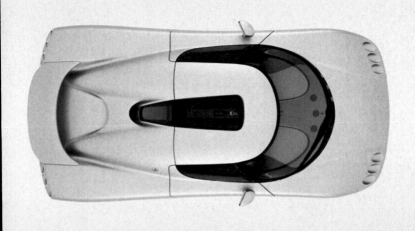

Koenigsegg CC 8 S producer: Koenigsegg AB
designer: Ergonomidesign, David Crafoord photographer: Jeffery Richt
www.koenigsegg.com

Caravan YAT producer: Knaus designer: naumann design
photographer: Rolf Nachbar www.naumann-design.de

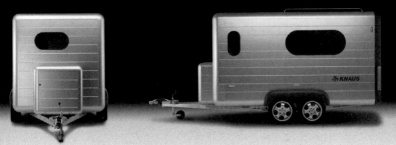

585

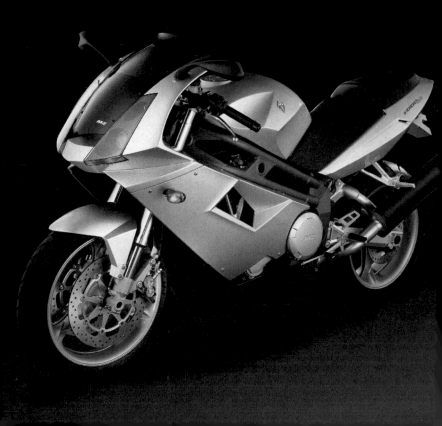

Motorbike MZ 1000 S producer: MZ engineering, Zschopau
designer: naumann design photographer: Percy Bongers www.naumann-design.de

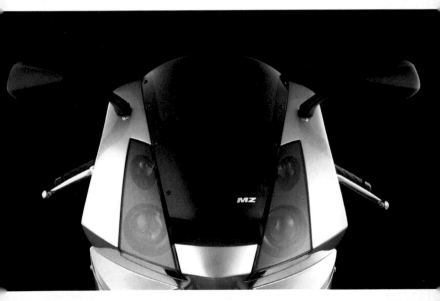

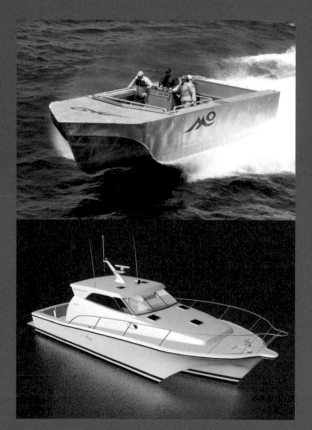

588

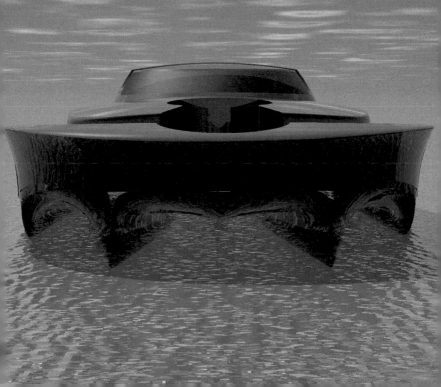

opposite MO 40 Sportfisher producer: Knight & Carver Yacht Center
below MO65 Luxury Yacht

designer: Mangia Onda Company www.mangiaonda.com

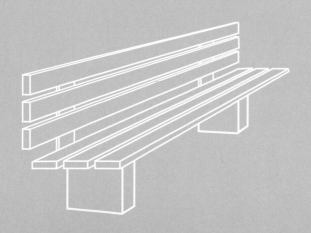

Entorno diseñado

Los semáforos y las señales dirigen el tráfico, las farolas iluminan las calles, las indicaciones marcan las direcciones, los bancos en los parques invitan al descanso.

Todo esto es el resultado de unos procesos creativos muy precisos y complejos que descubrimos cuando, por ejemplo, observamos el desarrollo que ha tenido lugar en la iluminación de las calles: desde las farolas de gas

Light signals and road signs of all kinds direct the flow of traffic, lights illuminate the streets, signposts indicate direction and park benches tempt us to rest awhile.

All these are the result of extremely precise and complex design processes. This becomes obvious when we look at the example of the development of street lighting from gas lamps to the high-tech installations of today.

The designed environment

hasta las actuales instalaciones de alta tecnología. O cuando analizamos las diferencias culturales: Todos sabemos que, antiguamente, los muñecos de los semáforos eran diferentes en la parte este de Berlín (una alegre figura con sombrero que se ha convertido en un ícono nostálgico), y que en Taiwán su movimiento en el semáforo se acelera conforme disminuye el tiempo que nos queda para cruzar la calle.

No deberíamos olvidar que todo el espacio público está diseñado: los contenedores de basura, las paradas de autobuses, los teléfonos públicos y los letreros de las calles. Los conocimientos sobre el diseño potencian además el desarrollo de sus posibilidades y de las mejoras que pueden realizarse. Va incluso más allá: A través del «diseño público» podemos juzgar la

594

Or consider cultural differences: take for instance the completely different 'little green man' formerly on the pedestrian crossing lights of East Berlin, a cheery hat-wearing symbol which has recently become a popular nostalgic icon, or its counterpart in Taiwan, which 'walks' faster the less time there is left to cross the road.

We should always remain aware that all our public space is designed – each garbage can as well as each bus stop, public payphone and street sign – for awareness of design issues also fosters insight into design potential and possibilities for improvement.

And there is yet more: the design competence of cities and communities can be judged well by their application of 'public design.' How visible and

capacidad creativa de las ciudades y municipios. ¿Son las señalizaciones visibles y legibles? ¿Están bien indicados los carriles para las bicicletas, y los aparcamientos? ¿En qué medida los tranvías y los autobuses (por ejemplo en Londres) caracterizan la imagen de la ciudad y su ambiente? Aquí el diseño no es sólo una ayuda para orientarse y conseguir una visión de conjunto, además es el responsable de la imagen de una ciudad o una región. El diseño es siempre público.

readable are their street signs? How clearly do they indicate bicycle paths or multistory parking facilities and their current occupancy? How much effect do trams or buses (London in particular springs to mind) have on the cityscape and its atmosphere?

Also in this field, design provides orientation and transparency, as well as carrying responsibility for the image of a city or region. Design is, therefore, always a public issue.

598

left Car Mall in Coral Gable, Miami
producer: The Collection
photographer: Santi Caleca
www.thecollection.com
right Audio Video Foto Stores
producer: Esselunga

designer: Massimo Iosa Ghini
www.iosaghini.it

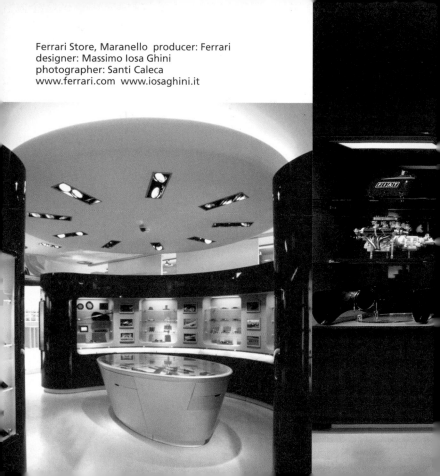

Ferrari Store, Maranello producer: Ferrari
designer: Massimo Iosa Ghini
photographer: Santi Caleca
www.ferrari.com www.iosaghini.it

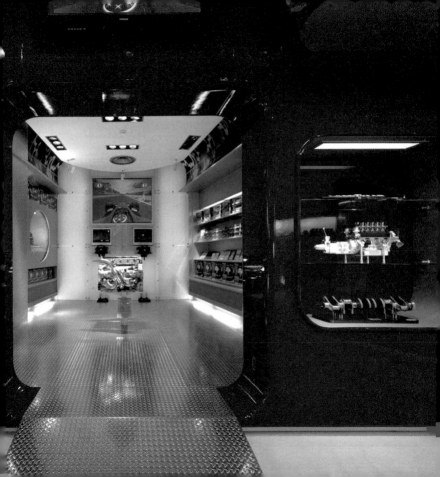

Skin & Structure
producer: Mabeg
designer: Greutmann Bolzern
www.mabeginterior.com

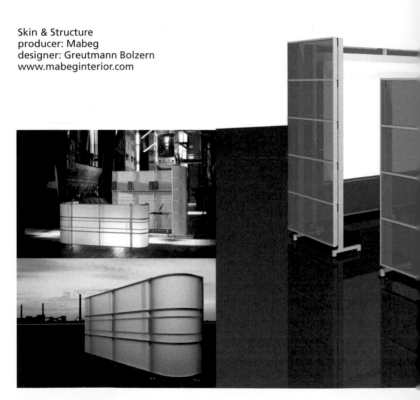

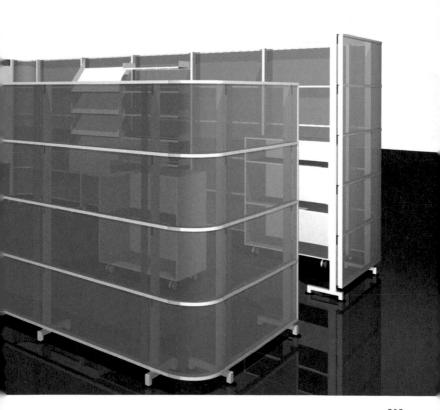

603

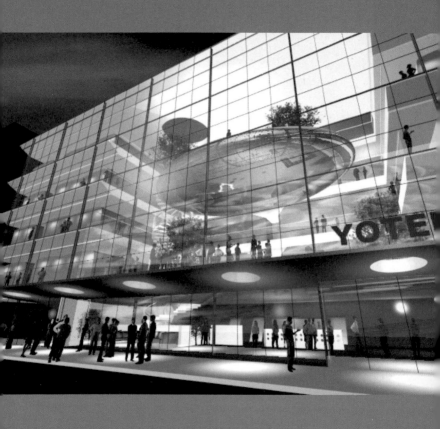

604

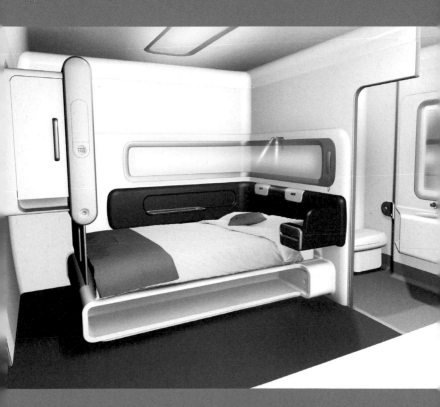

opposite and above Yotel – Capsule Hotel
designer: Opius – Russell Mulchansingh www.opius.co.uk

Interactive Cube producer Vodafone designer Ideo Europe
photographer Chris Gascoigne www.ideo.com

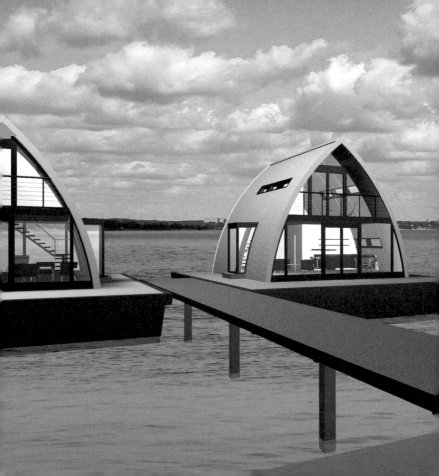

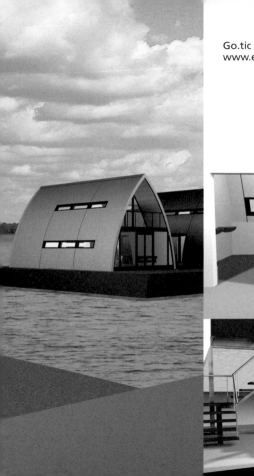

Go.tic designer: eckedesign
www.eckedesign.de

below Criss Cross **opposite** La Perga producer: Trueforms
designer: eckedesign www.eckedesign.de

611

left Wattis Institute
Entry Façade
designer:
Thom Faulders –
Beige Design
www.beigedesign.com

opposite GSM –
Digital Cellular Radio
Network Booster
producer: Alcatel SEL AG
designer: KPG Design
GmbH – Georg Kunz
www.kpg.de

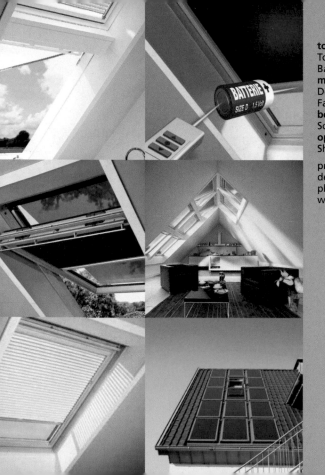

top Replacement
Top-Hung Window/
Battery Blind
middle
Double-Set DOP-DUO/
Favorit Integra
bottom Venetian Blind/
Solar Collector
opposite Roof
Shu0tter

producer: Velux
designer: Velux
photographer: Velux
www.velux.com

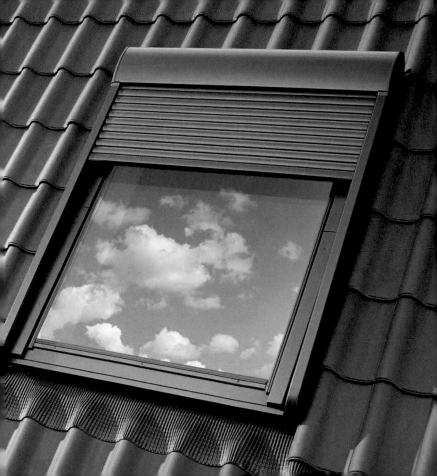

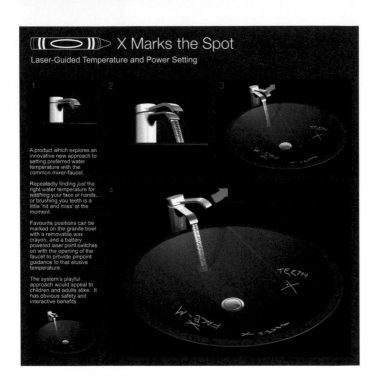

X Marks the Spot

Laser-Guided Temperature and Power Setting

1

2

3

A product which explores an innovative new approach to setting preferred water temperature with the common mixer-faucet.

Repeatedly finding *just* the right water temperature for washing your face or hands, or brushing you teeth is a little 'hit and miss' at the moment.

Favourite positions can be marked on the granite bowl with a removable wax crayon, and a battery powered laser point switches on with the opening of the faucet to provide pinpoint guidance to that elusive temperature.

The system's playful approach would appeal to children and adults alike. It has obvious safety and interactive benefits.

4

TEETH
X

FACE M

FACE M
TEETH
X

above Faucets **opposite top** Fluent **opposite bottom** Rickshaw
designer: Studio Platform www.studioplatform.co.uk

616

Shelf-Table designer: Studio Platform www.studioplatform.co.uk

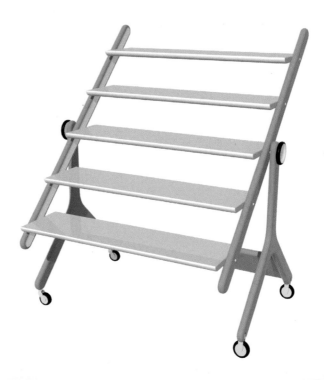

618

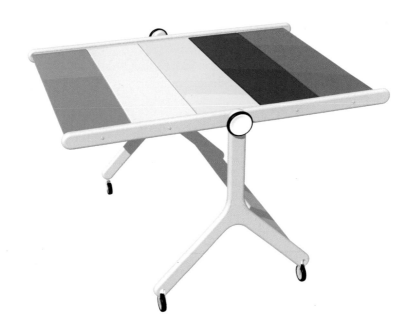

619

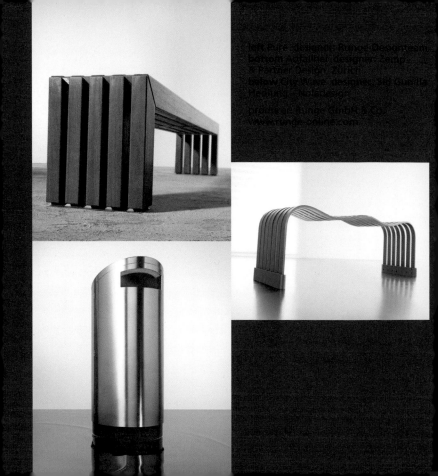

left Pure, designer: Runge-Designteam
bottom Abfalltuli, designer: Zemp,
& Partner Design, Zürich
below City Wave, designer: BD Gorilla
Heitung + Schadesign

product by: Runge GmbH & Co.
www.runge-online.com

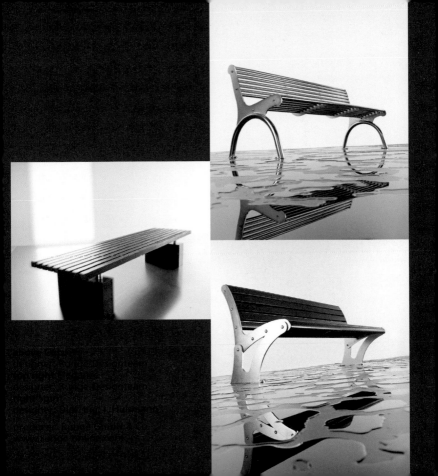

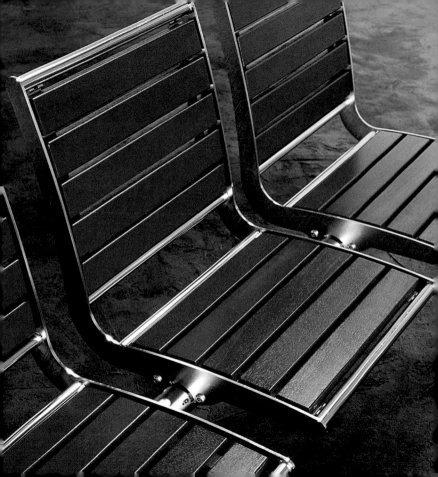

opposite Woodial **below** Spot
right Varial

producer: Runge GmbH & Co.
designer: Runge-Designteam
www.runge-online.com

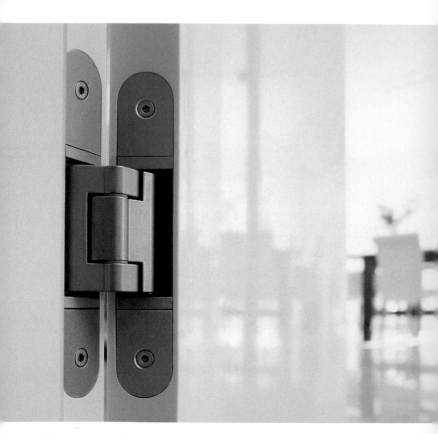

624

opposite Tectus producer: Simonswerk GmbH www.simonswerk.de
below Estante designer: Sol.Design www.sol-design.net

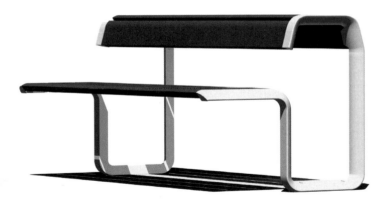

625

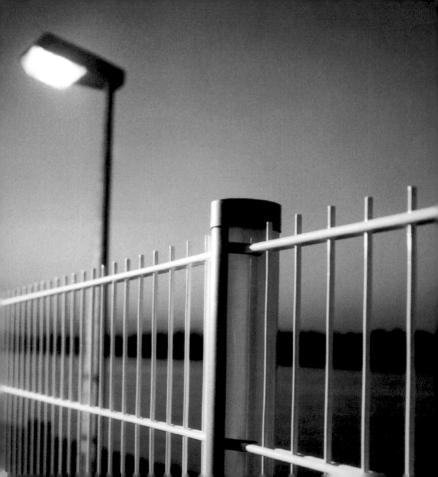

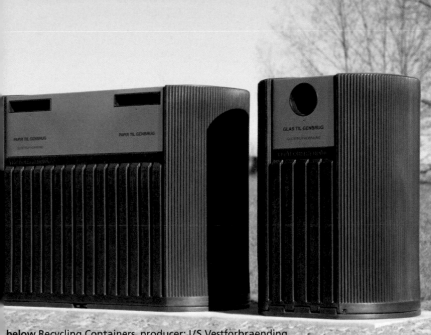

below Recycling Containers producer: I/S Vestforbraending
designer: Designit A/S www.designit.com
opposite IZ.1 producer: H.F. Finke GmbH & Co. KG
designer: Rahe+Rahe Design photographer: Gerrit Meier, Hamburg
www.rahedesign.de

Cartonhouse
designer:
Oskar Leo Kaufmann
www.olk.cc

by OSKAR LEO KAUFMANN www.olk.cc / produ

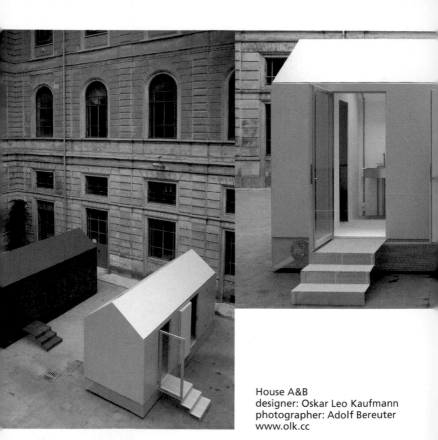

House A&B
designer: Oskar Leo Kaufmann
photographer: Adolf Bereuter
www.olk.cc

630

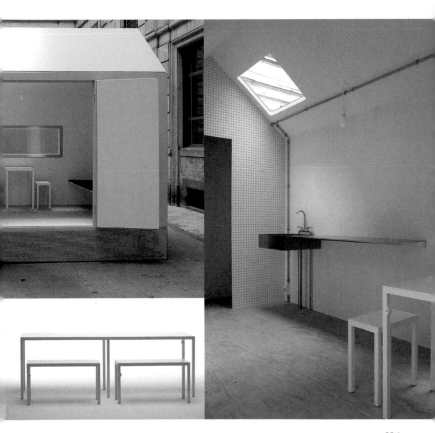

631

Just Landed designer: Walter Sindlinger & Björn Schimpf – Visual4 www.visual4.de

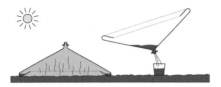

Watercone – Mobile Solar Potable Water
Generation from Sea Water or Brackish Water
producer: Disc-o-Bed GmbH
designer: Stephan Augustin
www.discobed.de www.augustin.biz
www.watercone.com

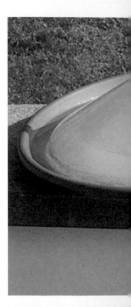

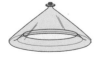 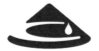

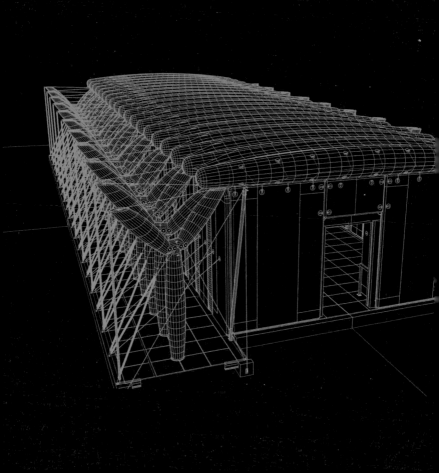

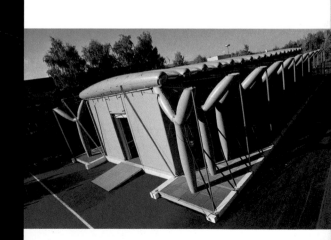

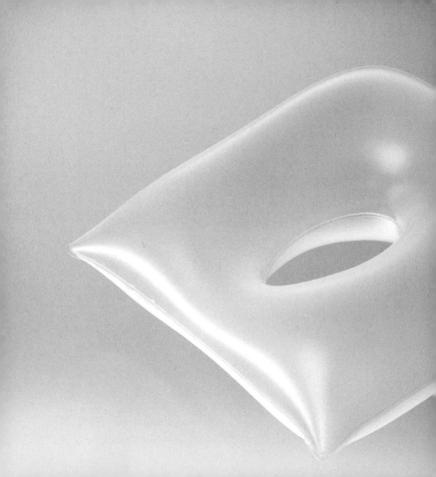

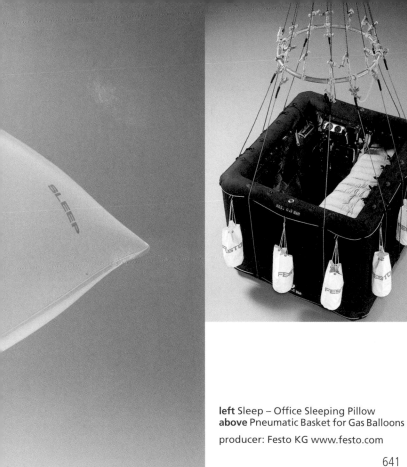

left Sleep – Office Sleeping Pillow
above Pneumatic Basket for Gas Balloons

producer: Festo KG www.festo.com

above and opposite Airquarium **below** Cocoon – Inflatable Mini Tent
producer: Festo KG www.festo.com

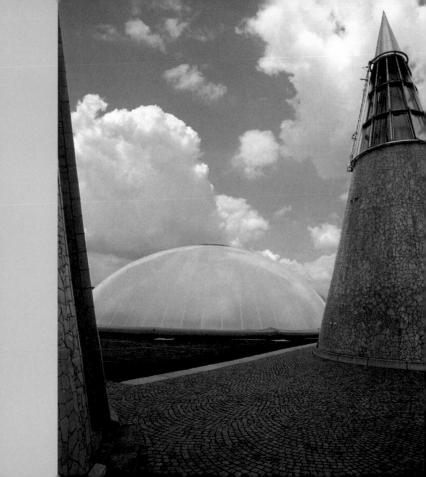

Cemusa Line 1 Bus Shelter
producer: Coporación Europea de Mobiliario Urbano SA
designer: Grimshaw www.grimshaw-architects.com

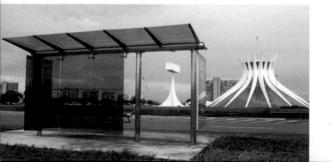

above and opposite top Burri Removable Security Bollard producer: Burri AG
below and opposite bottom Mabeg Profile One Information Display System
producer: Mabeg Kreuschner GmbH & Co. KG

designer: Grimshaw www.grimshaw-architects.com

647

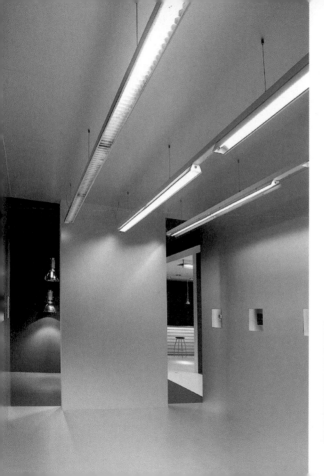

left Zumtobel Staff
Tecton Continious
Row Lighting System
producer:
Zumtobel Staff
below Merten Plantec
Room Control Panel
producer: Merten

designer: Grimshaw
www.grimshaw-
architects.com

above and right Merten Trencent Glass Switch
producer: Merten designer: Grimshaw
www.grimshaw-architects.com

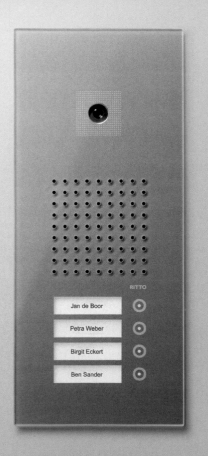

Jan de Boor

Petra Weber

Birgit Eckert

Ben Sander

RITTO

RITTO

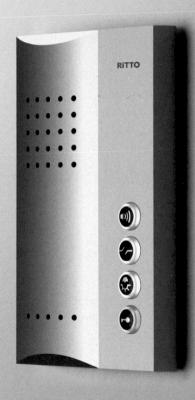

opposite Glass Doorstation Verrano
above Indoor Video Station
right Indoor Telephone

producer: Ritto designer: Prodesign
www.prodesign-ulm.de

Intus 3400
producer: PCS Systemtechnik GmbH
www.pcs.com

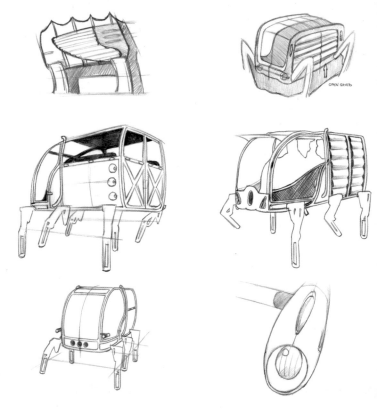

OPEN SPACE

654

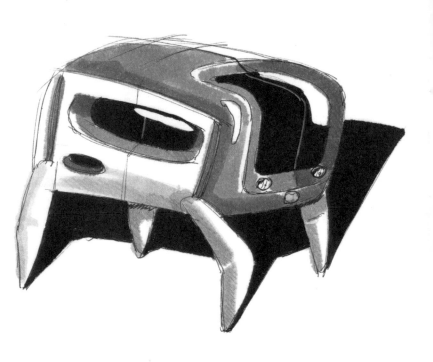

All Terrain Rescue Vehicle designer: Chris Holmes chd_redcar@hotmail.com

655

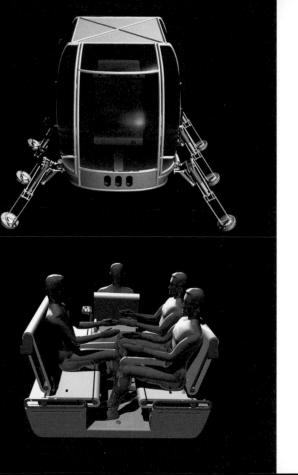

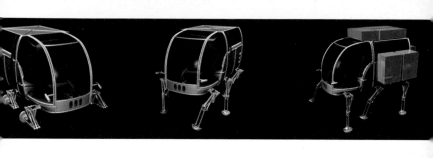

All Terrain Rescue Vehicle designer: Chris Holmes chd_redcar@hotmail.com

above left Alloy Wheel producer: Rinspeed AG designer: R 5/2 www.rinspeed.com
above right High Performance Break System producer: Rinspeed AG
designer: Rinspeed AG www.rinspeed.com
opposite V8 Engine Tatooo producer: Rinspeed AG designer: Rinspeed AG
www.rinspeed.com

above Electronic Lowering Module/Sport Rear Silencer/Set of Tailpipes Cayenne
producer: Rinspeed AG designer: Rinspeed AG www.rinspeed.com

opposite Swarowski
Rinspeed Logo
right Door Panel
Swarowski
bottom Gas Fuel Tank
producer: Rinspeed AG
designer: Rinspeed AG
www.rinspeed.com

662

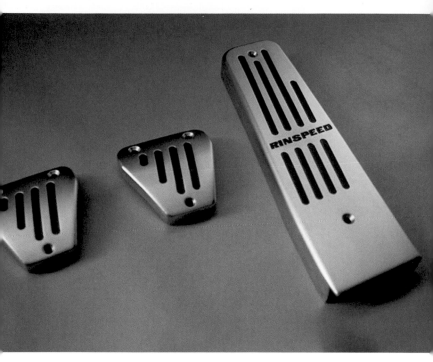

opposite top Lowering Springs Porsche 996
opposite bottom Height Adjustable Suspension
above Aluminium Pedals

producer: Rinspeed AG designer: Rinspeed AG www.rinspeed.com

663

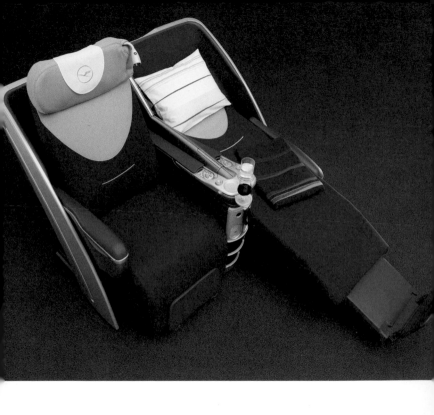

Seats Lufthansa A340-600 producer: Lufthansa
designer: Priestman Goode www.priestmangoode.com

664

665

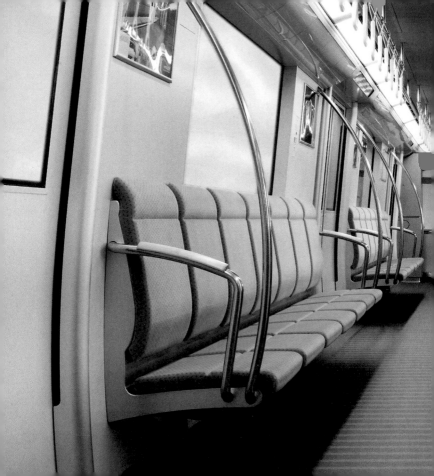

pages 666/667 Metro Fukuoka producer: Hitachi Ltd. Japan
above, below and opposite Velaro producer: Siemens AG
designer: Neumeister & Partner München www.neumeister-partner.de

669

Diseño industrial

El objetivo constante del diseño es la producción en serie, que es lo que lo diferencia del diseño artístico y de la artesanía. Por eso sus comienzos históricos están relacionados con la industria, es decir, con una producción en serie lo más variada posible.

Además, el diseño también ha estado desde el principio intimamente unido a la industria porque proyecta y crea las máquinas. El diseño ha dado

Design always focuses in effect on mass production – and this is one of the factors that differentiate design from the art and the craft industry. Thus, in terms of historical development, design is closely connected to industry and a wide diversity of mass productions.

Design has also been a constant ally of industry from the outset, beginning with the design and construction of machinery. Every assembly line, every

Industrial design

forma y ha organizado las cadenas de fabricación, las grúas, los robots y las herramientas, tanto grandes como pequeñas.

No se trata solamente de su forma exterior, que puede resultarnos de ayuda, sino también de su significado: dinamismo, finalidad y capacidad. Más importante aún es el diseño del manejo de las máquinas, de los botones y de su disposición. Gracias al diseño se distribuyen de forma precisa los lugares de trabajo, se consigue seguridad, limpieza y eficacia.

Incluso con las máquinas más pequeñas nos damos cuenta rápidamente de lo importante que es saber cuál su función y cómo se pueden utilizar. Saber cuál es la función tiene que ser un proceso sencillo y saber cómo se pueden utilizar es algo que está determinado, diseñado, desde el principio.

crane or robot, and all other tools, large and small, are shaped and organized by design.

Due consideration is of course given to outward appearance which conveys not only help but also meaning: dynamics, purpose and competence, if you will. Much more important, however, is the design of operational components, of specific buttons, their configuration and so on. It is here that individual workplaces are precisely structured and safety, maintenance and efficient operation are dealt with.

Even with the smallest machine, we rapidly learn how important it is to know what it can do and how to use it. The 'what' must of course be obvious, and the 'how' is shaped, arranged and determined from the outset by design. This

Esto es todavía más relevante con las máquinas de mayor tamaño y con las instalaciones, cuyo manejo debe quedar rápidamente claro. Por eso tienen que estar fabricadas de una forma segura y funcional, con una distribución de los botones e interruptores clara y eficaz.

Incluso la aplicación y la logística son tarea del diseño. Aquí es donde demuestra su gran capacidad organizativa, extremadamente productiva y emocionante.

is even more important in the case of complex machinery and installations, where operational features must immediately be clearly visible. This means that their bulk is most likely to be safely housed in functional casing, with all buttons and switches grouped together for overall visibility and efficiency. But, even implementation and logistics are design tasks. This is where design conclusively proves itself to be an extremely productive and stimulating organizational skill.

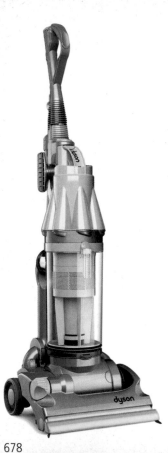

678

left DC 07 Hepa
below, bottom and opposite DC 11 Telescope

producer: Dyson GmbH www.dyson.com

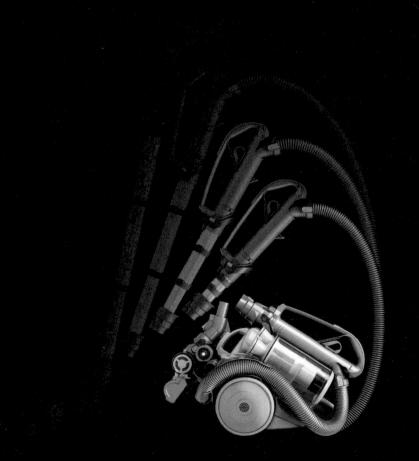

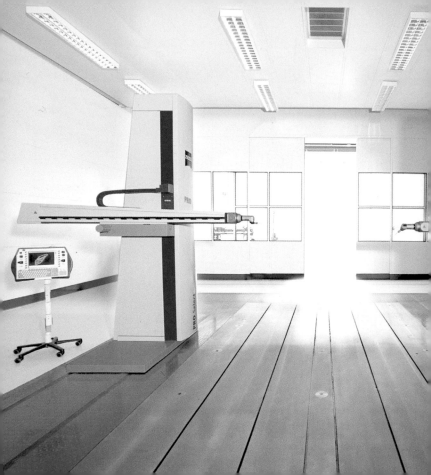

left PRO Select Measuring Machine
producer: Carl Zeiss IMT, Oberkochen
www.zeiss.de

above Mgun 4000 Automatic Screw
Feed for Drilling Machine
below ASW 12-19 Tar Angle Drilling
Machine

producer: C. & E. Fein, Stuttgart
designer: Hennsler & Schultheiss
Fullservice Productdesign www.fein.de

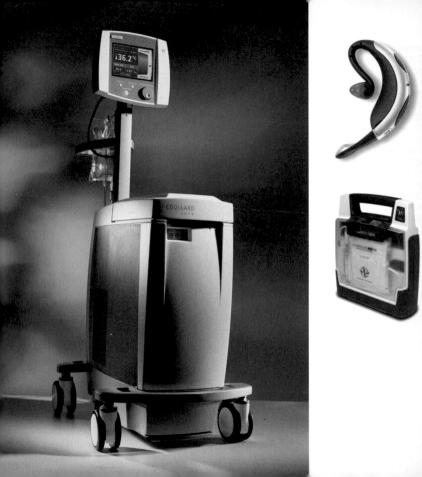

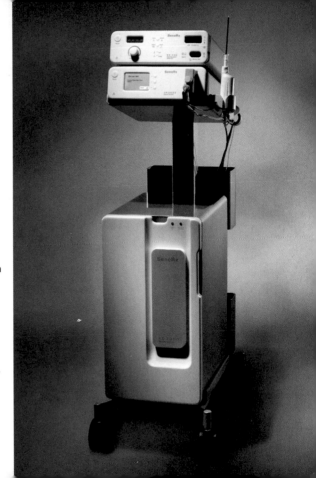

opposite left
CoolGard 3000 –
Intravascular Patient
Temperature
Management System
producer: Alsius
opposite top right
Pro Boom – Headset
for Mobile Phones
producer: Jabra
opposite below right
Powerheart AED G3
producer:
Cardiac Science
right SenoCor 360 –
Breast Biopsy System
producer: SenoRx

designer:
Stuart Karten Design
www.kartendesign.com

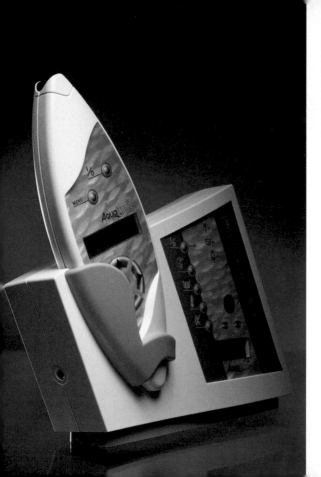

left Iguaçu –
Water Massage
producer: Aquajet
opposite Expert Series
producer: Physiomed

designer:
Designpartners
www.designpartners.de

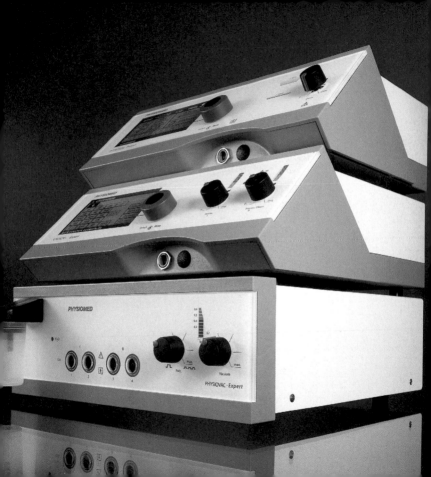

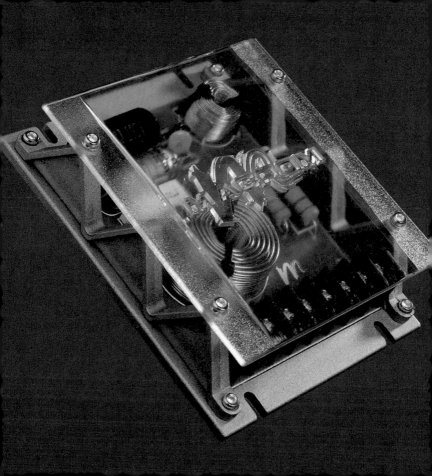

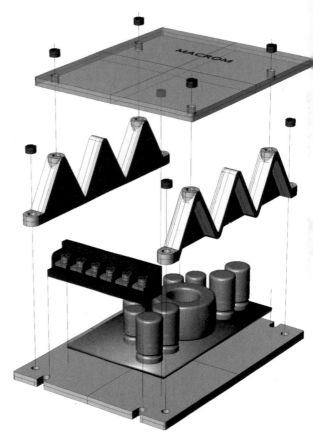

EXT – Car Audio
Passive Crossover
producer: Macrom SA,
Luxemburg
designer:
Pedrizetti Associati
www.macrom.ch
www.pedrizetti.it

687

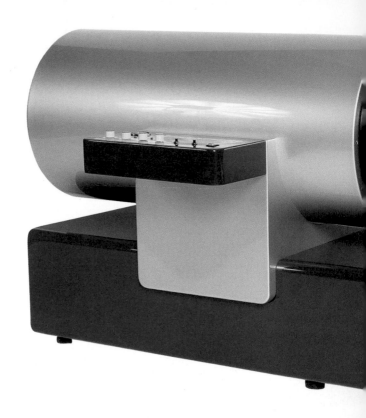

Vacustyler producer: Weyergans High Care AG
designer: Designschneider www.high-care.com

patent pending

VACUSTYLER®
LBNPD

689

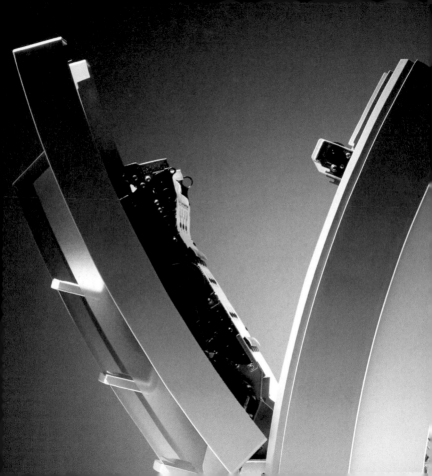

Numeron – Banknote Processing System
producer: Giesecke & Devrient München
designer: Neumeister & Partner München
photographer: Bernhard Lehn, München
www.neumeister-partner.de

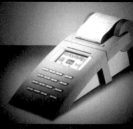

691

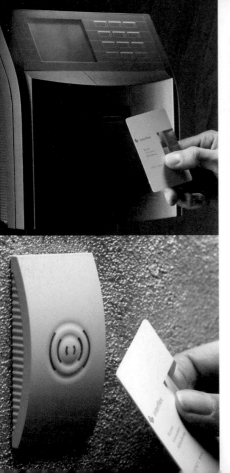

left IF 2338 Touchterminal
producer: Interflex Datensysteme
Stuttgart
bottom IF 60 Proximity Leser
producer: Interflex Datensysteme
Stuttgart
opposite Coach Chip Ei
producer: Frei AG Kirchzarten

designer: Neumeister & Partner München
photographer: Bernhard Lehn, München
www.neumeister-partner.de

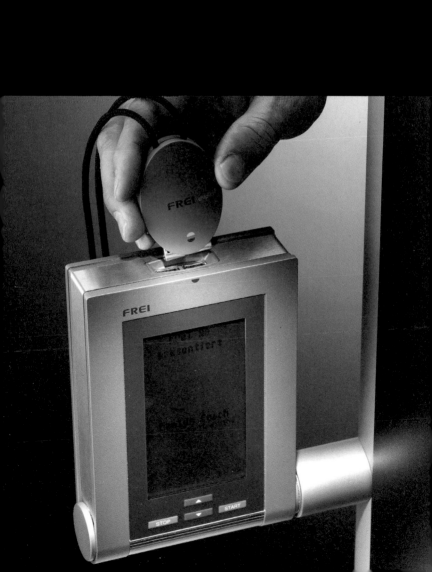

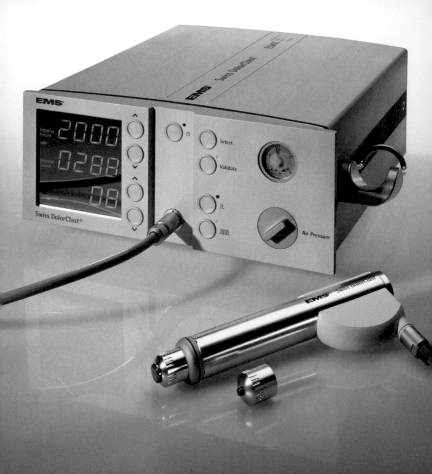

opposite DolorClast
above and right
Piezonmaster – Ultrasonic Scaler

producer: EMS Nyon, Schweiz
designer: Neumeister & Partner München
www.neumeister-partner.de

above Free Light2 producer: 3M ESPE Seefeld
designer: Neumeister & Partner München www.neumeister-partner.de
opposite Dental Grinder G3
producer: Langner Dentaltechnik GmbH/Schick Dentaltechnik GmbH
designer: KPG Design GmbH – Georg Kunz photographer: Ernesto Martens
www.kpg.de

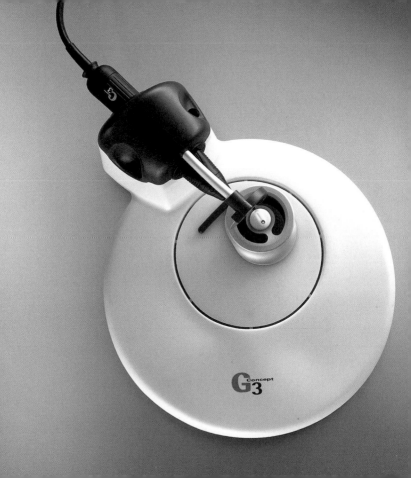

Columbus

Europäische Columbus-Labor

Lorem ipsum dolor sit amet, consectetur adipiscing elit, sed do eiusmod tempor incididunt ut labore et dolore magna aliqua. Ut enim ad minim veniam, quis nostrud exercitation ullamco laboris nisi ut aliquip ex ea commodo consequat.

European Columbus laboratory

Lorem ipsum dolor sit amet, consectetur adipiscing elit, sed do eiusmod tempor incididunt ut labore et dolore magna aliqua. Ut enim ad minim veniam, quis nostrud exercitation ullamco laboris nisi ut aliquip ex ea commodo.

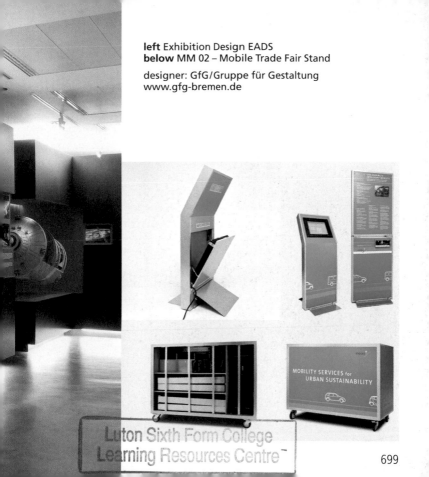

left Exhibition Design EADS
below MM 02 – Mobile Trade Fair Stand

designer: GfG/Gruppe für Gestaltung
www.gfg-bremen.de

MOBILITY SERVICES for
URBAN SUSTAINABILITY

699

A.S. Création 62f.
A.T. Cross 156f.
A/S Hammel Møbelfabrik 38f.
accavia GmbH 497
Accupunto 52f.
Adhoc GmbH 141
Adolf, Reinhold &
 Hans-Jürgen Schröpfer 68
Adrien, Rovero 240ff., 568
Aguadé Cerámica 408
Ahn, Christian von 80
Alberich, Javier 536f.
Alcatel SEL AG 613
Alessi SpA, Italy 100, 194ff.,
 222ff, 483, 288ff.
Alfi 200f.
Alloy 480f.
Aloys F. Dornbracht GmbH 214f.
Alsius 682
Alsop, William 195
Amino-Communications 496
Duffeleer, Anthony 336, 340ff.
Appeltshauser, Georg 92
Aquajet 684
Arabia 268
Arad, Ron 113
Art.collection/Haworth 451
Atallah, Serge 233
Auerhahn 155, 276
Augustin, Stephan 634ff.
Axia Srl 306f.

B&B Italia Spa, Italy 428
Ball, John Greg 28f.
B.R.F. 74f.
B.T. Dibbern 212f.
B/F Industrial Design 492ff., 564
Bang & Olufsen 487
Barskidesign 308f.
Bartoli Design 70f., 320f.

Bauscher 252
Bd Ediciones de Diseño 34ff., 267
Beat Karrer 431ff.
Beck, Norbert 93
Bellini, Mario/Claudio 58f., 271,
 424ff., 470, 485
Belux AG 404f.
Bengs, Carina 47
Berendsohn AG 202f.
Bernds/Bernds, Thomas 540f.
Bernhard & Heinrich Finke GmbH 98f.
Berufsbildungswerk München 248f.
Bette, Delbrück, Germany 304f.
Bézenville 170
Biomega, Denmark 144
Bisjak Graf & Richter 94
Björklund, Tord 46
Blanco Design 204f.
Blisse, Bjørn & Folker Königbauer
 & Reinhard Zetsche 24f.
Boa 234f., 284
Boblbee AB 164f.
Boffi 430
Bonaldo spa 49, 113, 218
Boos, Reinhard 263
Boym, Constantin &
 Laurene Leon 366f.
Breitenfeldt, Alexandra 54f.,
 145, 392
Bretz Brothers Design 64ff.
Brown, Julian 201
BT 480f.
Bull & Stein GmbH & Co. KG 69
Burri AG 646f.

Cactus & Quim d'Espona 84f.
Caimi Brevetti S.p.A., Italy 428
Caisse des Depots et Consignations
 & Fondation Grand-Duc
 Jean du MUDAM 91

Campana 197
Cannondale 536f.
Cardiac Science 682
Carell, Anna 567
Carl Zeiss IMT, Oberkochen 680f.
Casio 181, 508ff.
Castiglioni, Achille 370f.
Cattany Design, Thomas Cattany
 206
Celentano, Raffaele 371
Cherry, Terrace, Japan 271
Christine Kröncke Interior Design
 56f., 330
Christl, Claudia 256
Chroma Cutlery Inc. 270
Cimini, Ettore 372f.
Cinal 60f.
Cinova 48
Cisotti, Biagio & Sandra Laube 75
Citterio, Antonio 346, 350f.
Clemtone Design 172f.
Clerici, Marzio Rusconi 397
Cognito 552ff.
Colombo Design 320f.
Comforto/Haworth 452, 471
Concord GmbH 542
Conmoto 126
Contur_x 232
Coporación Europea de Mobiliario
 Urbano SA 644f.
Cor Sitzmöbel Helmut Lübke
 GmbH & Co. KG 68
Crafoord, David 566, 582f.
Crochet, Jean François 386f.

Dalí, Salvador 36f.
Daney, Philippe 400
Danzer Furnierwerke GmbH 114f.
Dark Lightning Company 336ff., 370
De Longhi 210, 211, 285, 287

700

Denz & Co AG 444f.
Design House Stockholm 40f.
Design Wiege 466
Designafairs 490f.
Designerslabel 108f.
Designit A/S 166f., 410f., 486f.,627
Designpartners 266, 684f.
Designschneider 114f., 208, 286f.,
316f., 484, 688f.
Desombre, Thibault 401
Dibbern Design Studio 212
Dierenbach, Hartmut 252
Dietiker Switzerland 128f.
Disc-o-Bed 634ff.
Domodinamica 227
Dordoni, Rodolfo 346, 348f.
Dörfel, Mikaela 220
Drabert GmbH 436ff.
Driade Spa Italy 58f.
Ducaroy, Michel 81
Dumas, Fabien 357
Duscholux 295, 298f.
Dyes 450f.
Dyson GmbH 678f.

Ecco Design 119, 498f. 504f.
Eckedesign 440, 608ff.
Eigenstätter, Bernhard 92
El Schmid 412
Elefanten GmbH 570f.
Ellips 26f., 413
Emdelight 394
EMS Nyon, Schweiz 694f.
Emsa Werke 216f., 284, 286
Erco Leuchten GmbH,
Lüdenscheid 344f.
Ergonomidesign 566f., 582f.
Erlenkamp, Kerstin &
Stefan Thielecke,
Röder Designteam 453

Eschenbach 564
Esselunga 598f.
Eve-Design 176f.
Eye Eye Denmark 166

F.A. Porsche 446f.
Factor ProductDesignagentur 249
Faulders, Thom – Beige Design
612
Fein, C. & E. Stuttgart 681
FELT GmbH 538f.
Ferebee, Chris 60f.
Ferrari 600f.
Ferreira, Marcus 69
Festo KG 638ff.
Figueroa, Daniel 436ff.
Fingermax GmbH 569
Fiskars 558f.
Flos 346ff., 366, 370f.
Flötotto, Elmar 140
Floyd, Charles, San Francisco 207
Foscarini 218
Franck, Thorsten 455
Frei AG Kirchzarten 693
Frey, Patrick & Markus Boge 72f.
Frezza S.p.A., Italy 429, 426f.
Fusi, Renata & Silvana Mollica
& Paolo Canotto 168f.

Gallery Klaus Engelhorn 20 Vienna
90
Gätjens, Jörg 94,248
Gebrüder Thonet GmbH,
Frankenberg 125, 250f.
GfG/Gruppe für Gestaltung
180, 698f.
Ghyczy Selection – Peter Ghyczy
30f.
Giesecke & Devrient München
690f.

Giller, Andreas 87
Giovannoni, Stefano 222ff., 300f.
Goetti, Nicole 275
Greutmann Bolzern Designstudio
128f., 404f., 442ff., 470, 602f.
Grimshaw 644ff.
Grosemans, Davy 341
Grundig 511
Gurioli, Giorgio 77, 396
Guzzini 219

H.F. Finke GmbH & Co. KG 626
Habitat, Great Britain 117, 332
Hack, Martin 488f.
Hadi Teherani 394f., 415, 468f.
Hadid, Zaha 198
Hajduga, Stefan 63
Hansa AG 293
Hansgrohe 294
Harlis, Eddie 250f.
Harri Koskinen Friends of
Industry Ltd. 40f., 154, 268
Harvey Lee, Stuart – Prime Studio
179
Hauck GmbH & Co. KG, Sonnefeld
544f.
Haworth, USA 426f., 450f.,
453, 471
Hedlung, Sid Gunilla – Nolandesign
620
Helit 446ff.
Hennsler & Schultheiss 681
Heraeus 308
Hey-Sign 112
Hickman, David 576ff.
High Tech 296f.
Hitachi Europe GmbH 484
Hitachi Ltd. Japan 666f.
Hoesch 317
Holmes, Chris 654ff.

Honka, Markus 108f.
Hopf & Wortmann / büro für form
116f., 140, 331ff., 568
Horst, Katja 158f.
Hülsmann, I. Dipl. Ing. 621
Hwang, Kap-Sun 220f.

i/i/d Institut für Integriertes Design,
Bremen – Prof. D. Rahe &
R. Hamadmad & F. Lieser 467
I/S Vestforbraending 627
ICF, Italy 470
Ideo Europe 184f., 606f.
iitala 268
Ikea 46f.
Ikra Mogatec 556f.
Ingo Maurer GmbH 354f., 362f.,
370f.
Interflex Datensysteme Stuttgart
692
Interstuhl 469
Iosa Ghini, Massimo 48f., 218,
393, 598ff.
Irvine, James 262
ITO Design 452, 471

Jabra 682
Jacob Jensen Design 182f.
Jakob Wagner design 441
Jehs & Laub 125
Jensen, Georg 167
Jonas & Jonas 108f.
Jordan AS, Norway 253
Jourdan, Eric 80
Jungbluth, Achim 368f.

Kaether & Weise 454ff.
Kahla/Thüringen Porzellan GmbH
230f., 287
Kaldewei 302f.

Karaaslan, A. Rasit 96f.
Karnagel, Wolf 272
Katana Design 200
Kaufmann, Oskar Leo 628ff.
KFF Design 42ff.
KinBag AB 567
Kita, Toshiyuki 218
Kleihues, Jan 310f.
Knaus 584f.
Koenig, Michael 454f.
Koenigsegg AB 582f.
Kolibri 364f.
König & Neurath 468
Korb, Danial 451
Kowalewski Andreas 76
Koziol 232f., 546
KPG Design GmbH – Georg Kunz
542f., 613, 697
KPM – Königliche Porzellan-
Manufaktur Berlin GmbH 272f.
Krause, Swen 95
Kron, Spain 70
Kundalini, Italy 77, 117,
396ff., 415
KWC Armaturen 286, 292f.

LaCie Group S.A., France 520f.
Lambert GmbH 76, 269, 412
Langner Dentaltechnik GmbH/
Schick Dentaltechnik GmbH 697
Lassen, Thore & Søren Nielsen MDD
470
Lassus, Kristiina 288ff.
Laufen AG, Il Bagno Alessi 300f.
Leonardo/Glaskoch 138f., 274
Lesser Modernes Wohnen GmbH
115
Levy, Arik 78f.
LFF Leuchten GmbH, Solingen
368f.

Liedtke, Matthias 354
Lifesteel 560f.
Lindén, Olavi 558f.
Lino Codato 306f.
Lissoni, Piero 82f.
Living Divani 82f.
Loewe AG 512ff.
Logitech 516
Lotos 395
Lovegrove, Ross 34f.
Löw, Glen Oliver 250
Ludwig, Chistoph & Axel Karremann
– Katana-Design 556f.
Lufthansa 664f.
Lumina Italia Srl 372f.

M.H. Wilkens & Söhne GmbH
256
Mabeg Kreuschner GmbH & Co. KG
646f.
Mabeg 602f.
Macrom SA, Luxemburg 686f.
Macura, Marko 74
Maly, Peter 81, 110f.
Mamoli Robinetterie S.p.A. 313
Mangia Onda Company 588f.
Manufacturas Celda S.A. 124
Marchand, Christophe 434f., 470
Mari, Enzo 273
Mariscal, Javier 267
Marley Deutschland GmbH
548f.
Massaloux, Laurent &
Thierry Balasse 91
Matthias, C. 357, 371
Matthias, Christoph & Hagen Sczech
363
Maurer, Ingo 354ff., 362f., 370
Medap 308
Meier, Susanne 112, 209